THE INDELIBLE IMAGE

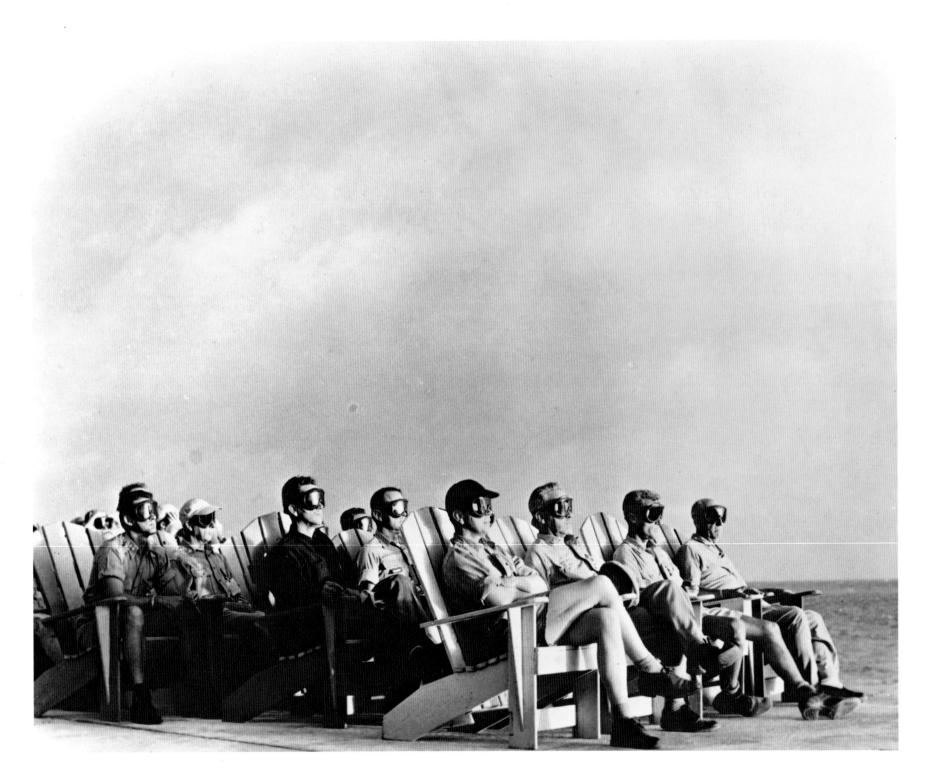

PHOTOGRAPHER UNKNOWN/U.S. Air Force, [*Observers, Operation Greenhouse*], 1951
U.S. Department of Defense, Washington, D.C.

"High ranking personnel are illuminated by the flare of an atomic detonation at the Atomic Energy Commission's
Pacific Proving Ground during Operation Greenhouse, staged by Joint Task Force Three, 1951."

779
F843

THE INDELIBLE IMAGE
PHOTOGRAPHS OF WAR·1846 TO THE PRESENT

FRANCES FRALIN

with an essay by
JANE LIVINGSTON

HARRY N. ABRAMS, INC., PUBLISHERS, NEW YORK

CORCORAN GALLERY OF ART, WASHINGTON, D.C.

Howard County Library
Big Spring, Texas 79720

088704

This book is published in conjunction with an exhibition of the same title organized by the Corcoran Gallery of Art and presented at the following institutions:

The Grey Art Gallery and Study Center
New York, New York
September 24–November 16, 1985

Institute for the Arts, Rice Museum
Houston, Texas
February 6–March 24, 1986

The Corcoran Gallery of Art
Washington, D.C.
April 26–June 22, 1986

Library of Congress Cataloging in Publication data

Livingston, Jane.
The indelible image.
Bibliography: p. 22.
1. War photography. I. Title.
TR820.6.L58 1985 779′.99098 85–6034
ISBN 0–8109–1110–8

Book design: Alex and Caroline Castro, HOLLOWPRESS, Baltimore

Copyright © 1985 Corcoran Gallery of Art, Washington, D.C.

Published in 1985 by Harry N. Abrams, Incorporated, New York. All rights reserved. No part of the contents of this book may be reproduced without the written permission of the publishers

Printed and bound in Japan

TABLE OF CONTENTS

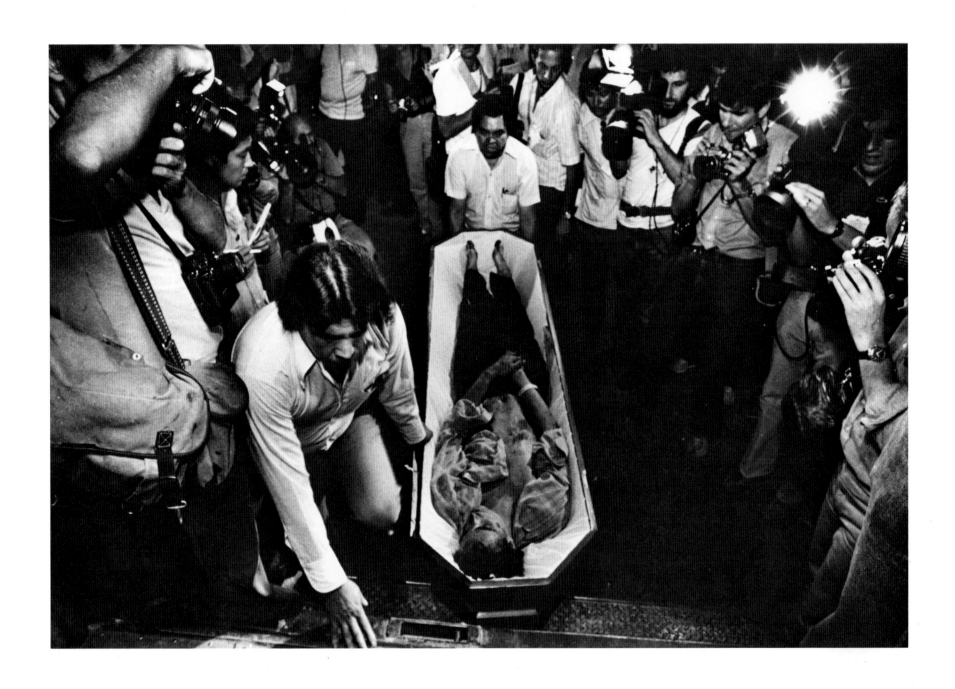

Mike Goldwater, *El Salvador*, 1982, Courtesy the Photographer

PREFACE

The genesis of this project dwells in a 1982 conversation with Jane Livingston in which we discussed the possibility of my organizing a photography exhibition lying beyond the confines of fine art photography. Photojournalism seemed an obvious area to explore in this city of world politics and in light of my own special interest in photography as a popular art form. After months of gestation, the idea of treating the subject of war seemed most challenging. My interest whetted by hearing of rare prints on other continents, I decided not to limit the geographic area of research. Narrowing the subject to one war or one historical period was either implausible or untempting—unnecessarily limiting from an aesthetic point of view or unavoidably political. Yet the wish to make a statement about the absurdity and futility of war was strong (notwithstanding knowledge of the theories of "just" and "unjust" wars or "good" ones).

Commencing with a few conversations with key curatorial and journalistic figures, each lead offering many others, I began to gather information by exploring the vast archives in Washington, D.C.: the American Red Cross, the Library of Congress, the National Archives, the Defense Department. With some assistance but mostly alone, I searched New York, its museums, galleries, photo agencies, and archives. I visited or wrote state historical museums or societies, as well as scores of art and photography museums and galleries around the country. I rummaged through hundreds of photography, war, and war photography books. I visited London and Paris, and delegated work in both cities to researchers. Work was also gathered from Germany, Japan, Mexico, the Soviet Union, and Spain. Eventually, we looked at tens of thousands of photographs.

The parameters for selecting work were left wide open in time and place. Chronology was limited only by the camera's history. The criterion for selection was simply the ability of the image to be remembered. This, of course, is not a simple matter. A memo-rable photograph might be formally evocative or appalling; it might involve beautiful or lyrical imagery, or quite differently, bizarre, humorous, or stunning pageantry; irony would play a major role. I decided that war would not be consciously portrayed as heroic or romantic. Recognizable personalities would be omitted, as would all consideration of who took the picture. The sentimental would be avoided. The most gory or emotionally assaultive images were, for the most part, excluded. Aesthetic considerations were always unavoidably present. The history of photography was broadly covered, but was in no way surveyed consistently. Images were picked for their visual impact, not for the war they reported. Not all wars waged since 1846 are represented here. In addition, some photographs were taken before or after the actual dates of hostilities, but relate to war, either in its preparation or its legacy.

We each have an image of war indelibly etched in our memory. My earliest and still most vivid image of war is that of the crying infant in the devastated Shanghai railway station taken August 28, 1937, by H. S. "Newsreel" Wong of Hearst Metrotone News. The October 14, 1937, issue of *Life* magazine estimated that 136 million people had seen Wong's "Chinese Baby." Pictures such as this that have become clichés were also avoided—these icons constitute an exhibition of their own—for the sake of presenting fresh images as powerful as those already in our memories. Works by many of the photographic masters and great photojournalists of the past ultimately did not find their way into the book. It was similarly impossible to include work by everyone in the proliferating new generation of first-rate war photographers and photojournalists. However, a good number are represented.

The role of the photographer/observer became an important issue in our research. One often sees the camera itself in these pictures—a reminder of the photographer's presence. What are the motives of the war correspondent? Humanitarian impulses? Adventure seeking or profit-making impulses? Most war correspon-

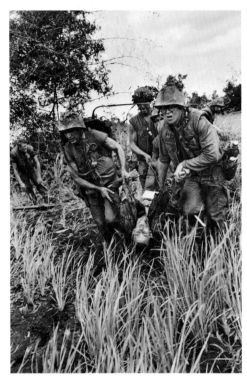

Catherine Leroy, *A Dead Marine Is Carried by His Buddies to a Helicopter . . .near DMZ,* 1966, Courtesy the Photographer

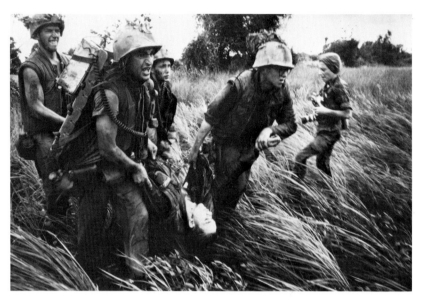

Larry Burrows, *Marines Recover a Body under Fire, Hill 484, South Vietnam,* 1966, original in color, Courtesy Russell Burrows (Catherine Leroy at right)

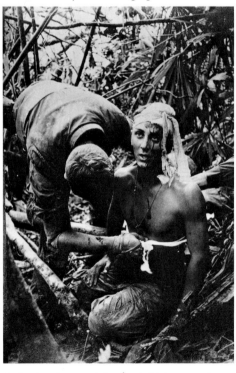

Catherine Leroy, *A Wounded Marine, Khe Sanh Area,* 1966, Courtesy the Photographer

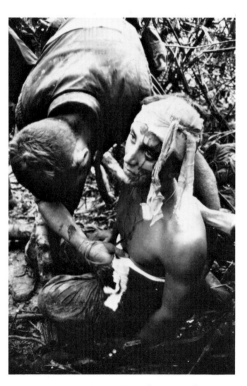

Larry Burrows, *A GI Casualty near the DMZ,* 1966, South Vietnam, original in color, Courtesy Russell Burrows

dents truly seem eager to educate, to document, and ultimately to change things. Is the photographer occasionally a participant? One story told me by Penny Tweedie, a photojournalist, has stuck in my mind: Tweedie and several other photographers were recording a scene in Bangladesh where three suspected Pakistani collaborators were being tortured by Bengali soldiers. Sensing that the drama was being enacted for the camera, Tweedie and a fellow photographer, Marc Riboud, withdrew and tried to dissuade the others from continuing. However, cameras kept clicking, possibly inciting further violence, until three executions ended the drama. Two of the photographers who continued to record the scene received awards for their work there; one a Pulitzer prize and the other the British Press Picture of the Year Award.

Since before the American Civil War, scenes have been rearranged or created for the camera. Bodies have been positioned for the photographic eye, deaths faked. This brings to issue the propagandistic power of the photograph. In 1855 Roger Fenton was dispatched to the Crimea under patronage of the queen of England to provide photo-documentation to counter reports of inhuman conditions in the army camps that were being published in the British press. Fenton's photographs, in fact, may have served to neutralize perceptions of that conflict, whether in his contemporaries' eyes or in the eyes of historians. Depending upon how the picture is used, any war image can serve as successful propaganda—overtly or covertly.

Early camera technology—the difficulty and fragility of the wet plate negative process and the length of exposure required—restricted what the camera could capture when Fenton and his contemporaries presented the first war reportage, the locale and aftermath of the battle, necessarily without action. Military portraits still required rather long exposures. Now one can catch the impact of the moment a bullet penetrates the skull, as in Eddie Adams's well-publicized picture of South Vietnam's national police chief assassinating a captive. Adams, who had a hard time adjusting to the fame of the picture, stated after winning a Pulitzer prize for the photograph: "It's one-five-hundredths of a second I was getting money for showing one man killing another. Two lives were destroyed, and I was getting paid for it. I was a hero" (quoted in Nakahara 1982, 1).

Until the Vietnam era, wars generally were photographed officially by governments or public agencies. More recently the soldier's personal camera has produced a different kind of repertory of images. Vietnam produced an unprecedented body of editorializing photographic essays. Any independent or news-supported photojournalist was able to cover this unpopular war, and the war's conclusion rests to a large degree in the camera's constant coverage of it—for many people worldwide, dinner was often eaten, if not digested, in the atmosphere of electronically communicated carnage in Vietnam—proving that photography can make a difference. Such reportage has been true ever since. It may also explain why the U.S. government barred photographers from covering its recent invasion of Grenada.

The two pairs of photographs reproduced here by Larry Burrows and Catherine Leroy portray the multiple presence of the camera at war and hint at the camaraderie that exists among photographers who pick such a violent workplace. The accompanying photograph by Britisher Mike Goldwater of the coffin of Hans ter Laag surrounded by photographers exemplifies the magnitude of present-day media coverage. It corroborates not only that photographing war is a dangerous business but that recording war has become a crowded business. Hans ter Laag was one of four Dutch television journalists shot in El Salvador in spring 1982.

Times have changed since November 1943, when in historian William Manchester's (1979) words:

> In Washington's new Pentagon building, officers studied the pictures of dead Marines on Tarawa, debating whether to release them in the press. They decided to do it; it was time, they felt, to shock the home front into understanding the red harvest of combat. The published photographs touched off an uproar. Nimitz received sacks of mail from grieving relatives...and editorials demanded a congressional investigation. The men on Tarawa were puzzled. The photographers had been discreet. No dismembered corpses were shown, no faces with chunks missing, no flies crawling on eyeballs; virtually all the pictures were of bodies in Marine uniforms face down on the beach. Except for those who had known the dead, the pictures were quite ordinary to men who had scraped the remains of buddies off bunker walls or who, while digging foxholes, found their entrenching tools caught in the mouths of dead friends who had been buried in sand by exploding shells. (242)

Today the fact remains that one can describe war in words summoning unimaginable horrors, but photographs of the same depredations are seldom acceptable or permissible.

War itself parallels the camera's tendency to chronicle its transformation from terrifying but majestic to senselessly sordid. Paul Fussell (1975) brilliantly inspects man's loss of innocence, never to be regained, in *The Great War and Modern Memory*: "The innocent army fully attained the knowledge of good and evil at the

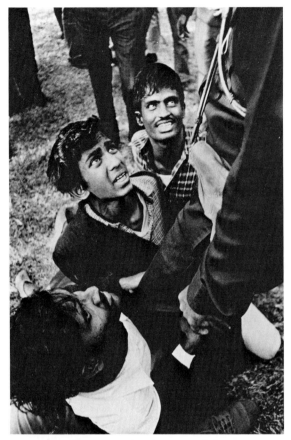 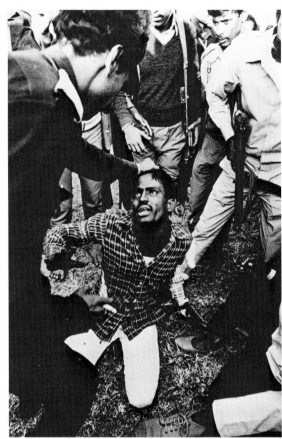 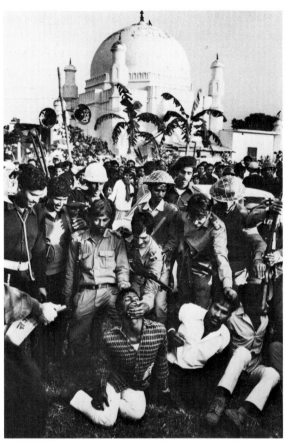

Marc Riboud, *Suspected Pakistani Collaborators Publicly Tortured to Death in Front of a Mosque, Dacca, Bangladesh,* 1971, International Center of Photography, New York, International Fund for Concerned Photography, Purchase

Penny Tweedie, *Bangladesh, 1971,* Courtesy the Photographer

Penny Tweedie, *Bangladesh, 1971,* Courtesy the Photographer

Somme on July 1, 1916. That moment, one of the most interesting in the whole long history of human disillusion, can stand as the type of all the ironic actions of the war" (29). The troops were optimistic and well prepared, expecting this to be the war's final battle; even the weather was clement. In *The Great War* Fussell quotes Henry Williamson's vivid recall thirteen years later:

> I see men arising and walking forward; and I go forward with them, in a glassy delirium wherein some seem to pause, with bowed heads, and sink carefully to their knees, and roll over slowly, and lie still. Others roll and roll, and scream and grip my legs in uttermost fear, and I have to struggle to break away, while the dust and earth on my tunic changes from grey to red.
>
> And I go on with aching feet, up and down across ground like a huge ruined honeycomb, and my wave melts away, and the second wave comes up, and also melts away, and then the third

wave merges into the ruins of the first and second, and after a while the fourth blunders into the remnants of the others, and we begin to run forward to catch up with the barrage, gasping and sweating, in bunches, anyhow, every bit of the months of drill and rehearsal forgotten, for who could have imagined that the "Big Push" was going to be this? (29–30)

The four-month long Somme attack cost the British alone four hundred and twenty thousand killed and wounded.

Freeman Dyson (1984, 134) has written, "In both [world] wars, the beginning was young men going out to fight for freedom in a mood of noble self-sacrifice, and the end was a technological bloodbath that seemed in retrospect meaningless In both wars, history proved that those who fight for freedom with the technology of death end by living in fear of their own technology."

William Shawcross (1984) illuminates our contemporary dilemma when he describes Cambodia as having "an importance beyond itself, because there in its fragile heart paraded, throughout the 70's, many of the most frightful beasts that now stalk the world. Brutal civil war, superpower intervention carelessly conducted from afar, nationalism exaggerated into paranoid racism, fanatical and vengeful revolution, invasion, starvation and back to unobserved civil war without end."

This exhibition asks us to look not at specific problems and to lay blame, but perhaps to glimpse more directly the living reality of institutionalized conflict, to see more clearly what war is for its participants, and to suggest that we perhaps cannot afford to retreat from the consequences in each of us of this confrontation.

This project, so unintentionally ambitious and increasingly complex, could not have been achieved without the help of a number of researchers and assistants, many of whom served on a voluntary basis. Early in our progress William Dunlap, Washington, D.C., artist, amateur photographer, and military historian, joined me in conducting research. Valerie Lloyd gathered material in England. Abigail Solomon-Godeau, in Paris, and Christopher Phillips and Alexandra Truitt, in New York, also carried on research, as did Stacey Bredhoff at the National Archives and Defense Department archives. More recently, Stacey Bredhoff and Betty Weatherley, with imagination and painstaking thoroughness, have assisted in gathering and organizing material for the project. At the Corcoran, Pamela Lawson, Assistant to the Chief Curator, and Curatorial Assistant Dena Andre contributed invaluably. Director Michael Botwinick, William Bodine, Assistant to the Director, and Cathy Sterling, Administrative Officer, lent support throughout the development of this project. Corcoran Librarian Ann Maginnis and her assistant, Barbara Erickson, were always helpful. I am deeply indebted to the following people who gave voluntary assistance: Kyle Roberts, Margy Clay, Anna Marie Remakus-Davidson, Leah Gilliam, Sharon Keim, Susan Moeller, Miyuki Tsuchiya, Karen Doyle, and Barbara Hadley. I would like especially to thank Katherine Whitney for her research on the wars; and Stacey Bredhoff for writing the biographies of the photographers. William F.

Stapp, Curator of Photography at the National Portrait Gallery, generously gave advice and assistance, as did Doug Lang, Michael Kernan, and Paul Helmreich.

Sam Wagstaff was an early and encouraging adviser, as were Harry Lunn, Cornell Capa, Max Desfor, Jerry Maddox, Howard Chapnick, Ted Hartwell, Roy Flukinger, Will Stapp, Ron Hill, Gerd Sander, Lee Battaglia, and scores of other individuals who were generous with information and guidance. The staff of the National Archives Still Picture Branch, particularly Jonathan Heller and James Trimble, offered ongoing cooperation and assistance. Our selection of pictures from the Union of Journalists of the USSR was graciously made available through Eduard Malayan, First Secretary of the Soviet Embassy. Yasushi Hara of Asahi Shimbun and Norihiko Matsumoto of the Japan Professional Photographers Society courteously aided in obtaining photographs. It has been especially enriching to become acquainted with Time Inc. picture editors Robert Stevens and Anne Callahan, Barrett Gallagher, a member of the Steichen World War II Naval Aviation Photographic Unit, and prime-time *Life* photographers Carl Mydans and Edward Clark. Lunch with Don McCullin and *Time* staffers, during a furious April snowstorm, was a highlight of this project, as was meeting innumerable fascinating members of the present-day photojournalist corps: Gilles Peress, Richard Swanson, David Kennerly, Bill Pierce, David Burnett, Penny Tweedie, Eugene Richards, Ed Grazda, Stephen Brown, James Pickerell, Steve McCurry, and Harry Mattison. Many others were met through correspondence.

The final selection of photographs was a collaborative effort among myself, Jane Livingston, William Dunlap, Alex Castro, and Caroline Castro. Alex and Caroline designed this book. They have given me invaluable advice; their eyes and hearts have informed my own in this project's evolution. I would like to thank all those mentioned and the many others who graciously have cooperated in this endeavor, particularly the lenders, who have been extraordinarily helpful. Finally, I am grateful to Gordon Fralin for his patient endurance and support.

Frances Lindley Fralin

Howard County Library
Big Spring, Texas 79720

088704

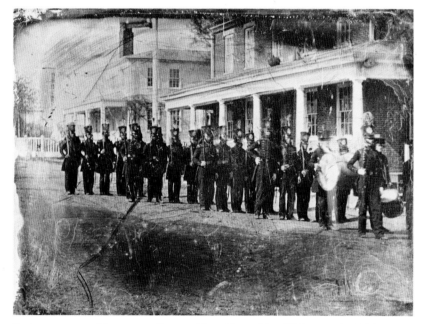

PHOTOGRAPHER UNKNOWN, *Exeter, New Hampshire [Volunteers]*, 1846, Mexican War, Quarter-plate daguerreotype, Amon Carter Museum, Fort Worth, Texas

The daguerreotypes of the Mexican War are the first known war photographs. Many soldiers had individual portraits taken before or after the war, but this is the only known view of American troops marching off to the Mexican War.

THOUGHTS ON WAR PHOTOGRAPHY

Photography has responded to, documented, reported, and sometimes influenced virtually every major war since the camera's invention. Photographs of war have a long history in the press. They are embedded in our culture if not in our artistic tradition. They assist immeasurably in our perception of recent events; often our very awareness of specific international conflict relies upon the still photo press.

The journalistic use of photographs in relation to war is only one aspect of photography's identity. Photographs count heavily in modern military practice, fulfilling several functions within the military agencies of government, serving as strategic tools and record-keeping artifacts. The medium is in a way integral to both the "science" and the public's apprehension of war.

As our interest in photography's history has intensified, we have studied not only its technical evolution but its life in the popular media and, more and more attentively, its nature as an artistic/cultural phenomenon. Moreover, we are increasingly sensitive to the ways in which the interrelationships between photographs as art and photographs made for purely pragmatic purposes can be seen to suggest new "aesthetics" within the medium. Great photographs are not necessarily made in the name of art: photography attests to this when its subject is war as it does in no other realm.

For millennia only participants or spectators of battle witnessed what later became universally available—and in the most unassailably "real" terms—through the photographic medium. First in the 1850s with Roger Fenton, James Robertson, and Felice Beato in Europe and Asia; then in the 1860s with Mathew Brady, Alexander Gardner, George N. Barnard, and Timothy O'Sullivan in the United States, war began to present itself in the press. From those decades forward, the genre burgeoned. But as the images themselves show, it took decades for a sense of immediacy to be communicated in war photography. This was not only for reasons of the heavy equipment, long exposure time, and elaborate developing techniques in photography's earlier stages, but perhaps also for psychological reasons.

Radical changes occurred in the physical and the cultural nature of photography beginning after World War I and accelerating in the succeeding decades. The development of high-speed shutters and increasingly more sensitive film resulted in an economy and ease of execution that would make obsolete the posed or staged approach to the camera's subject. A gradual and yet dramatic shift occurred from the carefully framed, and often either panoramic or symmetrically composed photographic image, to a kind of image that could be an intimate close-up of a face, or an instantaneous freezing of bodies in violent motion. This profoundly divergent set of new pictorial attitudes inevitably altered our perceptions about what the world was like through the camera lens. In short, style has changed in war photography, both the style of the technique of the images and the style of the journalistic presentation. Both have evolved so drastically as to make of still photography not just one artistic medium, but several. To trace this evolution is to follow an important part of the recent history of visual culture.

The history of changing conventions in the official recording of wars forms a web of interlocking factors too intricate to enumerate fully here. But certain broad tendencies are evident even to the casually observing eye, and are worth mentioning. One of the continuing realities of the genre is the ambiguous role of the photographer in relation to his subject, particularly when the subject is the immediate aftermath of battle: Recently, in walking the fields of Gettysburg, retracing the conflict and comparing photos of the site taken in 1863 with the present-day landscape, I became aware of the detective work needed to determine the accuracy of some of the supposedly candid and unedited early photographs. William Frassanito, who has spent years studying photographs

13

taken at Gettysburg, showed definitively that a few of the scenes were staged. Occasionally, he found bodies had been moved, posed; scenarios had been created, as the wet-plate artist set up his equipment and processing lab on the site and used the site to its fullest potential. (Some re-creations were even staged at Gettysburg years later.) The main visible effect of this staging is an odd character of formality, even of decorousness, in this early work that simply does not exist after World War II. This development is counter to the medium's tendency to become more classical and formally controlled in other genres.

The decorum, what seems a serene dignity in Brady's body-strewn fields, contrasts starkly with the palpable chaos, the sense of the complex psychology of violent battle, to which we have now become accustomed. To compare the Roger Fenton image, *Valley of the Shadow of Death* (fig. 1), with Larry Burrows's *Yankee Papa 13* (fig. *103*) is to see the difference in what the photographers wanted to depict and in what the news journal and magazine publishers wanted the public to see of the contemporary battleground. Between these extremes lie an infinity of subtleties, a huge repertory of framing devices and individual stylistic idiosyncrasies that have formed the conditions for a photography of war and its aftermath, a visual genre we need to examine as we would study the development of any other visual tradition.

Yet to undertake a distanced study of this particular aspect of our culture is not easy now and seems to have presented difficulties all through its history. Most books and articles treating photographs of war tend to focus on a single war, a single artist, or a single style (see Capa 1968, 1972, 1974; Duncan 1951, 1970; Graves 1977; National Historical Society 1981; Phillips 1981). Even the most apparently diverse or inclusive compendia of war photographs tend basically to embrace a unified set of assumptions, often limiting their perspective to a nationalist one. Most photographic essays until recently have tended, in other words, to spring from a more or less uncomplicated moral or aesthetic position about what photographs of political conflict ought to imply, or look like.

The nature of war, its physical brutality and its traumatic political and social consequences, naturally makes of its visual embodiment an emotionally charged subject. We instinctively resist finding beauty or grandeur, or sublime dispassion, or any of the usual responses associated with the artistic experience, in images we know to be brought literally out of disaster. Thus when images that are evocative of war's hellishness are also aesthetically provocative, or successful as authentic art works—we rebel inwardly. There is an intrinsic difficulty in even considering them as art.

Photography's place in the world of fine art, its alternating status between being shunned and exalted, is still somehow a subject for debate. Often even the most self-consciously artistic photographs—those made by men and women acknowledged to be masters in the schooled traditions of high art—cannot be easily viewed as great art. This difficulty perhaps applies more powerfully to war photography than to most of the medium's other forms.

War has, of course, been much treated in painting. From the Egyptians and Greeks through modern times, from Uccello to Delacroix, from Trumbull to Picasso, we find examples of artists depicting military aggression, either quite literally as with Goya, or symbolically, as in Picasso or Robert Motherwell. Indeed it is interesting to observe the wide range of genres in painting (from the depiction of a political execution in Manet's bravura *Death of Maximilian,* to the representation of an assassination in David's *Death of Marat*) in comparison with a similar gamut of stylistic and political atmospheres in great war photographs, ranging from the stark image of Maximilian's white shirt (fig. *22*) to the famous Margaret Bourke-White image of the multiple suicide (fig. *92*).

Photographs engage precisely the same realm of meaning about human conflict as do other art forms. And photography's aesthetic is just as susceptible both to greatness and to failure as the other arts. The primary barrier, of course, in the way of taking photography in the same spirit we do painting lies in its deceptively accidental quality. Often, the more climactic the subject of a photograph, the more suspect is its potential status as art. The painter, in contrast, may select a momentous occasion to depict, and through it impart a sense of simultaneous immediacy and psychological veracity to his work. But the photographer, in "selecting" a moment of crisis to record, often creates a sensation in the viewer of some unreality, even an atmosphere of uncomfortable theatricality. Our response to historic photographs of war, such as the famous Eddie Adams picture of an execution in the moment of its happening, is thus not one of genuine identification or even credulity: rather, we may find ourselves *studying* the image, reading it rather as we would a painting or drawing, but with even less credulity than a drawing or painting often stimulates. This odd phenomenon, a kind of suspended belief or emotional distancing when we confront the actual moment recorded in the photograph, suggests a moral problem in relation to photographs of palpably amoral, or immoral, acts or scenes. It is not that the acts or scenes themselves, or even the picturing of them, are altered—but that our reaction to what is seen after the fact, may open questions about ourselves.

John Berger, in his book *About Looking,* 1972, comments succinctly on the issue of the morality of our response to the ever more explicit images of atrocity, when he locates our inability to respond to a photograph of horror with appropriately active emotion. Berger postulates a sense of being inwardly immobilized when we see a war photograph because of some helplessness either fully to assimilate what we see, or, if taken in, to respond appropriately. "The reader who has been arrested by the photograph," he writes, "may tend to feel this discontinuity [of the depicted moment of agony from other moments] as his own personal moral inadequacy. *And as soon as this happens even his sense of shock is dispersed:* his own moral inadequacy may now shock him as much as the crimes being committed in the war. Either he shrugs off this sense of inadequacy as being only too familiar, or else he thinks of performing a kind of penance—of which the purest example would be to make a contribution to OXFAM or UNICEF." [Berger's italics]

Berger continues, "In both cases, the issue of the war which has caused that moment is effectively depoliticized. The picture becomes evidence of the general human condition. It accuses nobody and everybody."

During the American Civil War, the conflict that, thanks to its depiction in the periodicals of the day, may be said to have sensitized the American public to the sordid reality of battle, the photographers themselves were regarded and probably considered themselves to be very much like the illustrators who depicted news scenes for magazines like *Vanity Fair, Leslie's Weekly,* and *Harper's Weekly.* It seems indeed that for photographers and the public alike during the various photographed conflicts of the 1860s and well into the twentieth century, the project of visually recording scenes of battle and its aftermath was somehow associated with bourgeois acceptability, if it was not always a culturally palatable undertaking. This state of affairs has changed significantly since World War II, as photographers of war have become subject to the increasingly complex political and social ramifications both of international free press journalism, and its censorship.

The contemporary politics of world conflict is an intricate and fluid construct. To record aspects of this shared and yet often remote global reality is unavoidably to reflect, or even to create, prevailing attitudes about various specific conflicts, and about war itself. Our greater and greater tolerance of the complexities and the inevitable ambiguities of modern politics itself may be influenced by the necessity in our contemporary environment to assimilate complexity in other areas. And our fascination with photography in all its uses, our willingness to find aesthetic value in all sorts of photographs, relates directly to this incrementally greater general capacity for grasping and expressing ambivalence, paradox, layered meaning, in the political events of our time.

The relationship between political history and aesthetic history in war photography has fascinated writers particularly in the past decade. Many have noticed and attempted to analyze the striking difference between the relatively conventionalized, static, often contrived (yet often powerful) photographs of the Civil War, and the explosion of styles and approaches characterizing present-day war photographs (see Frassanito 1975, 1978, 1983; Grover 1983, 1984; Munson and Snyder 1976). It is a phenomenon too striking, too suggestive of the very evolution both of photography and warfare to ignore. But the sheerly historical rationale for stylistic change is transcended in the present selection of images by another factor: regardless of the variations among these works in subject, medium, chronology, they assert something much larger than themselves. Often they are emblematic of our fears about war; sometimes they elicit remembrance or even an odd kind of nostalgia. And occasionally they show us acts or realities we did not imagine possible. The evidence of bestiality made incontrovertible by some of these photographs cannot help but expand our awareness of history, and of what may always be imminent.

As photographers have been granted greater access to fields of battle, as typified by the Vietnam War—where at times virtually any free-lance journalist from any nation could enter the country and work at will—the results of their endeavors have accordingly become personally biased or transparently ambivalent, ideologically charged or consciously "non-editorializing." The so-called "photographers of fortune" who find their way to contemporary civil-war battlegrounds all over the world have created as many attitudes in war photography as there are individual ideals or motives.

Depictions of acts of murder, or torture, or of the mutilation resulting from those acts, assume shifting moral and aesthetic appearances, depending on the style and outlook of their authors. Faced with the richness of implication in even the simplest or most seemingly transparent photograph from Lebanon or El Salvador, we have found ourselves applying a kind of transcendent standard in evaluating it as a potentially "indelible" image. This standard can only be identified with our aesthetic sense—and it is this faculty that is consistently applied in the project at hand.

In viewing and reviewing the thousands of photographs considered for inclusion in this book, certain principles of selection gradually declared themselves. Some images survived the repeated

scrutiny of those of us who participated in their selection; most, and among these many of the most well-known images, failed (often after months of deliberation) to make the final cut. (There are a number of works in the exhibition that are not reproduced here; even so, the proportion of finally selected works is exceedingly small in relation to the total material surveyed.)

One of the key principles we found in determining the power of what we are calling an indelible war photograph to take its place among the enduring works of art was the photograph's integrity of both physical and psychological presence. The image must be seen to express the truest essence of its medium—whether glass-plate-negative image or albumen print, or 35 millimeter shot—and thus validate its historical placement in terms of the medium itself. It should also give an immediate recognition of its geo/political place, as well as the nature of the historic event recorded. Discerning this quality of integrity is often an elusive task, except to the intuition. One of the mysteries of the successful war photograph is the extent to which the image can contain neither descriptive data nor climatic eventfulness and yet remain fully expressive of an entire ethos or event. An image so fragmentary, so abstracted as the *Oswiecim Prison Camp Clean-up (Glasses)* (fig. 91) or *Beer Bottle after the Atomic Bomb Explosion* (fig. 95) obviously has the power to evoke an enormity of associations. Even more poignantly, the photograph that becomes a light-induced trace of another, horrible, light-induced trace—the pattern of the woman's garment transferred indelibly to her skin by the obliterating flash of the atom bomb (fig. 96)—speaks of the capacity for the tiny detail, the almost random side-effect of war, to build, as it were, a macrocosm around itself. Although this power to expand upon itself may be inherent in many "great" photographs, whether or not their subject is war, its consistent presence as a criterion for marking the enduring war photograph far outweighs that quality in photography's other genres.

In the selection for this book (and exhibition), the photographs that eventually separated themselves from the rest were surprisingly often made by unknown photographers or by "non artists," that is, those photographers whose ambitions are either for useful technical documentation or simple journalistic recording. Indeed, we were continually surprised by the high proportion of work by little-known or unidentified authors that emerged insistently as the best photographs, and, equally, by the failure of images by some of the major artists of the twentieth Century to survive our repeated consideration.

This is not to say that our considered task has been difinitively to present a group of the greatest war photographs, but instead to discover or rediscover important works that simply did not happen to be widely disseminated. And in part, we have wanted to dramatize the extraordinary number of important photographs of war that remain to be discovered, by introducing a relatively great number of images that will be unfamiliar even to the expert photographic historians, collectors, and curators.

Perhaps what one must finally conclude from the exercise of confining the purview of a given selection of enduring photographs, to the subject of warfare, is merely this: great photographs generally seem embedded in some profoundly integral self-definition of technology and of their historical environment. In limiting our range of view to war and its aftermath, we chose a cultural frame that itself provides drama and meaning, and a subject that usually discourages the impulse a photographer might have to glamorize or sanitize his or her subject. Thus we are given access to one of still photography's most powerful capabilities, that of distilling and encapsulating, sometimes almost uncannily, entire segments of cultural history in the most economical terms.

Jane Livingston

BIOGRAPHIES OF THE PHOTOGRAPHERS

MAX ALPERT, Soviet (1899–1980)

FRANÇOIS AUBERT, French (1829–1906)
François Aubert studied art at the Ecole des Beaux-Arts in Lyon. In 1854 he traveled to Mexico, where he learned photography and became established as photographer of the privileged classes. Aubert's position as official photographer for the Emperor Maximilian enabled him to witness and photograph the extraordinary events of the empire's collapse and the emperor's execution in 1867.

DMITRI BALTERMANTS, Soviet (born 1912)
Dmitri Baltermants, a self-taught photographer, began working as a photo-reporter with the Red Army. He is best known for his World War II trench reportage of the Russian front. Baltermants was a pacifist before and after the war, and his photographs communicate his pacifist leanings.

MICHA BAR-AM, Israeli (born Germany, 1930)
Micha Bar-Am has succeeded in recording most major events in Israel since 1949, working for Israeli newspapers, *Bamahane* magazine, the *New York Times*, and as a freelance photojournalist. He has lived in Israel since the age of six, when his family emigrated from Germany. He is adviser on photography to the Museum of Art, Tel Aviv, and a correspondent for Magnum Photos.

GEORGE N. BARNARD, American (1819–1902)
George Barnard took some of the earliest photographs of the American Civil War. He worked for a time with Mathew Brady, but later disassociated himself from Brady's organization. He accompanied William Tecumseh Sherman on his "March to the Sea," and recorded the destruction of the battles. He felt that if people could see the devastation wrought by war, future hostilities might be avoided.

SIDNEY JACKSON BARTHOLOMEW, American (born 1922)
Pfc. Sidney Bartholomew made hundreds of photographs with a Kodak 126 camera, while serving in the United States Army in the Pacific theater from 1944 to 1946. He now lives in Tarboro, North Carolina, where he continues to be an avid amateur photographer.

FELICE BEATO, British (born Italy, date unknown; died 1903)
Felice Beato's photographs of the Indian Mutiny, the Second Opium War, and the Franco-British War against China suggest a fascination with war's destructiveness. Although the photographic technology of his time precluded the reproduction of actual combat scenes, Beato's pictures document the devastation that accompanies warfare. A naturalized British subject, he also toured the Far East and recorded the landscapes, architecture, and people of exotic countries.

DR. WILLIAM A. BELL, British (1841–1921)
As the photographer accompanying the Kansas Pacific Railroad Survey, Dr. William Bell, an English physician, traveled to the American West and later produced two books describing his observations and adventures. Among the dangers Dr. Bell described was the threat of attack by Indians.

MARGARET BOURKE-WHITE, American (1904–1971)
As a photojournalist, Margaret Bourke-White witnessed and recorded some of the most momentous events of the mid-twentieth century. She began her career as a freelance architectural and engineering photographer in Cleveland. Subsequently, her portfolio won her a job with *Fortune* magazine. In 1936 she was chosen to become one of *Life* magazine's four original photographers, beginning an involvement with that publication that lasted until her death. The first cover of *Life* magazine was a photograph by Bourke-White. An accredited war photographer during World War II, she photographed military activities, the destruction of cities, and the bodies of prominent Nazis who took their own lives in the closing days of the war. Other subjects of her work include rural poverty in the United States, the partition of India, conditions in South Africa (1949–1950), and the Korean War.

MATHEW BRADY, American (1823–1896)
Mathew Brady is the most famous of the American Civil War photographers. Having established three successful photographic studios from which he produced portraits of the most celebrated figures of his time, Brady's interest turned from social portraiture to war photography with the outbreak of the Civil War. His most important achievement was his conception and realization of the goal to produce a pictorial history of the war. Brady fielded photographic teams to create a comprehensive visual record, and occasionally participated in the photographic work as well. His practice of putting his name on all photographs taken by himself and his staff makes it difficult to attribute specific images to him.
The cost of training, outfitting, and employing some twenty photographers contributed to Brady's financial ruin. He never received financial support from the government for his Civil War project, and he mistakenly presumed a public interest in viewing scenes of war brutality. Although the U.S. War Department did purchase a large portion of his collection, and the government paid him for right and title to the pictures, it was many years before the full value of Brady's legacy was appreciated.

STEPHEN R. BROWN, American (born 1947)
In 1982 Stephen Brown accepted an assignment to cover the landing of the U.S. Marines in Beirut. Expecting initially to be there a few days, Brown spent eight weeks in the city. He attributes his being in Beirut to an "accident" (from interview with author, 1985) and does not foresee doing any further war coverage. Brown's work has appeared in *National Geographic*, *Life*, *Time*, *Newsweek*, and *Smithsonian*. He also does advertising photography.

T. SGT. W. G. BRUNK, U.S. Marine Corps, American (dates unknown)

HENRI BUREAU, French (born 1940)
Henri Bureau was associated with the photo agency Gamma until 1973, when he left to become a founder of Sygma. Since 1981 he has served as editor-in-chief at Sygma-Paris.

JOHN BURKE, British (dates unknown)
John Burke was a professional British photographer in the Punjab in India. He was employed by the Indian government as a civilian to take pictures of the campaign in Afghanistan in 1878–1879.

LARRY BURROWS, British (1926–1971)

Larry Burrows is a major figure of modern war photography. He covered fighting in the Suez, the Congo, and Cyprus, as well as assignments on other topics. With a special interest in Asia, in 1962 he agreed to cover the Vietnam War for *Life* magazine, an assignment that was to last for nine years. His work there provided the first comprehensive documentation of a war in color. Living and working with the fighting men, his greatest challenge, in his words, was "to keep *feeling*, in an endless succession of terrible situations. Yet if you feel too much . . . you'd crack." His strongest wish was "to be around to photograph Vietnam in peaceful days when all the trouble's over" (quoted in Walsh, Naylor, and Held 1982, 118). Burrows died when his helicopter was shot down over Laos.

AGUSTIN VICTOR CASASOLA, Mexican (1874–1938)

Agustin Victor Casasola was a Mexican photographer active in the early twentieth century. He was to the documentation of the Mexican Revolution what Mathew Brady was to that of the American Civil War. Casasola was known to be an avid collector of photographs and, like Brady, had many photographers working under him. Thus, it is likely that many of the photographs in his collection were not taken by him.

EDWARD CLARK, American (born 1911)

Edward Clark joined *Life* magazine in 1936, and gradually came to specialize in politics, people, and places. He covered political conventions, campaigns, personalities, and subjects ranging from the Nuremberg trials to Hollywood stars. He denies having any philosophy about photography: "I just tried to get people to stop. If a photograph can arrest you for a moment, then you've really got something" (*The Washingtonian*, June 1983, 124).

KELSO DALY, American (dates unknown)

THOMAS DANIEL, American (born 1948)

After serving eighteen months in the field in Vietnam, Thomas Daniel—with little experience in photography—talked his way into a job as an Army photographer. The assignment inspired him to pursue a photographic career: "You start seeing all of this madness, so it's got to have an effect on you When I saw those kids [in orphanages] I knew how I felt, and I began to wonder if I could make anybody else feel those things. And I think then it became evident to me that maybe I had something to say as a photographer" (*Throttle*, April 1984, 15). Daniel has completed assignments for United Press International, and has taught at the Colorado Institute of Art and Virginia Commonwealth University.

JACK DELANO, American (born Russia, 1914)

As photographer for the Farm Security Administration, Jack Delano traveled to the Virgin Islands and Puerto Rico, the latter becoming his permanent home. He has worked as a book designer, as a composer, and as director of a national television service. Although his photographs reflect a strong concern for composition and form, his primary goal in photography is to record and interpret the human condition around the world.

RAYMOND DEPARDON, French (born 1942)

While in the French Army, Raymond Depardon served as a war reporter in Algeria during the early 1960s. Since that time, he has covered conflicts in Chile, Chad, Lebanon, and Afghanistan, and has produced five documentary films. Depardon was a founding member of Gamma and is a member of Magnum.

EMMANUEL EVZERIKHIN, Soviet (dates unknown)

ROGER FENTON, British (1819–1869)

Known as a professional photographer for his portraits, landscapes, and artistic photographs, Roger Fenton documented the Crimean War under the patronage of Queen Victoria. As an official servant, he was charged with recording evidence to refute newspaper accounts of hardships suffered by the British military. Mindful of Victorian sensibilities back home, he carefully avoided any gruesome scenes of war's brutalities. His 360 glass negatives from the Crimea comprise the first extensive photo-documentation of a war.

BARRETT GALLAGHER, American (born 1913)

When Barrett Gallagher joined Edward Steichen's Naval Aviation Photographic Unit during World War II, he became one of the few photographers on the project with military training and experience. His three and a half years as a naval officer in the Atlantic and his pre-war photographic experience uniquely qualified him to record the naval battles in the Pacific. Since the war Gallagher has traveled widely and—with the assistance of his wife, Timmie— has completed over two hundred assignments for *Fortune* magazine alone. The broad range of subjects he has photographed include industrial growth in the United States, the Apollo Space Program, and developments of modern science. Gallagher's work has appeared in *Fortune, Colliers, Time, Life,* and other publications.

MIKE GOLDWATER, British (born 1951)

Mike Goldwater has covered events in Southeast Asia, Central America, and Africa. He is a founder-member of the photo agency, Network, in London.

JOHN C. H. GRABILL, American (dates unknown)

A serious photographer who copyrighted his work, John C. H. Grabill took pictures in the Western territories in the late 1880s and early 1890s. In addition to taking scenic pictures portraying frontier life, he is believed to have been among those photographers who went to Wounded Knee following the massacre of December 1890.

ED GRAZDA, American (born 1947)

Since 1972 Ed Grazda has photographed in Mexico, Guatemala, Peru, India, Thailand, Pakistan, and Afghanistan. His work has appeared in *Camera, Creative Camera, Art Forum,* and *Christian Science Monitor.*

PHILIP JONES GRIFFITHS, British (born 1936)

Philip Jones Griffiths has worked as a freelance photojournalist since 1963. He spent three years taking photographs of the war in Vietnam, many of which were published in his book, *Vietnam Inc.* His coverage of this war includes the viewpoints not just of the American soldier but also of the Vietnamese civilian. Jorge Lewinski, photography and art historian, has described *Vietnam Inc.* as "a balanced viewpoint . . . a comprehensive, profound image of the totality of war, the way it affects soldier and civilian alike, the way the two become intertwined and together create the environment of a country at war" (Walsh, Naylor, and Held 1982, 384). Griffiths has also covered the Algerian war, the Yom Kippur War, and has worked in Cambodia and Thailand. His photos have appeared internationally in leading magazines. He currently serves as president of Magnum.

ALAIN GUILLO, French (born Vietnam, 1943)

A writer and photographer, Alain Guillo has covered the events in Afghanistan since 1980 and has illegally crossed the Afghan border seventeen times to follow developments of the conflict there. Guillo has also worked in Europe, Canada, and Asia.

JAMES HENRY (JIMMY) HARE, American (born England; 1856–1946)
As a news photographer, Jimmy Hare often covered sports events, where he learned "to catch the action at just the right moment" (quoted in Gould and Greffe 1977, 10–11). This lesson served him well in his subsequent work as a war photographer. Hare covered the Spanish-American War, the Russo-Japanese War, the Mexican Revolution, and World War I, working for *Illustrated American*, *Collier's*, and *Leslie's Weekly*.

HIMES, U.S. ARMY, American (dates unknown)

LEWIS WICKES HINE, American (1874–1940)
Lewis Hine is known as the "spiritual father of 'concerned photography'" (Gutman 1974); he used the medium to effect social reform. Hine's explicit documentation of child labor conditions in the United States prodded Congress to pass the first child labor laws. During World War I, he joined the American Red Cross and recorded the plight of refugees from Italy and Serbia. He also photographed immigrants on Ellis Island, factory workers, people living in slums, and the construction of the Empire State Building. Looking back on his work, he defined his objectives: "There were two things I wanted to do. I wanted to show the things that had to be corrected; I wanted to show the things that had to be appreciated" (quoted in Gutman, in "Introduction" by Cornell Capa 1974, 5).

HAYAKAWA HIROSHI, Japanese (dates unknown)

HANNS HUBMANN, German (born 1910)
After training in photography at the Staatslehranstalt für Lichtbildwesen in Munich, Hanns Hubmann photographed the 1936 Olympic Games in Berlin. His career as a freelance photojournalist was launched by his work for *Berliner Illustrierte* and *Münchner Illustrierte*. During World War II Hubmann worked for *Signal*, and after the war became chief photographer for *Stars and Stripes*. In 1948 he began a long association with the new German illustrated journal, *Quick*.

CHARLES FENNO JACOBS, American (1904–1975)
Before joining Edward Steichen's Naval Aviation Photographic Unit, Fenno Jacobs had worked as a photographer for the Farm Security Administration, for *Life* magazine, for *U.S. Camera* in Europe, and later for *Skipper* in Annapolis, Maryland. Jacobs retired from photography in the early 1960s, moved to New Hampshire, and opened a gourmet restaurant.

KIMURA KENICHI, Japanese (1905–1973)
As an Army photographer, Kimura Kenichi began to document the condition of Hiroshima a few days after the atomic bomb blast. He photographed the city's wounded at the request of an investigating team from the Tokyo Medical Army Museum. Kimura Kenichi was a native of Hiroshima; his wife did not survive the atomic blast. During the course of his career, he also worked for the *Chugoku* newspaper.

DMITRI KESSEL, American (born Russia, 1902)
One of Dmitri Kessel's early memorable experiences as a war photographer occurred while he was serving in the Ukraine Army: his camera was smashed over his head by an army officer who objected to Kessel's photographing the massacre of a Polish army unit. In 1923 Kessel moved to the United States, where he later joined *Life* magazine, covering the Greek Liberation and Civil War, the German retreat of 1945, and events in the Congo, the Middle East, and other regions. He also became a specialist in photographing architecture and fine arts.

EUGENE KHALDEY, Soviet (dates unknown)

MANFRED KREINER, American (born Germany, date unknown)
With a background in fine arts, Manfred Kreiner came to the United States in 1954 and began a career in photography. He has worked as both a writer and an art director, and has run the New York office of *Quick*, the German weekly magazine.

CONSTANCE STUART LARRABEE, American (born England, 1914)
Constance Stuart Larrabee, an American citizen since 1953, was South Africa's first woman war correspondent in World War II. Accredited to *Libertas*, a South African magazine, she followed the troops through Europe between July 1944 and March 1945. She wrote *Jeep Trek*, an illustrated war diary, in 1946. Internationally known for her World War II and tribal documentary photography, she has had major exhibitions in South Africa, Canada, and the United States.

GUSTAVE LE GRAY, French (1820–1862)
Gustave Le Gray studied painting with Paul Delaroche. His photography, now considered among the greatest in the history of the medium, was influenced by Alphonse Louis Poitevin. A landscape-seascape photographer, Le Gray initiated the process of combination printing, a method using two negatives to print sky and sea or sky and land separately with different exposures. Le Gray recorded scenes of military life at Châlons and covered Napoleon III's visit there in 1858.

CATHERINE LEROY, French (born 1944)
Afghanistan, Africa, Cyprus, Iran, Lebanon, and Vietnam are among the areas of conflict that Catherine Leroy has covered. She first became known for her coverage of the war in Vietnam, from 1966–1968. While there, she was captured by the North Vietnamese Army and succeeded in obtaining a unique record of their activities.

ROYAN M. LINN, American (dates unknown)
Royan Linn was an itinerant portrait photographer. He sold many carte de visite portraits at his "Gallery Point Lookout" on Lookout Mountain in Tennessee, including photographs of generals and soldiers posing on the point.

JAMES LLOYD, British (c. 1828–1913)
Painter and photographer James Lloyd departed from Britain and settled in Natal in 1850 or 1851. Described as one of the first two press photographers of Natal, he also made sketches that were reproduced in the *Illustrated London News*. He took many pictures of the Zulu War of 1879.

DON MCCULLIN, British (born 1935)
Don McCullin is a venerated photographer whose work reflects with passion the pain and suffering of human existence. He has photographed wars in Vietnam, Cyprus, the Congo, and Biafra, and victims of famine in Bangladesh. In his book, *Is Anyone Taking Any Notice?* he says of himself, "I don't make any protest other than take photographs and show how bad it is" (1971, unpaginated). McCullin's other books include *The Destruction Business*, *The Homecoming*, and *Hearts of Darkness*. He was formerly associated with Magnum.

SGT. JAMES L. MCGARRIGLE, U.S. Signal Corps, American (dates unknown)

HARRY MATTISON, American (born 1948)
Harry Mattison worked as a research assistant in Mexico and as an assistant to photographer Richard Avedon before beginning his own career as a documentary photographer in Central and South America. His commitment to photojournalism was strengthened in 1978 when he was one of only two foreigners who happened to be inside Esteli, Nicaragua, during the bombing of the city. He has photographed extensively in Latin America and in Lebanon as contract photographer for *Time* magazine. He is now engaged in a project on the lives of new immigrants in the United States.

SUSAN MEISELAS, American (born 1948)

Susan Meiselas, who has a graduate degree in education, has brought programs and workshops in photography to the New York City public schools as well as to schools throughout South Carolina and Mississippi. She became well known as a freelance photographer traveling to Chad, Cuba, El Salvador, and Nicaragua for the *New York Times*, *Harper's*, *Time*, *Life*, *Geo*, and other publications. She was in Nicaragua during the outbreak of the revolution in 1978. Her book of photographs, *Nicaragua*, is a powerful document on the background and eruption of the revolution. She is a member of Magnum.

HANSEL MIETH, American (born Germany, 1909)

Before joining *Life* as staff photographer in 1937, Hansel Mieth was a Works Project Administration photographer working on the West Coast project. She later became a specialist in medical research stories.

LEE MILLER, American (1907–1978)

Lee Miller studied art in Paris and New York, worked as a model for Edward Steichen and Man Ray during the 1920s, and played the lead in a 1930 Jean Cocteau film. As an accredited war correspondent during World War II, she was with the American liberating forces from the time of the siege of Malo until the burning of the Bertchesgaden. Her photographs and descriptions of the war were published in *Vogue* magazine. She became best known for her fashion photography, which documented women coping with wartime conditions.

ARTHUR S. MOLE, American (born England, 1889; death date unknown)
JOHN D. THOMAS, American (birth date unknown; died c. 1940)

Following the choreographic directions of Arthur Mole and John Thomas, thousands of soldiers would arrange themselves in formations of patriotic symbols such as the Liberty Bell, the Statue of Liberty, and Woodrow Wilson's profile. Arthur Mole first began using this technique of collective portraiture in a religious context, when—as a member of a religious community—he photographed large groups of his fellow church members assembled in the shape of various religious symbols. With America's involvement in World War I, Mole and Thomas devoted themselves to patriotic themes. *The Human U.S. Shield*, the largest composition by Mole and Thomas, was composed of thirty thousand men.

CARL MYDANS, American (born 1907)

Carl Mydans began his career as a photojournalist by joining the staff of the Farm Security Administration. He later worked as a war correspondent for *Life* magazine, covering the Russo-Finnish Winter War, World War II in Europe and the Pacific, the Korean War, and the war in Vietnam. Since 1972 he has worked for *Time* magazine. He is the author of *More than Meets the Eye* and coauthor, with Shelley Mydans (1968), of *The Violent Peace: A Report on Wars in the Postwar World*. In the latter work, the authors suggest the importance of war photography: "We cannot hope to control what we do not understand, nor to confront our adversary, war, with our eyes averted" (p. VI).

JAMES NACHTWEY, American (born 1948)

James Nachtwey has photographed conflicts in Northern Ireland, the Middle East, and Central America. Since leaving his job as staff photographer with the *Albuquerque Journal* in 1980, he has traveled repeatedly to places besieged by turmoil and violence. He is associated with the Black Star photo agency.

TIMOTHY O'SULLIVAN, American (1840–1882)

Timothy O'Sullivan is known for his photographs of the American Civil War and western landscapes. Having learned photography while working for Mathew Brady, O'Sullivan photographed the battlefield at Gettysburg as part of Alexander Gardner's team. The preponderance of bloated and mutilated bodies in the Gettysburg photographs reflects the team's interest in communicating the atrocities of war. After the Civil War, O'Sullivan traveled to Nevada, California, Utah, Arizona, and Panama on various photographic missions. In 1880 he was named chief photographer for the U.S. Treasury Department.

JOSEPH J. PENNELL, American (1866–1922)

Joseph Pennell was a professional photographer in Junction City, Kansas. His photographs of Junction City and of nearby Fort Riley document civilian life in a midwestern town and military life in Camp Funston, one of the major military centers in the United States during World War I.

GILLES PERESS, French (born 1946)

Gilles Peress traveled to Northern Ireland for the first time in 1970, and has continued to record the country's religious and political turmoil for the past fourteen years. Other subjects he has covered include immigrant workers in Europe, a French coal-mining town, the U.S. elections of 1976, and Iran after the revolution. Peress's work examines the social, political, and cultural nature of the world he is photographing. He has been a member of Magnum since 1974.

JAMES H. PICKERELL, American (born 1936)

During James Pickerell's three-year stay in Vietnam, from 1963–1967, his photographs appeared on the cover of *Newsweek* and in other major news magazines. In 1967 he published the book *Vietnam in the Mud*, in which he talks about his coverage of the war. He operated, he says, "at the level of the foot soldier, as all photographers must, because this is where the pictures are While I may not have clearly understood the high-level plans, I have been closely associated with the men who have tried to make these plans work" (p. XVI). Since 1967 he has covered the White House and Congress and has traveled to more than eighty countries on assignment. Much of his present work is in the corporate field.

LT. REID, U.S. Signal Corps, American (dates unknown)

MARC RIBOUD, French (born 1923)

Marc Riboud has worked as a freelance photojournalist and photographer since 1952, following a four-year career in industrial engineering. He has photographed extensively in mainland China, as well as Vietnam, Japan, and Bangladesh. Riboud has been a member of Magnum since 1954.

EUGENE RICHARDS, American (born 1944)

Eugene Richards has photographed in Beirut, El Salvador, and the United States. A former social worker in Arkansas, he is also a writer whose books include: *Few Comforts and Surprises*, *Dorchester Days*, and *Exploding into Life*. Heir to the tradition of "concerned photography," Richards explains that he is "always feeling pressure from Gene Smith, Robert Frank, and Leonard Freed" (Sandra Berler, press release, Nov. 11, 1983, Chevy Chase, Md.). He is a member of Magnum.

DAVID SEYMOUR ("CHIM"), American (born Poland; 1911–1956)

As a freelance photographer, David Seymour (Chim) photographed pre–World War II France and the Spanish Civil War. After World War II, he traveled through Europe, photographing the maimed and orphaned children left in the war's wake. He also documented the early development of Israel by covering the settlements, the kibbutzim, and Jerusalem. Chim was a founder-member of Magnum. He was killed while covering the Suez crisis just hours after the armistice.

STEPHEN SHAMES, American (born 1947)

SUZUKI SHINICHI, Japanese (born 1835; death date unknown)

After opening his own photography studio in Nagoya, Japan, Suzuki Shinichi traveled to the United States to study retouching techniques. He returned to Japan and opened an additional studio in Tokyo. In 1889 he became official photographer of the Imperial Household.

LEIF SKOOGFORS, Swedish and American (born United States, 1940)

Having traveled to Northern Ireland to cover the nonviolent civil rights movement in 1969, photojournalist Leif Skoogfors witnessed and documented the violence that erupted in the country soon after his arrival. He has returned there many times and has produced *The Most Natural Thing in the World*, a book of his photographs from Northern Ireland. He has also covered conflicts in Nicaragua and El Salvador. Retired from war photography since 1979, he is now engaged in a variety of photographic and literary projects. Skoogfors's photographs have appeared in *Time*, *Newsweek*, the *New York Times*, and other publications.

W. EUGENE SMITH, American (1918–1978)

Working as a war correspondent during World War II, W. Eugene Smith produced photographs that he hoped would serve as an "indictment of war" (quoted in Walsh, Naylor, and Held 1982, 702). The photo essays he did for *Life* magazine have become classics. He was motivated by a wish to speak to people, to report honestly on what he saw: "Through the passion I have put into my photographs —no matter how quiet those photographs—I want to call out, as teacher and surgeon and entertainer" (quoted in Browne and Partnow 1983, 569). Smith worked for *Newsweek*, *Life*, the *New York Times*, and other periodicals. He was also a member of Magnum.

WILFRED DUDLEY SMITHERS, American (born Mexico, 1895–1981)

Working as a teamster on a pack-mule train in 1916, Wilfred Smithers saw the Rio Grande's Big Bend for the first time. During the next several decades, he returned a number of times to witness and record the activity in the Big Bend. His eye-witness accounts described the U.S. Cavalry Patrol looking for "bandits" along the border, and also documented the smuggling and liquor-running operations that accompanied Prohibition. His experiences in the Big Bend resulted in a photographic record of the border way of life in the early twentieth century.

CHRIS STEELE-PERKINS, British (born Burma, 1947)

Chris Steele-Perkins, whose background is in psychology, has worked as a photographer since 1970. He has photographed in Bangladesh while working for various relief organizations, as well as in England, joining "Exit Group" to document problems of human behavior in major British cities. His photographs have appeared in the *London Sunday Times Magazine*, the *New York Times Magazine*, *Time*, the *Economist*, and many other publications. He is a member of Magnum.

WOLF STRACHE, German (born 1910)

During World War II, Wolf Strache was a war reporter covering the German Air Force. He is publisher of a series of photography books and of *Das Deutsche Lichtbild*.

SERGUEI STRUNNIKOV, Soviet (dates unknown)

SGT. R. SULLIVAN, U.S. Signal Corps, American (dates unknown)

REINHOLD THIELE, German (dates unknown)

Reinhold Thiele was a German press photographer residing in London. His coverage of the Boer War was described in *Photogram*, a contemporary periodical, as "more varied, more accurate, and more complete than anything previously attempted in the field of pictorial war correspondence If war-time photography can be made a success, Reinhold Thiele is just the man to make it so." One of the goals of the war correspondents was to send home pictures that would raise the patriotic spirits of the British, many of whom were opposed to the war.

SHOMEI TOMATSU, Japanese (born 1930)

Shomei Tomatsu is coauthor of *Hiroshima-Nagasaki '61*, published by an antinuclear league, and author of *11:02-Nagasaki* (1966). Since completing these projects, he has returned to Nagasaki regularly to photograph the city and its citizens. Nagasaki, he says, "is a monument to people's forgetfulness, their capacity to gloss over past events even while living out the consequences of those events" (*American Photographer*, May 1984, p. 63). Shomei Tomatsu is cofounder of VIVO, a group of photographers that has influenced the establishment of photography as a contemporary art form. His photographs record the conflicts and contrasts of modern Japanese society, rather than the harmony and aesthetics of traditional Japan. He has served as director of the Japan Professional Photographers Society.

PENNY TWEEDIE, British (born 1940)

Although Penny Tweedie has covered wars from the front line, she most often records the plight of innocent victims who are caught in the midst of conflict by chance. She has worked in Vietnam, Cambodia, Bangladesh, and Australia, producing photographs that have appeared in *National Geographic*, *Time*, *Paris Match*, and other major publications. For several years she has photographed the aborigines of Australia.

BIBLIOGRAPHY

Appel, Alfred, Jr. *Signs of Life*. New York: Alfred A. Knopf, 1983.

Associated Press. *Moments in Time: 50 Years of Associated Press News Photos*. New York: W. H. Smith Publishers, Gallery Books, 1984.

Barnard, George N. *Photographic Views of Sherman's Campaign*. 1866. Reprint. Preface by Beaumont Newhall. New York: Dover Publications, 1977.

Beaton, Cecil. *War Photographs, 1939–45*. London: Imperial War Museum, 1981.

Beaton, Cecil, and Gail Buckland. *The Magic Image: The Genius of Photography from 1839 to the Present Day*. Boston: Little, Brown & Co., 1975.

Berger, John. *About Looking*. New York: Pantheon Books, 1980.

Berlin, Isaiah. *Against the Current: Essays in the History of Ideas*. New York: Penguin Books, 1982.

Bernard, Bruce. *Photodiscovery: Masterworks of Photography, 1840–1940*. New York: Harry N. Abrams, 1980.

Bourke-White, Margaret. *Shooting the Russian War*. New York: Simon & Schuster, 1942.

Bourke-White, Margaret. *Purple Heart Valley: A Combat Chronicle of the War in Italy*. New York: Simon & Schuster, 1944.

Brown, Theodore M. *Margaret Bourke-White, Photojournalist*. Ithaca, N.Y.: Cornell University, Andrew Dickson White Museum of Art, 1972.

Browne, Turner, and Elaine Partnow. *Macmillan Biographical Encyclopedia of Photographic Artists and Innovators*. New York: Macmillan Co., 1983.

Bunting, Josiah. *The Lion Heads*. New York: George Braziller, 1972.

Capa, Cornell, ed. *The Concerned Photographer*. New York: Grossman Publishers, 1968.

Capa, Cornell, ed. *The Concerned Photographer 2*. New York: Grossman Publishers, 1972.

Capa, Cornell, ed. *David Seymour–"Chim," 1911–1956*. New York: Grossman Publishers, 1974.

Capa, Cornell. *Robert Capa*. Tokyo: International Center of Photography and Pacific Press Service, 1980.

Capa, Robert. *Images of War*. New York: Grossman Publishers, 1964.

Caputo, Philip. *DelCorso's Gallery*. New York: Dell Publishing Co., 1984.

Catton, Bruce. *Picture History of the Civil War*. 2d ed. New York: Bonanza Books, 1982.

Chapnick, Howard. "Looking for Bang Bang." *Nieman Reports* 36 (Nov. 3, Autumn 1982): 28-33.

Clifton, Tony, and Catherine Leroy. *God Cried*. London: Quartet Books, 1983.

Current, Karen, and William R. Current. *Photography and the Old West*. New York: Harry N. Abrams, 1978.

Delpire, Robert, ed. *From One China to the Other*. New York: Universe Books, 1956.

Donald, David Herbert, ed. *Gone for a Soldier*. Boston: Little, Brown & Co., 1975.

Doty, Robert, ed. *Photography in America*. New York: Random House, 1974.

Doyle, Edward, and Samuel Lipsman. *The Vietnam Experience: America Takes Over, 1965-67*. Boston: Boston Publishing Co., 1982.

Duncan, David Douglas. *This is War!* New York: Harper & Bros., 1951.

Duncan, David Douglas. *War Without Heroes*. New York: Harper & Row Publishers, 1970.

Duroselle, J.-B. *Histoire Diplomatique de 1919 à Nos Jours*. Paris: Dalloz, 1981.

Dyson, Freeman. *Weapons and Hope*. New York: Harper & Row Publishers, 1984.

Fabian, Rainer, and Hans Christian Adam. *Bilder Vom Krieg*. Hamburg: Stern-Buch, 1983.

Favrod, Charles-Henri. *Terre de Guerre*. Paris: Magnum Photos, 1982.

Fitzgerald, Frances. *Fire in the Lake*. New York: Random House, Vintage Books, 1972.

Fontcuberta, Joan. "Notes on Spanish Photography, 1930–1980." *Afterimage* 10, no. 3 (Oct. 1982): 8–11.

Forché, Carolyn, Harry Mattison, Susan Meiselas, and Fae Rubenstein, eds. *El Salvador: Work of Thirty Photographers*. New York: Writers & Readers Publishing Cooperative, 1983.

Frassanito, William A. *Gettysburg: A Journey in Time*. New York: Charles Scribner's Sons, 1975.

Frassanito, William A. *Antietam: The Photographic Legacy of America's Bloodiest Day*. New York: Charles Scribner's Sons, 1978.

Frassanito, William A. *Grant and Lee: The Virginia Campaigns, 1864–1865*. New York: Charles Scribner's Sons, 1983.

Fussell, Paul. *The Great War and Modern Memory*. New York: Oxford University Press, 1975.

Fussell, Paul, ed. *Siegfried Sassoon's Long Journey*. New York: Oxford University Press, 1983.

Gallagher, Barrett. *Flattop*. New York: Doubleday & Co., 1959.

Gardner, Alexander, and others. *Gardner's Photographic Sketch Book of the War*. Washington, D.C.: Philp & Solomons, 1866.

Gardner, Robert, and Karl G. Heider. *Gardens of War: Life and Death in the New Guinea Stone Age*. New York: Random House, 1968.

Gernsheim, Helmut, and Alison Gernsheim. *The Recording Eye: A Hundred Years of Great Events as Seen by the Camera, 1839–1939*. New York: G. P. Putnam's Sons, 1960.

Gilbo, Patrick F. *The American Red Cross: The First Century*. New York: Harper & Row Publishers, 1981.

Gould, Lewis L., and Richard Greffe. *Photojournalist: The Career of Jimmy Hare*. Austin: University of Texas Press, 1977.

Graves, Eleanor, ed. *Life Goes to War: A Picture History of World War II*. Boston: Little, Brown & Co., 1977.

Green, Shirley L. *Pictorial Resources in the Washington, D.C., Area*. Washington, D.C.: Library of Congress, 1976.

Griffiths, Philip Jones. *Vietnam Inc*. New York: Collier Books, 1971.

Grover, Jan Zita. "Philosophical Maneuvers in a Photogenic War." *Afterimage* 10, no. 9 (Apr. 1983): 4–6.

Grover, Jan Zita. "Star Wars: The Photographer as Polemicist in Vietnam." *Afterimage* 11, nos. 1, 2 (Summer 1983): 20–24.

Grover, Jan Zita. "The First Living-Room War: The Civil War in the Illustrated Press." *Afterimage* 11, no. 7 (Feb. 1984): 8–11.

Gutman, Judith Mara. *Lewis W. Hine, 1874–1940: Two Perspectives*. New York: Grossman Publishers, 1974.

Hampton, Veita Jo, ed. *The Best of Photojournalism/7*. Philadelphia: Running Press, 1982.

Heiferman, Ronald. *World War II*. Secaucus, N.J.: Derby Books, 1973.

Henisch, B. A., and H. K. Henisch. "James Robertson of Constantinople." *History of Photography. An International Quarterly* 8, no. 4 (Oct.–Dec. 1984): 299–313.

Herr, Michael. *Dispatches*. New York: Alfred A. Knopf, 1977.

Hiroshima-Nagasaki Publishing Committee. *Hiroshima-Nagasaki: A Pictorial Record of the Atomic Destruction*. Tokyo: Hiroshima-Nagasaki Publishing Committee, 1978.

Hodgson, Pat. *Early War Photographs*. Boston: New York Graphic Society, 1974.

Holmes, Oliver Wendell, "Doings of the Sunbeam." *Atlantic Monthly* 7, no. 69 (July 1863): 1–15.

Howell-Koehler, Nancy, ed. *Vietnam: The Battle Comes Home. A Photographic Record of Post-Traumatic Stress with Selected Essays.* New York: Morgan & Morgan, 1984.

Hyman, Nat. *Eyes of the War, Vol. 2: A Photographic Report of World War II.* New York: Telpic Sales, 1945.

Jackson, Beverly, ed. *The White House News Photographers' Best.* Washington, D.C.: Acropolis Books, 1977.

Japan Photographers Association. *A Century of Japanese Photography.* New York: Random House, Pantheon Books, 1971.

Johnson, William S., ed. *W. Eugene Smith: Master of the Photographic Essay.* Millerton, N.Y.: Aperture, 1981.

Johnson, William Weber. "Modern Mexico Was Formed in the Crucible of Revolution." *Smithsonian*, July 1980, 30–41.

Josephy, Alvin M., Jr., ed. *The American Heritage History of World War I.* New York: American Heritage Publishing Co., Bonanza Books, 1982.

Kaiser, Robert S., and Hannah Jopling Kaiser, eds. *Russia from the Inside.* New York: E. P. Dutton & Co., 1980.

Keegan, John. *The Face of Battle.* New York: Random House, Vintage Books, 1976.

Keegan, John, and Joseph Darracott. *The Nature of War.* New York: Holt, Rinehart & Winston, 1981.

Kennerly, David Hume. *Shooter.* New York: Newsweek Books, 1979.

Lesy, Michael. *Bearing Witness: A Photographic Chronicle of American Life, 1860–1945.* New York: Pantheon Books, 1982.

Leventhal, Albert R. *War.* Chicago: Playboy Press, 1973.

Lewinski, Jorge. *The Camera at War: A History of War Photography from 1848 to the Present Day.* New York: Simon & Schuster, 1978.

Library of Congress. *Viewpoints: A Selection from the Pictorial Collections of the Library of Congress.* Washington, D.C.: Library of Congress, 1975.

Lockwood, Lee. *Castro's Cuba, Cuba's Fidel.* New York: Random House, Vintage Books, 1969.

Loke, Margarett, ed. *The World as It Was, 1865–1921: A Photographic Portrait from the Keystone-Mast Collection.* New York: Summit Books, 1980.

Lossing, Benson J. *Mathew Brady's Illustrated History of the Civil War.* New York: Fairfax Press, 1912.

Lucas, James. *War on the Eastern Front, 1941–1945: The German Soldier in Russia.* New York: Bonanza Books, 1979.

Lucie-Smith, Edward. *The Invented Eye: Masterpieces of Photography, 1839–1914.* London: Paddington Press, 1975.

McCullin, Don. *Is Anyone Taking Any Notice?* Cambridge: MIT Press, 1971.

McCullin, Don. *Hearts of Darkness.* New York: Alfred A. Knopf, 1981.

McCullough, David G., ed. *The American Heritage Picture History of World War II.* New York: American Heritage Publishing Co., 1966.

McJunkin, James N., and Max D. Crace. *Visions of Vietnam.* Novato, Calif.: Presidio Press, 1983.

Maloney, Tom, ed. *U.S. Camera, 1954.* New York: U.S. Camera Publishing, 1953.

Manchester, William. *Goodbye, Darkness: A Memoir of the Pacific War.* Boston: Little, Brown & Co., 1979.

Marshall, S.L.A. *The American Heritage History of World War I.* New York: American Heritage Publishing Co., 1964.

Meiselas, Susan, and Claire Rosenberg, eds. *Nicaragua: June 1978–July 1979.* New York: Pantheon Books, 1981.

Meredith, Roy. *The World of Mathew Brady: Portraits of the Civil War Period.* Los Angeles: Brooke House Publishers, 1976.

Miller, Frances Trevelyan, ed. *The Photographic History of the Civil War.* 10 vols. New York: Review of Reviews Co., 1912.

Milwaukee Art Center. *Six Decades: The News in Pictures.* Milwaukee: Milwaukee Journal, 1976.

Munson, Doug, and Joel Snyder. *The Documentary Photograph as a Work of Art: American Photographs, 1860–1876.* Chicago: The David and Alfred Smart Gallery, The University of Chicago, 1976.

Mydans, Carl. *More than Meets the Eye.* New York: Harper & Bros., 1959.

Mydans, Carl. *Carl Mydans: (An Eye Witness to Turbulent Japan) 1941–1951.* Japan: Nikkor Club, 1983.

Mydans, Carl, and Shelley Mydans. *The Violent Peace: A Report on Wars in the Postwar World.* New York: Atheneum Publishers, 1968.

Nakahara, Liz. "Pulitzers: The Power and the Pressure." *Washington Post*, 12 Sept. 1982, G1, 12–13.

Nakahara, Liz. "In the Eye of the Storm." *Washington Post*, 6 Nov. 1983, K1, 6–7.

Nassib, Selim, and Caroline Tisdall. *Beirut: Frontline Story.* London: Pluto Press, 1983.

National Archives. *The American Image: Photographs from the National Archives, 1860–1960.* New York: Pantheon Books, 1979.

National Historical Society. *The Image of War: 1861–1865.* 6 vols. New York: Doubleday & Co., 1981.

Newhall, Beaumont. *The History of Photography from 1839 to the Present Day.* New York: Museum of Modern Art, 1964.

O'Brien, Tim. *Going After Cacciato.* New York: Dell Publishing Co., 1975.

Odhams Press. *The War's Best Photographs: Pictorial Masterpieces of the Greatest Struggle the World Has Known.* London: Odhams Press, after 1943.

Olson, Cal, ed. *The Best of Photojournalism/8.* Philadelphia: Running Press, 1983.

O'Neil, Doris, C. *Life: The First Decade.* Boston: New York Graphic Society, 1979.

Page, Tim. *Tim Page's Nam.* New York: Alfred A. Knopf, 1983.

Peress, Gilles. *Telex Iran: In the Name of Revolution.* Millerton, N.Y.: Aperture, 1983.

Phillips, Christopher. *Steichen at War.* New York: Harry N. Abrams, 1981.

Pickerell, James. *Vietnam in the Mud.* New York: Bobbs-Merrill Co., 1966.

Pimlott, John. *World War II in Photographs.* New York: Military Press, 1984.

Readers Digest Association, eds. *Great Photographs of World War II.* Pleasantville, N.Y.: Readers Digest Association, 1964.

Reston, James, Jr. "A Reporter at Large (General William Tecumseh Sherman)." *New Yorker*, 28 Jan. 1985, 35–71.

Riboud, Marc. *Face of North Vietnam.* New York: Holt, Rinehart & Winston, 1970.

Robertson, Peter. *Relentless Verity: Canadian Military Photographers since 1885.* Toronto: Public Archives of Canada Series, University of Toronto Press, 1973.

Russell, Andrew J. *Russell's Civil War Photographs: 116 Historic Prints.* New York: Dover Publications, 1982. (From original scrapbook album by Russell entitled, "United States Military Railroad Photographic Album.")

Sandweiss, Martha A. *Masterworks of American Photography: The Amon Carter Museum Collection.* Birmingham, Ala.: Oxmoor House, 1982.

San Francisco Examiner. "Central America: The Tortured Land." *San Francisco Examiner*, 25 July–8 Aug. 1982.

Shawcross, William. "Too Many Holocausts Have Made Mankind Numb." *Washington Post*, 2 Sept. 1984, D1, 4.

Shermer, David. *World War I.* Secaucus, N.J.: Derby Books, 1973.

Skoogfors, Leif. *The Most Natural Thing in the World.* New York: Harper & Row Publishers, 1974.

Solomon-Godeau, Abigail. "The War Room." *Photocommunique* 6, no. 1. Toronto: Fine Art Photography Publication, 1984.

Stapp, William F. "'These Terrible Mementoes': Civil War Photography." *Chicago History* 9, no. 4 (Winter 1980–81): 197–210.

Steichen, Edward. *Memorable Life Photographs.* New York: Museum of Modern Art, 1951.

Steichen, Edward, ed. *U.S. Navy War Photographs: Pearl Harbor to Tokyo Bay.* New York: Bonanza Books, 1984.

Szarkowski, John, ed. *From the Picture Press.* New York: Museum of Modern Art, 1973.

Szarkowski, John, and Shoji Yamagishi, eds. *New Japanese Photography.* New York: Museum of Modern Art, 1974.

Time-Life Books. *Photography Year 1978.* Alexandria, Va.: Time-Life Books, 1978.

Time-Life Books. *World War II.* 39 vols. Alexandria, Va.: Time-Life Books, 1979.

Time-Life Books. *Great Photographers.* Alexandria, Va.: Time-Life Books, 1983.

Time-Life Books. *The Civil War.* 27 vols. Alexandria, Va.: Time-Life Books, 1984.

Topping, Ira, ed. *The Best of Yank, the Army Weekly.* New York: Arno Press, 1980.

Tourtellot, Arthur B., ed. *Life's Picture History of World War II.* New York: Time, 1950.

Tuchman, Barbara. *The Guns of August.* New York: Macmillan Co., 1962.

Tuchman, Barbara. *The Proud Tower.* New York: Macmillan Co., 1966.

U.S. Naval History Division. *U.S. Naval History Sources in the United States.* Washington, D.C.: Department of the Navy, 1979.

Walker Art Center. *Press Photography: Minnesota since 1930.* Minneapolis: Walker Art Center, 1977.

Walsh, George, Colin Naylor, and Michael Held, eds. *Contemporary Photographers.* New York: St. Martin's Press, 1982.

Way, Peter. *The Falklands War.* 14 weekly parts. London: Marshall Cavendish, 1983.

Willmann, Heinz. *Geschichte der Arbeiter-Illustrierten Zeitung, 1921–1938.* Berlin: Dietz Verlag Berlin, 1975.

Worswick, Clark, and Ainslie Embree. *The Last Empire: Photography in British India, 1855–1911.* Millerton, N.Y.: Aperture, 1976.

THE INDELIBLE IMAGE
PHOTOGRAPHS OF WAR · 1846 TO THE PRESENT

Unless otherwise indicated, all caption notes in quotes are taken from texts appended directly onto the photographs. Many are by the photographers; others are anonymous. Brackets around titles indicate editorial authorship. In given dimensions, height precedes width. Brackets around dimensions indicate size of photograph made for exhibition purposes.

Brief notes on the wars represented are given for the reader's convenience. Authoritative histories should be sought elsewhere.

THE CRIMEAN WAR, 1854–1856

The Crimean War was waged by France, Britain, Piedmont-Sardinia, and Turkey against Russia in the Crimea—a Russian peninsula on the north shore of the Black Sea—to block czarist expansion into Turkey and maintain the balance of power in the Near East. Ill-prepared for the harsh conditions of the Crimea and totally dependent upon an unreliable supply line by sea, the Allied troops suffered enormously, and newspaper accounts of their hardships aroused unfavorable public opinion at home. A war of attrition that foreshadowed the First World War, the Crimean War ended in a military defeat for Russia. Peace was concluded by the Treaty of Paris, signed March 30, 1856.

1.
ROGER FENTON, British (1819–1869)
The Valley of the Shadow of Death, 1855
Crimean War
Salt print
10¾ × 14 in.; 27.3 × 35.6 cm
Library of Congress, Washington, D.C.

The Crimean War set the pattern for war reporting for the rest of the nineteenth century. Photographers, correspondents, and artists from all of the countries involved were on campaign together for the first time. New illustrated journals back home commanded verbal and pictorial news.

Under the queen of England's patronage, Roger Fenton made an expedition to the Crimea. He arrived in Balaclava in 1855 and took nearly four hundred glass negatives of the war. These pictures comprised the first extensive photo-documentation of a war. Fenton avoided any subject matter that would offend English Victorian sensibilities, particularly photographs of the dead and wounded.

Newspaper accounts of the brutal conditions suffered by the British troops in the Crimea turned public opinion against British involvement in the Crimean War. William Russell, a correspondent covering the war for the *Times*, quoted a young officer who described the site of this photograph as [a valley] "so exposed to the enemy's fire that it has been called 'The Valley of Death' " (quoted Hodgson 1974, 39). However, according to Albert R. Leventhal (1973, 20), "it was a harmless gully near Sevastopol, cluttered with Russian shot that had missed the target."

2.
ROGER FENTON
Cavalry Camp, 1855
Crimean War
Salt print
10¾ × 14 in.; 27.3 × 35.6 cm
Library of Congress, Washington, D.C.

3.
ROGER FENTON
The Harbour of Balaclava, the Cattle Pier, 1855
Crimean War
Salt print
11¾ × 14 in.; 28.8 × 35.6 cm
Library of Congress, Washington, D.C.

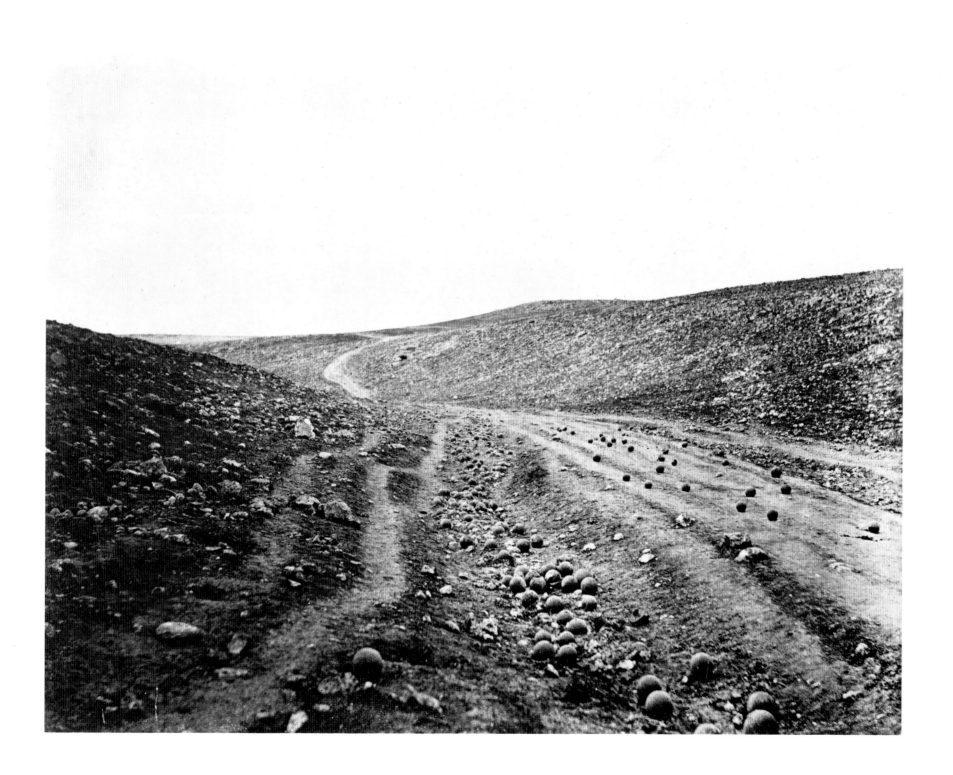

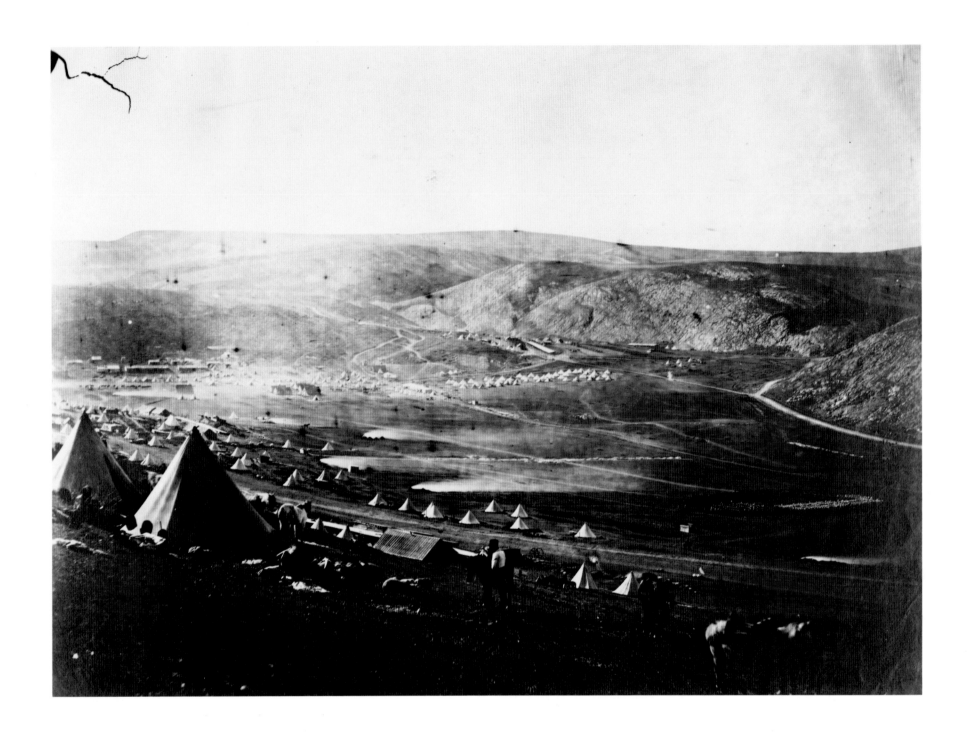

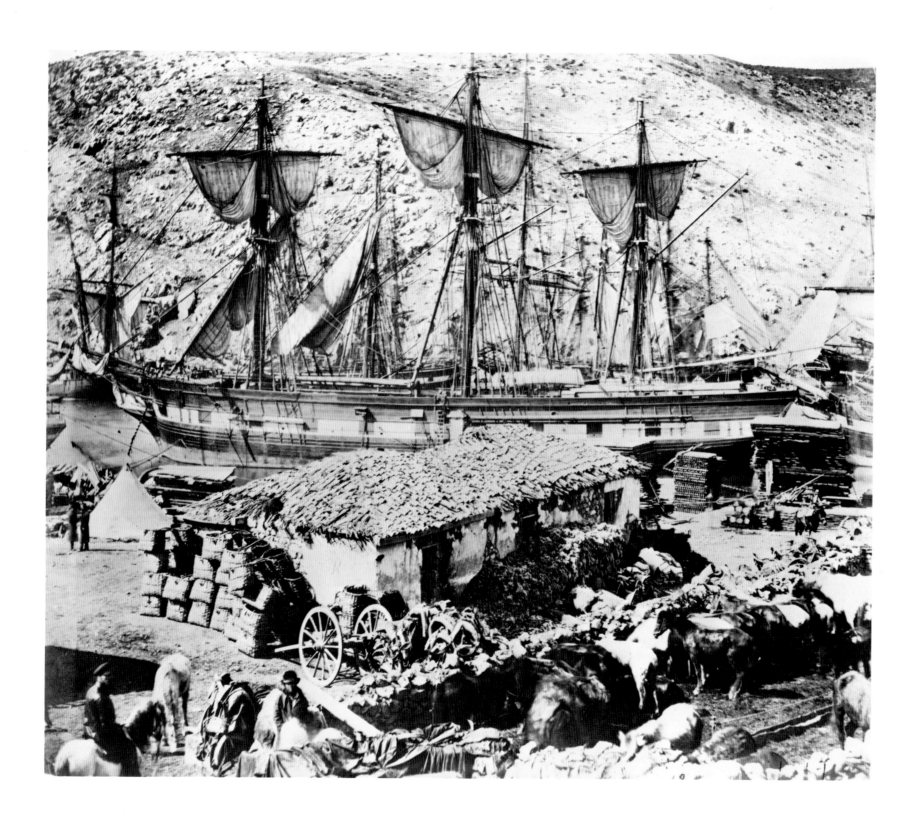

4.
Gustave Le Gray, French (1820–1862)
Cavalry Exercises at Châlons, 1857
Albumen silver print
10½ × 13¼ in.; 26.7 × 33.7 cm
J. Paul Getty Museum, Santa Monica, California

A landscape-seascape photographer, Gustave Le Gray initiated the
process of combination printing, a method using two negatives to
print sky and sea or sky and land separately with different exposures.
Le Gray recorded scenes of military life at Châlons and covered
Napoleon III's visit there in 1858.

5.

Gustave Le Gray, French (1820–1862)
Camp de Châlons, no date
Albumen silver print
6 × 12½ in.; 15.2 × 31.7 cm
Galerie Octant, Paris

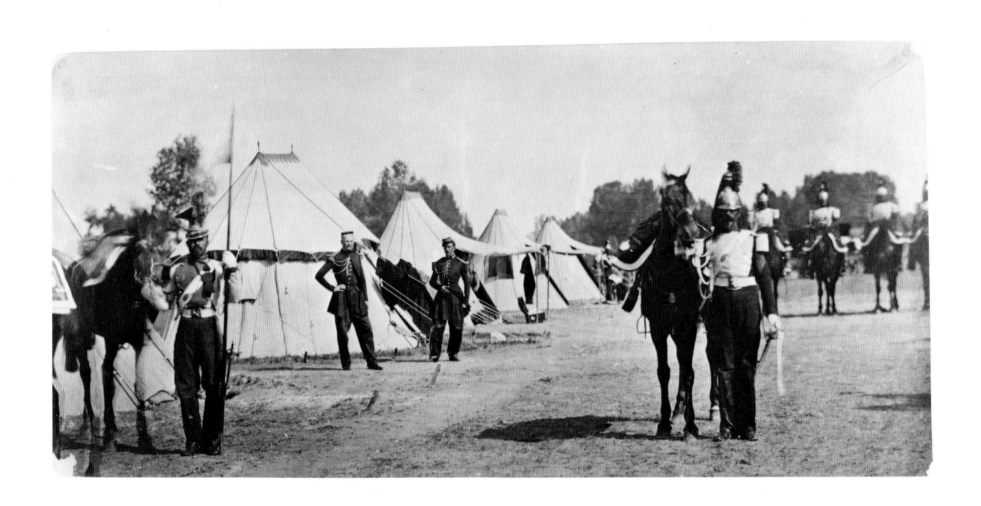

THE OPIUM WARS, 1839–1842, 1856–1860

Conflict between Britain and China over Chinese trade restrictions, especially China's ban on the importation of opium from India, instigated the Opium Wars. At the end of the first war, in 1842, the Chinese ceded Hong Kong to the British and opened Canton to foreign residence and commerce. Tensions continued, however, and war broke out again in 1856 after China seized the crew of a British trading vessel. In retaliation, the British and their French allies bombarded Canton and the Pehtang and Taku Forts guarding the route to Peking. In 1858, to save Peking, the Chinese agreed to a treaty permitting the British importation of opium, the residence of foreign diplomats in Peking, foreign travel rights in the interior of China, and freedom of trade. The Chinese did not ratify the treaty for two years, however, and hostilities continued until 1860.

6.

FELICE BEATO, British (born Italy, date unknown; died 1903)
Interior of the Angle of North Forts of Taku, Immediately After Its Capture, August 21, 1860
Opium War
Albumen silver print
8¾ x 12¾ in.; 22.4 x 29.8 cm
Courtesy Lunn Ltd., Washington, D.C.

When the north Taku Fort was attacked by the British, the magazine blew up with a huge explosion. The Chinese had built an elaborate system of obstacles around the fort, which made retreat difficult. Thus the Chinese were killed trying to escape, and their bodies were found strewn around the interior of the fort. Beato took the photograph shortly after the attack. British scaling ladders can be seen to the left of the gun embrasure.

THE INDIAN MUTINY, 1857–1858

From 1757 to 1857 the British East India Company increasingly dominated the Indian subcontinent economically, politically, and militarily. In 1857, Hindu and Muslim elements of the East India Company's Army of Bengal at Meerut revolted, killed their British officers, and marched on Delhi in an attempt to restore the power of the decayed Mughal Empire. The revolt spread to Kanpūr, where the rebellious Nana Sahib troops massacred several hundred British civilians including women and children, and to Lucknow, where the British garrison took refuge in the besieged British Residency. After bitter fighting at Delhi, Lucknow, and in central India against the rebel army of the Rani of Jhānsi, the Mutiny was suppressed in 1858. However, the restoration of order was accompanied by indiscriminate, often terrible reprisals by British troops and loyal native troops against the rebels and innocent Indians alike.

7.

FELICE BEATO
Indian Mutiny: Mutineers Being Hanged, 1857
Albumen silver print
8⅝ × 10¼ in.; 22 × 26 cm
National Army Museum, London

8.

FELICE BEATO
The Interior of the Secundra Bagh, Lucknow, 1858
Indian Mutiny
Albumen silver print
10⅜ × 11⅞ in.; 26.3 × 30.2 cm
Courtesy Michael Wilson, London

This photograph was taken at the time of the final capture of Lucknow, when corpses of the rebels still lay on the ground. It is the earliest known photograph of war dead; Victorian squeamishness had precluded such images before this time. By breaking the death taboo, this photograph set the tone for photographic reportage of victims of the American Civil War.

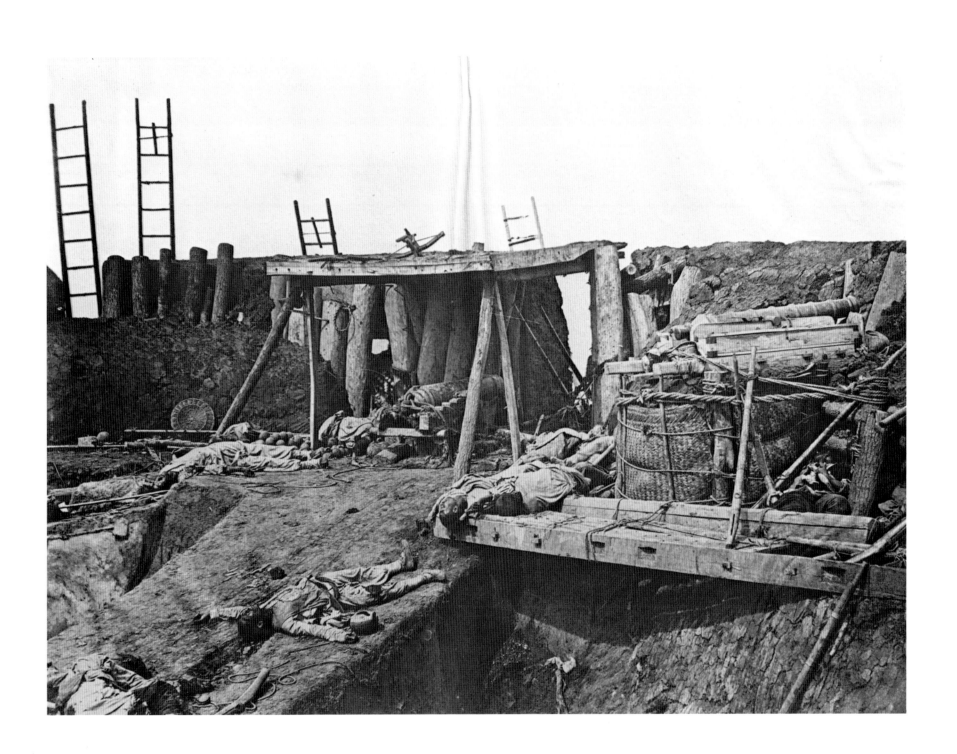

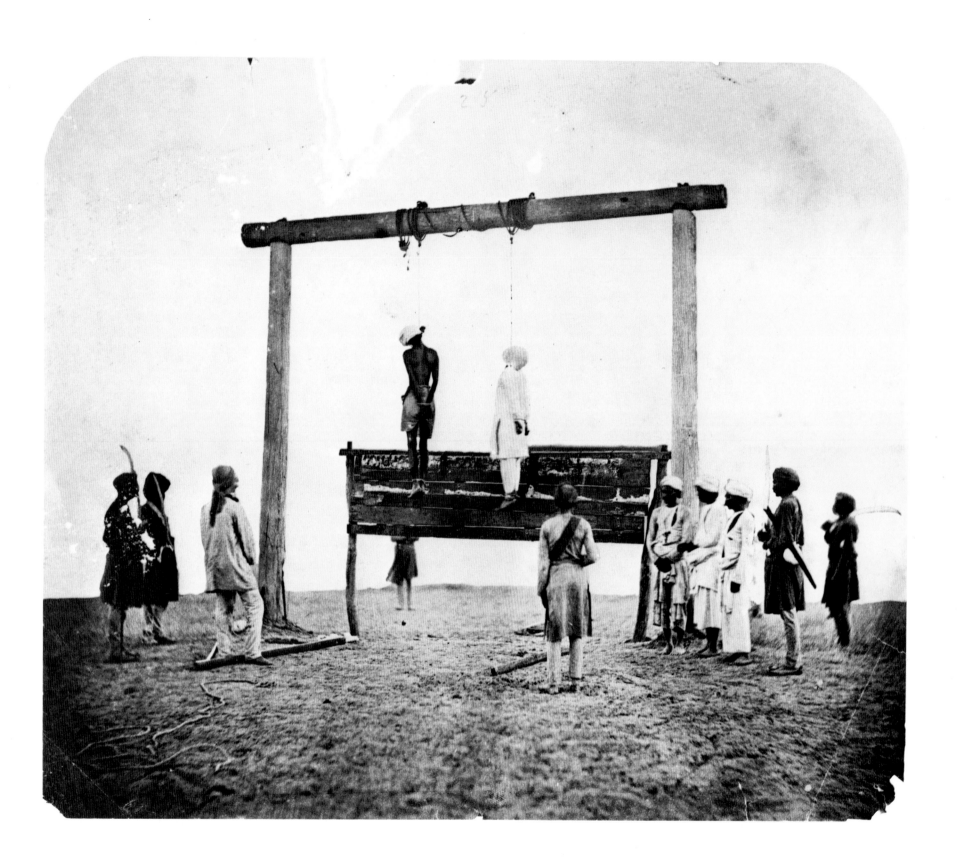

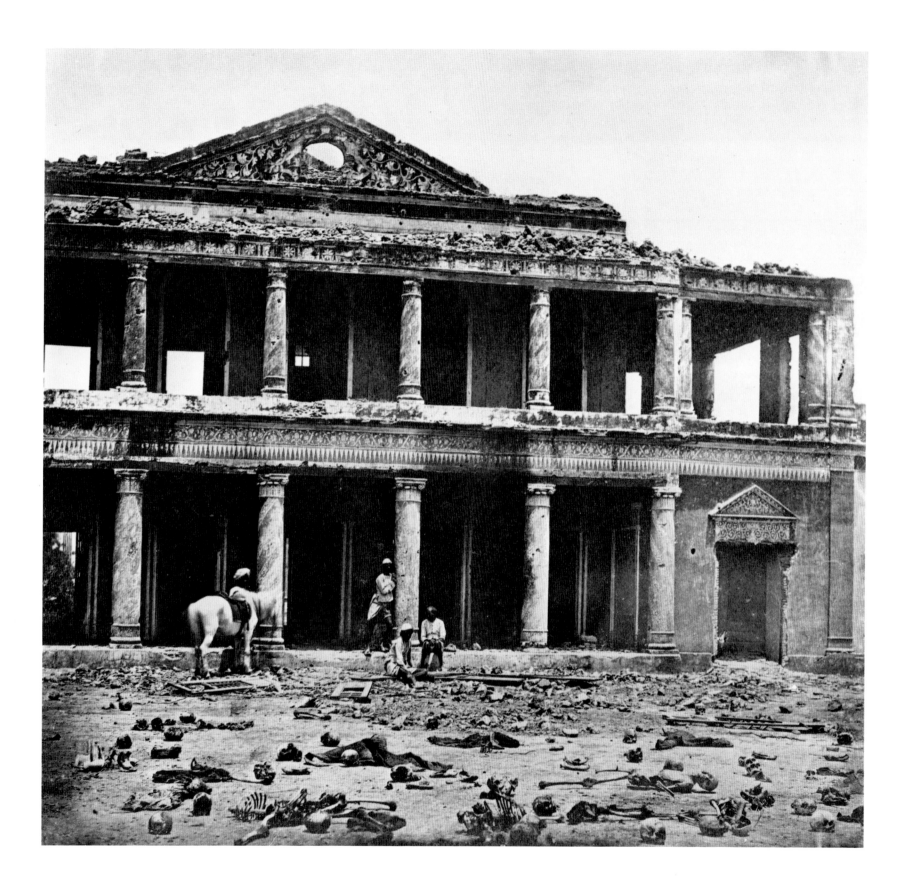

JAPAN 1853–1869: THE FALL OF THE TOKUGAWA SHOGUNATE

By the mid-nineteenth century, Japan was under intense pressure from the Western nations to end its traditional policy of national seclusion. An American naval expedition to Japan led by Admiral Mathew Calbraith Perry resulted in the Treaty of Kanagawa, signed March 31, 1854, with the Tokugawa Shogunate, the military dynasty that had ruled Japan in the name of the emperor since 1603. The end of Japan's isolationism, however, was opposed by many of the country's feudal lords and their samurai retainers. Resistance to the Tokugawa Shogunate evolved into a nationalist movement that united behind the emperor. In 1867 the Tokugawa shogun surrendered to the newly constituted, modernized Imperial Army, and on January 1, 1868, the emperor was restored to power; fighting continued, however, into the next year.

9.
PHOTOGRAPHER UNKNOWN
[*Corpse of Admiral Richardson*] (from British album of Japan, c. 1860s)
Albumen silver print
4 × 7⅛ in.; 10.1 × 18.2 cm
Courtesy Lunn Ltd., Washington, D.C.

"Corpse of Admiral Richardson murdered on the To-Kondo by order of Shimidzu Saburo (a Satsuma prince) whose place Kagasuma was subsequently bombarded by the British fleet under Admiral Ruper, 1860s."

10.
PHOTOGRAPHER UNKNOWN
[*Panoramic View of Fleet off Shimonishi*] (from British album of Japan, c. 1860s)
Albumen silver print
8½ × 22¾ in.; 21.7 × 57.6 cm
Courtesy Lunn Ltd., Washington, D.C.

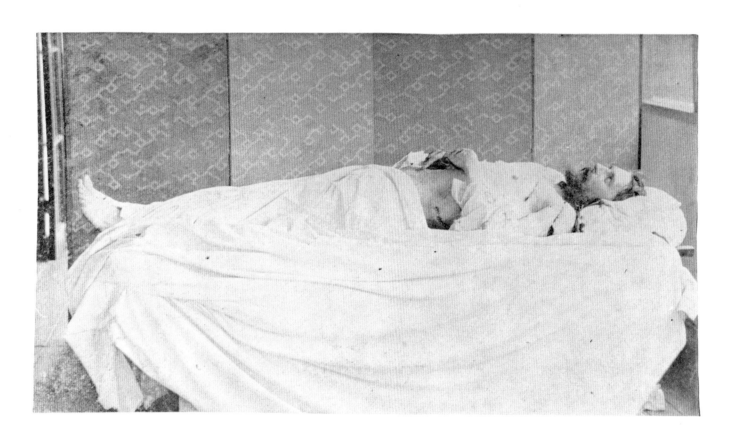

The American Civil War, 1861–1865

The American Civil War was the culmination of years of sectional friction and economic rivalry. The failure to reach a political compromise on the issue of slavery's expansion into the western territories and the election to the presidency of the new Republican Party's candidate, Abraham Lincoln, precipitated the secession from the Union of eleven southern states, which formed the Confederate States of America.

The ensuing war was the bloodiest and most costly in human lives lost that the nation has yet experienced. The first modern war, it saw the introduction of the ironclad gunboat, the submarine, the torpedo, aerial observation, the rifled musket, and the repeating rifle, among other technological innovations.

The Union's superior industrial base, manpower pool, and Navy proved too much for the Confederacy, and the hoped-for European intervention on behalf of the South never materialized. After four years and some 600,000 casualties (from a total population of 32 million), the Southern armies surrendered unconditionally. President Lincoln's "oath registered in Heaven" to preserve the Union was upheld.

11.

MATHEW BRADY, American (1823–1896)
The Monitor Onondaga [on the James River, Virginia], July 1864
American Civil War
Albumen silver print
4⅝ × 7⅜ in.; 10.9 × 18.6 cm
Minneapolis Institute of Arts
The John R. Van Derlip Fund

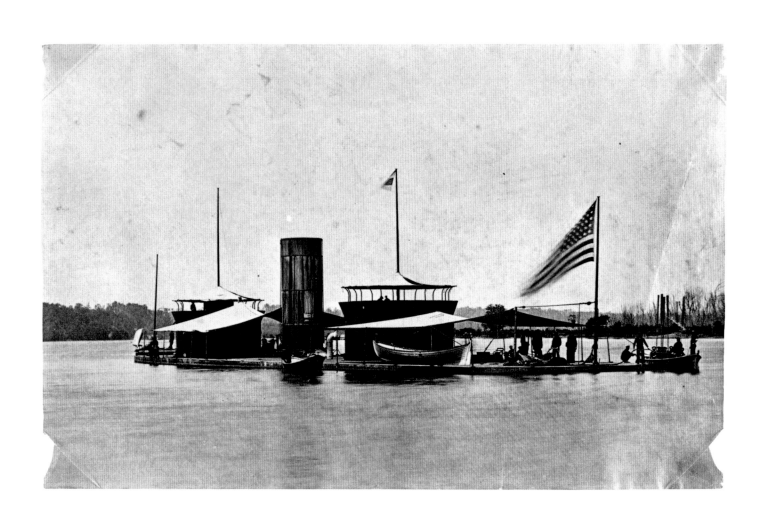

12.

PHOTOGRAPHER UNKNOWN
Embarkation for White House from Yorktown, Virginia, 1862
American Civil War
Albumen silver print
8½ × 6¾ in.; 21.6 × 17.3 cm
Records of the Office of the Chief Signal Officer, 111-B-82
The National Archives, Washington, D.C.

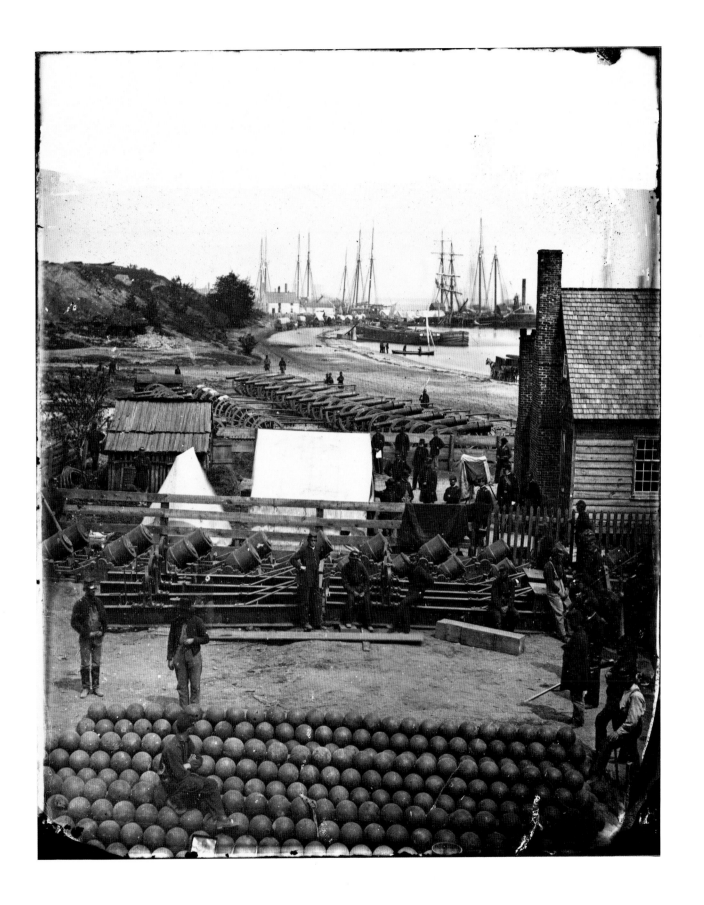

13.

TIMOTHY O'SULLIVAN, American (1840–1882)
A Harvest of Death, (from *Gardner's Photographic Sketch Book of the War* by Alexander Gardner), July 1863
American Civil War
Albumen silver print
6¾ × 8⅞ in.; 17.2 × 22.5 cm
The Rare Books and Manuscripts Division
The New York Public Library
Astor, Lenox and Tilden Foundations

In the summer of 1863 the Confederates, under General Robert E. Lee, invaded Pennsylvania, and the greatest battle of the war ensued at Gettysburg. There were fifty-one thousand casualties during the first three days of fighting. Lee was able to withdraw with his troops, but the battle was a major victory for the North, turning the tide for the Union forces.

Slowly, over the misty fields—as all reluctant to expose their ghastly horrors to the light—came the sunless morn, after the retreat by Lee's broken army. Through the shadowy vapors, it was, indeed, a "harvest of death" that was presented; hundreds and thousands of torn Union and rebel soldiers—although many of the former were already interred—strewed the now quiet fighting ground, soaked by the rain, which for two days had drenched the country with its fitful showers.

A battle has been often the subject of elaborate description; but it can be described in one simple word, *devilish!* and the distorted dead recall the ancient legends of men torn in pieces by the savage wantonness of fiends. Swept down without preparation, the shattered bodies fall in all conceivable positions. The rebels represented in the photograph are without shoes. These were always removed from the feet of the dead on account of the pressing need of the survivors. The pockets turned inside out also show that appropriation did not cease with the coverings of the feet. Around is scattered the litter of the battle-field, accoutrements, ammunition, rags, cups and canteens, crackers, haversacks, &c., and letters that may tell the name of the owner, although the majority will surely be buried unknown by strangers, and in a strange land. Killed in the frantic efforts to break the steady lines of an army of patriots, whose heroism only excelled theirs in motive, they paid with life the price of their treason, and when the wicked strife was finished, found nameless graves, far from home and kindred.

Such a picture conveys a useful moral: It shows the blank horror and reality of war, in opposition to its pageantry. Here are the dreadful details! Let them aid in preventing such another calamity falling upon the nation. (From *Gardner's Photographic Sketch Book of the War*)

Timothy O'Sullivan photographed the battlefield at Gettysburg as part of Alexander Gardner's team. The preponderance of bloated and mutilated bodies in the Gettysburg photographs reflects the team's interest in communicating the atrocities of war.

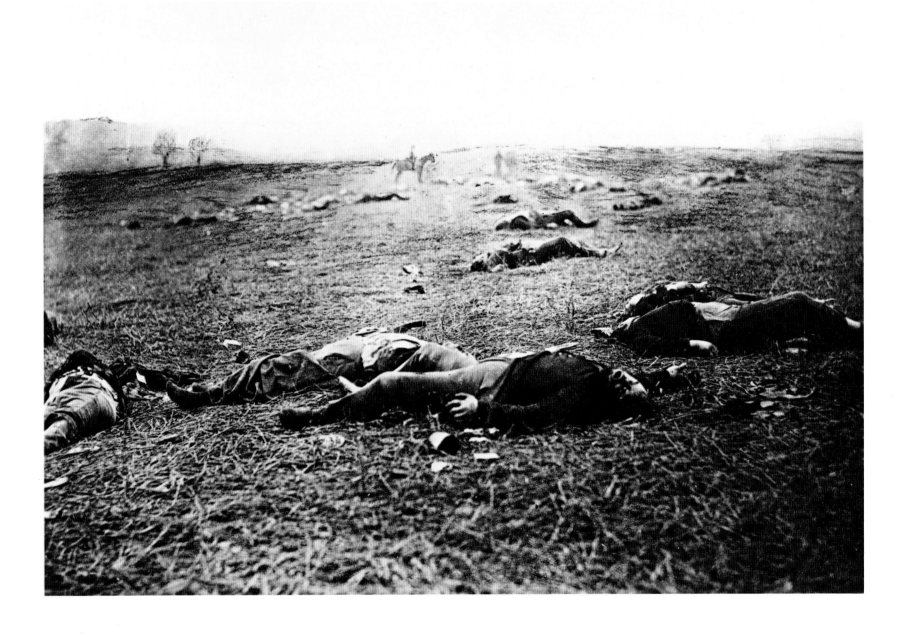

14.

ROYAN M. LINN, American (dates unknown)
Lookout Mountain, Tennessee, c. 1864
American Civil War
Albumen silver print, stereographic view
6¾ × 3½ in.; 17.2 × 8.9 cm
State Historical Society of Wisconsin, Madison
Iconographic Collections

In September 1863 the Confederate Army advanced on the Union
Army and occupied Lookout Mountain and Lookout Valley in Ten-
nessee. Lookout Valley was a vital supply route by rail and river for
the Union troops, and on November 1, 1864, that supply route was
reclaimed by the Union Army. This photograph was taken after the
battle.

15.

PHOTOGRAPHER UNKNOWN
Point of Lookout Mountain Taken during High Water,
Looking Down the River, c. 1864
American Civil War
Albumen silver print
11 × 8½ in.; 27.9 × 21.6 cm
Records of the Office of the Chief of Engineers, 77-F-147-2-11
The National Archives, Washington, D.C.

Royan M. Linn, an itinerant portrait photographer, took thousands of
carte de visite portraits of generals and soldiers at his "Gallery Point
Lookout" in Lookout Mountain, Tennessee. In this photograph, Linn
himself sits, cane in hand, beside a stereo camera.

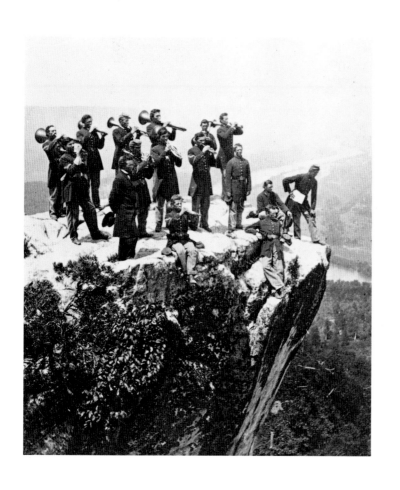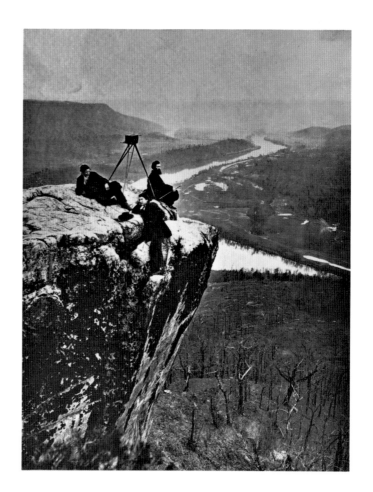

16.

Photographer Unknown
*Surgical Photograph No. 117. United Gunshot Fracture of the
Upper Third of the Left Femur* (from *Medical and
Surgical Report of the War of the Rebellion*,
compiled by the Surgeon-General, 1862-1883)
American Civil War
Albumen silver print
8⅝ × 7¼ in.; 21.9 × 18.4 cm
Otis Historical Archives, Armed Forces Medical Museum
Armed Forces Institute of Pathology, Washington, D.C.

This private, aged 38, was wounded at Cold Harbor on June 3, 1864, by a musket ball. He was admitted to the Lincoln Hospital in Washington, D.C., on June 3, 1864. The ball was extracted through an incision. The limb was shortened four and a half inches, and the patient recovered slowly. The limb was very distorted when this photograph was taken at Lincoln Hospital on June 7, 1865. The surgeon-general declared that the patient should not have been allowed to leave the hospital in his condition. The patient reentered the hospital in April 1866 for amputation of his left leg and died on May 7, 1866.

17.

Photographer Unknown
Surgical Photograph No. 186. Case of Cheiloplasty (from *Medical
and Surgical Report of the War of the Rebellion*,
compiled by the Surgeon-General, 1862–1883)
American Civil War
Albumen silver print
8¼ × 6½ in.; 21 × 16.5 cm
Otis Historical Archives, Armed Forces Medical Museum
Armed Forces Institute of Pathology, Washington, D.C.

This private, aged 46, was wounded at Ream's Station on August 25, 1864, by a shell fragment. The shell destroyed and carried away the chin and all the soft parts of the neck, mutilating the floor of the mouth completely and allowing the tongue to protrude and hang down on the neck. The patient was admitted to Lincoln Hospital in Washington, D.C., on August 28, 1864. He did well and improved rapidly. Doctors operated to reconstruct the floor of the mouth. The patient recovered and was able to articulate clearly and eat and drink without difficulty.

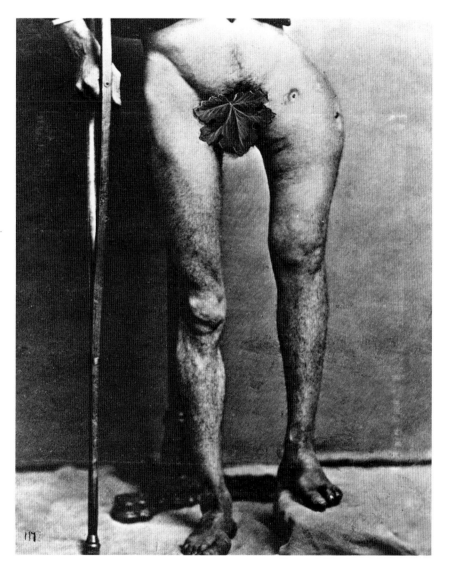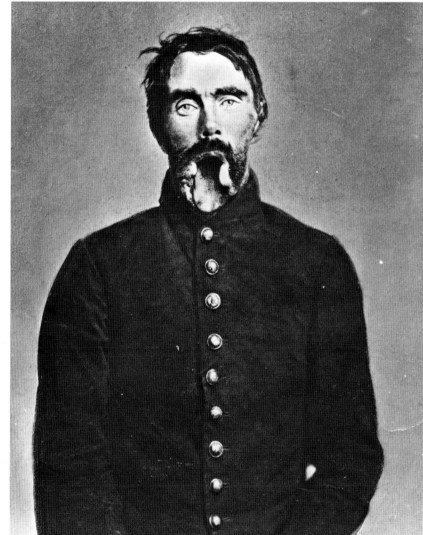

18.

George N. Barnard, American (1819–1902)
Ruins in Columbia, South Carolina, No. 2, c. 1865
American Civil War
Albumen silver print
10 × 14¼ in.; 25.4 × 36.1 cm
George H. Dalsheimer Collection, Baltimore, Maryland

General William Tecumseh Sherman widened the limits of acceptable warfare during the Civil War. By waging war against southern civilians, Sherman also attacked the army they supported. Sherman was convinced of the necessity to demoralize the southern people—to make them feel the punitive effects of warfare. In a letter to the mayor of Atlanta, Sherman wrote, "War is cruelty, and you cannot refine it; and those who brought war into our country deserve all the curses and maledictions a people can pour out" (Reston, Jr. 1985, 53).

After General Sherman's famous "March to the Sea," he turned toward the North and the Carolinas. Applying his philosophy of "Total War," he destroyed everything in his path, directing his forces against civilians as well as armies. He was especially ruthless in South Carolina, which he considered to be the source of the conflict. When he reached Columbia, the state capital, in February 1865, Sherman ordered the destruction of public buildings, railroad property, and machine shops. Looting and pillaging were rampant, and by the time Sherman rode in to occupy the city, much of it lay smoldering in ruins.

George Barnard took some of the earliest news photographs of the American Civil War. He worked for a time with Mathew Brady, but later disassociated himself from Brady's organization. Barnard accompanied General Sherman on his March to the Sea, and recorded the destruction of the battles. He felt that if people could see the devastation wrought by war, future hostilities might be avoided.

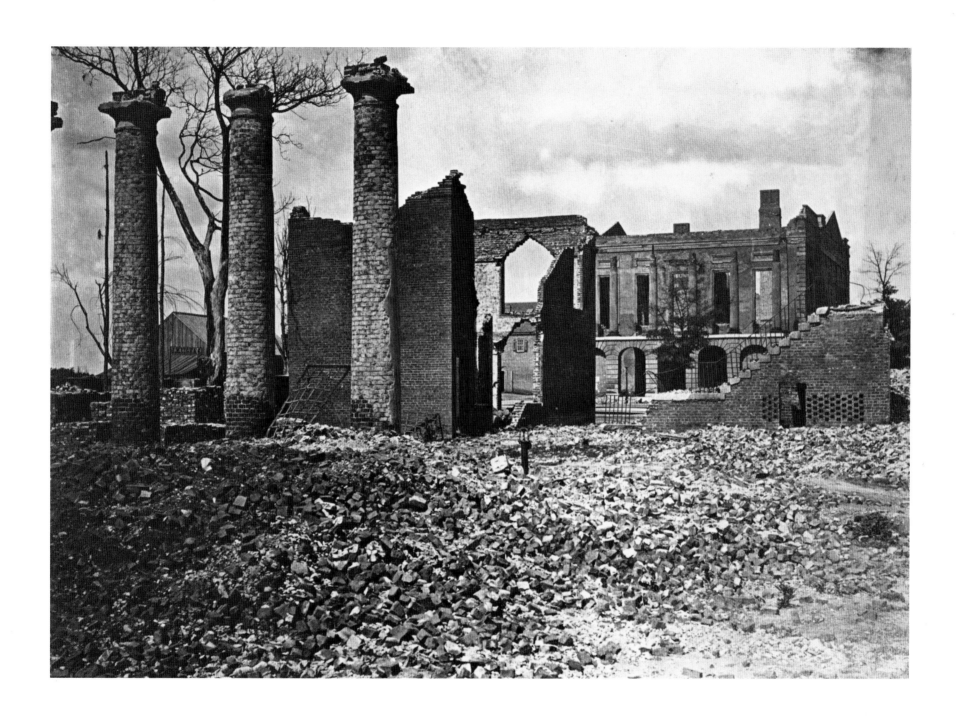

19.

TIMOTHY O'SULLIVAN, American (1840–1882)
Council of War at Massaponax Church, Virginia, 1864
American Civil War
Albumen silver print
[10 × 10 in.; 25.4 × 25.4 cm]
Library of Congress, Washington, D.C.

On May 21, 1864, Ulysses S. Grant and George Gordon Meade set up temporary headquarters at Massaponax Church, Virginia. The two commanders and their staffs pulled the pews out of the church and held an open-air council of war to plan the movement southward toward Richmond. At the far left of this photograph, Grant leans over the back of a pew to examine a map. Timothy O'Sullivan had the fortitude, or the luck, to be present with his camera and to position himself in a second-story window of the church to record the historic scene below. This is one of a sequence of five photographs taken by O'Sullivan at Massaponax.

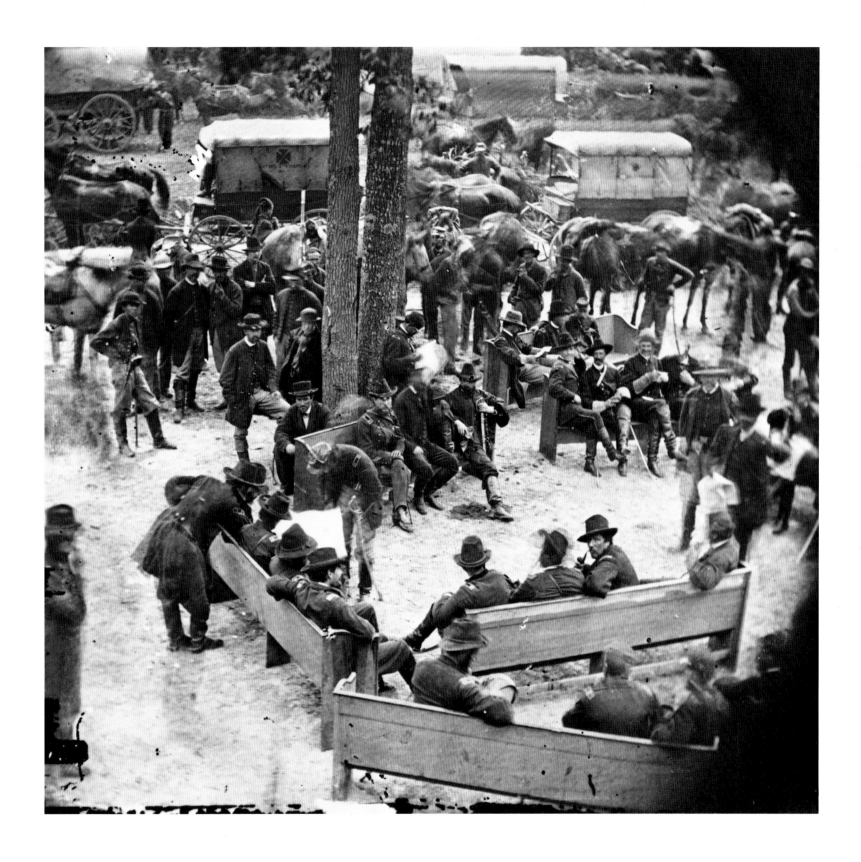

20.

PHOTOGRAPHER UNKNOWN/POCOHONTAS CO.
J. Woods Price - 2nd Lieut. of Co. F, 19th Virginia Cavalry, 1861–1865
American Civil War
Albumen silver print
7⅞ × 6 in.; 20 × 15.2 cm
The Museum of the Confederacy, Richmond, Virginia

21.

PHOTOGRAPHER UNKNOWN
J. Woods Price at Reunion, 1907
American Civil War
Albumen silver print
7⅞ × 6 in.; 20 × 15.2 cm
The Museum of the Confederacy, Richmond, Virginia

L. Woods Price 2d Lieut of
19th Va Cav. 1861 - 1865

The Reign of Maximilian, 1864–1867

Maximilian, archduke of Austria, was crowned emperor of Mexico by a committee of Mexican conservatives who were exiled opponents of Benito Juárez, and who were backed by the emperor Napoleon III of France. Maximilian lacked popular support, however, and his throne was secured only by a French army, which defended it during the three years of civil war that marked his reign. In 1867, after the United States delivered an ultimatum, the French forces withdrew, but Maximilian chose to stay in Mexico rather than flee into exile. Captured by the Republican troops of Benito Juárez, he was tried and executed at Querétaro on June 19, 1867.

22.

François Aubert, French (1829–1906)
Maximilian's Shirt (worn by the Emperor Maximilian of Mexico on the day of his execution), 1867
Albumen silver print
8⅝ × 6⅜ in.; 22.1 × 16.2 cm
Amon Carter Museum, Fort Worth, Texas

23.

François Aubert
The Emperor Maximilian of Mexico in His Coffin, 1867
Albumen silver print
8⅝ × 6⅜ in.; 21.9 × 16.2 cm
Courtesy Paul M. Hertzmann, Inc., San Francisco

In 1854 François Aubert traveled to Mexico, where he learned photography and became established as photographer of the privileged classes. Aubert's position as official photographer for the Emperor Maximilian enabled him to witness and photograph the extraordinary events of the empire's collapse and the emperor's execution in 1867.

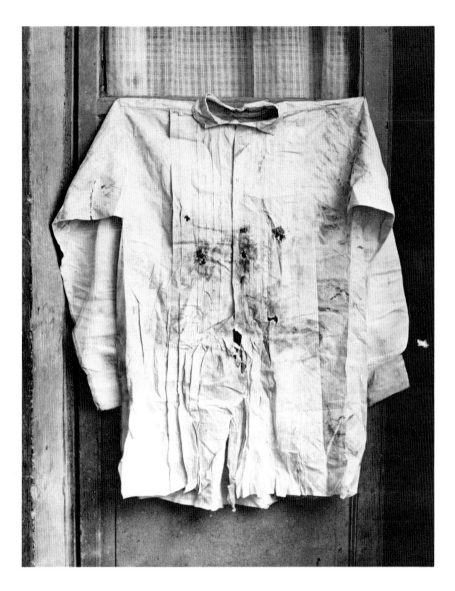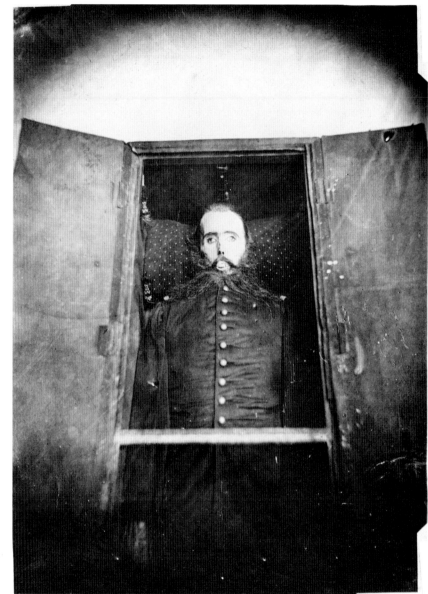

The Paris Commune, 1871

At the end of the Franco-Prussian War (1870–1871), France capitu-
lated to Germany, with the new government of Adolphe Thiers favor-
ing the restoration of either the Bourbon or the Orleanist dynasty.
The Parisians, who had just withstood a four-month siege of their
city, were enraged that the government had betrayed them. The
Central Committee of the National Guard established itself at the
Hôtel de Ville and proclaimed the Government of the Commune of
Paris on March 28, 1871. This government did not recognize Thiers's
pro-royalist regime, which had withdrawn with the army to Ver-
sailles, declaring it the capital. On May 21 the troops of the Versailles
Government entered Paris. A week of fighting known as "Bloody
Week" followed. Although both sides were merciless, the government
forces massacred an estimated twenty thousand men, women, and
children, a number far in excess of those killed by the Communards.
On May 23 and 24 the Communards set fire to the principal public
buildings of Paris, including the Tuilleries, the Palais Royal, the Palais
du Luxembourg, and the Hôtel de Ville. One-quarter of the city was
destroyed before the revolt was put down.

24.

Photographer Unknown
Dead Communists in Their Coffins, 1871
Paris Commune
Albumen silver print
7½ × 10¼ in.; 19.1 × 26.2 cm
Gernsheim Collection
Harry Ransom Humanities Research Center, The University of Texas at Austin

The bodies in this photograph, from which the clothes were stolen,
were among the twenty thousand insurgents mercilessly murdered by
the Versailles troops during the "Bloody Week" of May 21—28,
1871. The dead were numbered, laid out for identification, and bur-
ied in mass graves in the Père Lachaise Cemetery.

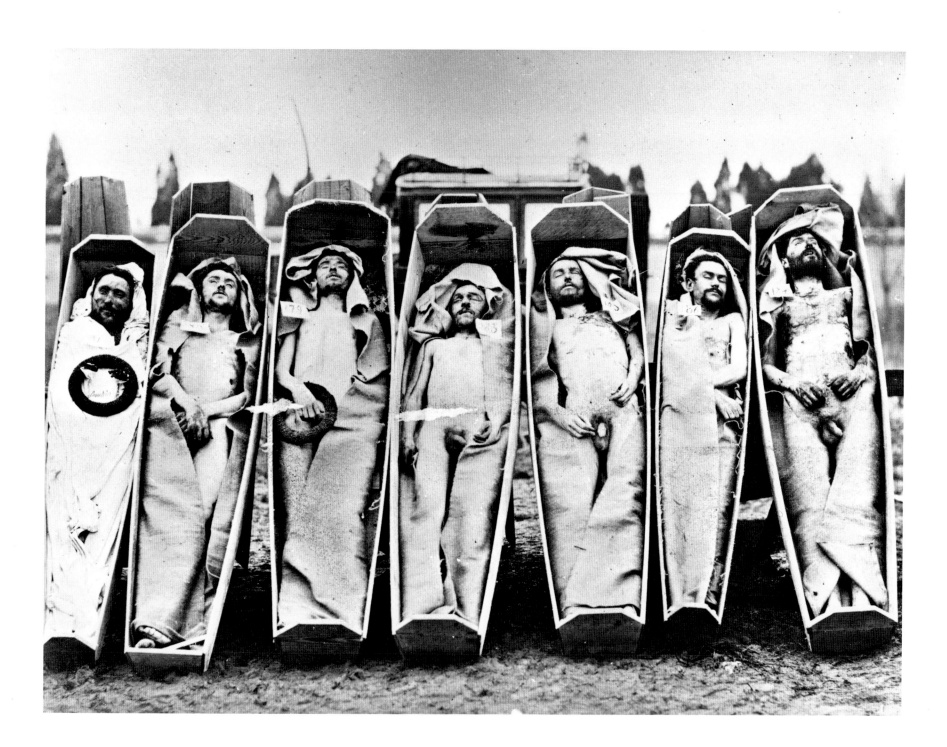

THE INDIAN WARS in NORTH AMERICA

During the American colonial period, white settlers waged war with the native Indians to subjugate them and acquire additional territory. Fighting between the Indians and whites was a continuous fact of life as the American frontier moved westward. Before the American Civil War, the wars were generally the result of Indians' reaction and resistance to invasion, to removal farther West, and to mistreatment and fraud. After the Civil War, the conflicts resulted from the U.S. government's mandate to force all Indians onto reservations.

25.

DR. WILLIAM A. BELL, British (1841–1921)
Sgt. Wylliams, G Troop, 7th Cavalry. Killed in battle with the Cheyenne Indians. June 26, 1867. This photo taken as he was found on the battle field on the eve of June 26. Fort Wallace, Kansas
Indian Wars in North America
Albumen silver print
Carte de visite
Blake Collection, Kansas Collection, University of Kansas Libraries, Lawrence

This carte de visite photograph was enclosed in a letter from Richard Blake, a sutler at Fort Wallace, to his family. The letter reads, "Dr. Bell . . . photographed the body of Serg't. Wylliams, after it was brought to the post, just to show our friends at Washington, the Indian Agents, what fiends we have to deal with!" (quoted in *Life in Custer's Cavalry: Letters and Diaries of Albert & Jennie Barnitz* [New Haven: Yale University Press]).

THE ZULU WAR, 1879

In 1879, to eliminate the threat of the militaristic Zulu empire of King Cetewayo to the borders of the British South African territories of Natal and the Transvaal, British forces invaded Zululand. After hard fighting, Cetewayo was defeated and exiled, and in 1887, Zululand was annexed by Great Britain and became part of the empire.

26.

JAMES LLOYD, British (c. 1828–1913)
Dead Zulu near Prince Imperial, 1879 (from J. Lloyd album, *Zulu War—Tugela Views and Vicinity—West End Studio*)
Albumen silver print
3⅞ × 5 ¾ in.; 10 × 14.5 cm
National Army Museum, London

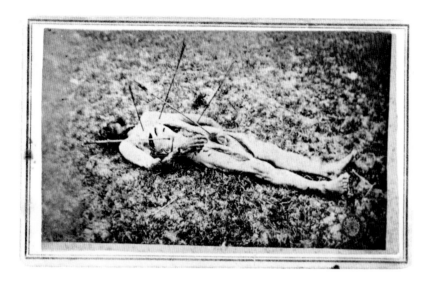

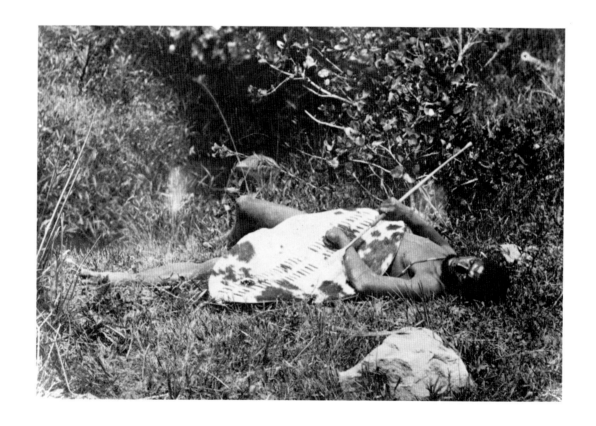

THE SECOND AFGHAN WAR, 1878–1880

Throughout the nineteenth century, British policy required a neutral
Afghanistan to buffer her Indian empire against the threat of Russian
expansionism. In 1878, to counter the growing threat of Russian
influence on the Afghan amir, British and Indian troops invaded
Afghanistan. After two years of fighting, during which Kabul was
occupied, a new amir was installed who was more friendly to British
interests.

27.

JOHN BURKE, British (dates unknown)
General Roberts and Staff Inspecting Captured Guns, Sherpur
(from the album, *Afghan War, 1878–1879: Peshawur Valley Field Force*)
Albumen silver print
7⅛ × 12⅝ in.; 18.1 × 31.9 cm
Collection Centre canadien d'architecture/Canadian Centre for
Architecture, Montreal

John Burke was a professional British photographer in the Punjab in
India. He was employed by the Indian government as a civilian to
take pictures of the campaign in Afghanistan.

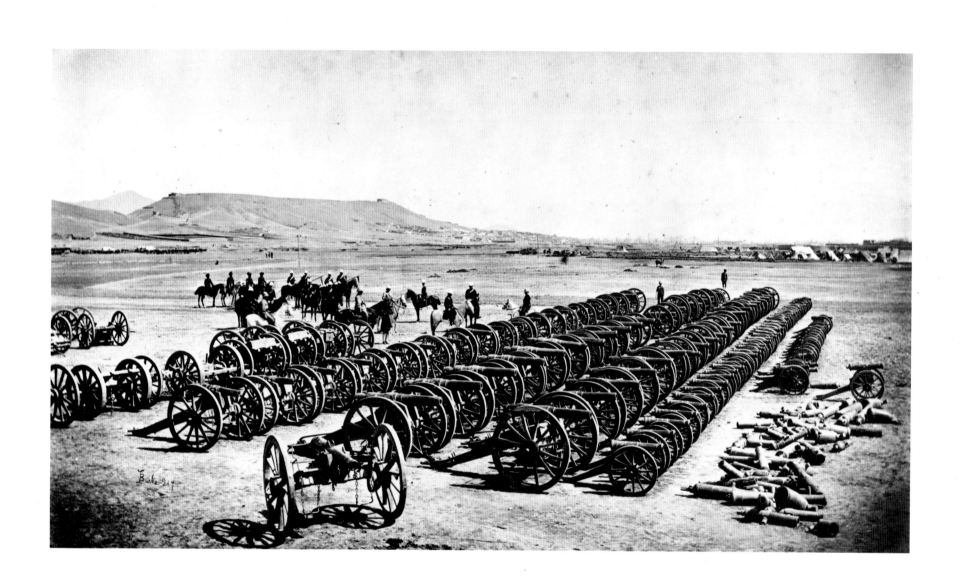

28.

JOHN C. H. GRABILL, American (dates unknown)
Villa of Brule, the Great Hostile Indian Camp on River Brule near Pine Ridge, S.D., 1891. Taken less than a month after the events at Wounded Knee, where had come to an end "all the long and tragic years of Indian resistance on the Western plains."
Albumen silver print
9¾ × 12¼ in.; 24. 7 × 31.1 cm
Library of Congress, Washington, D.C.

The tragedy of Wounded Knee, where two hundred Indian men, women, and children were massacred, further aggravated existing discontent on the Pine Ridge and Rosebud reservations, and precipitated an exodus of the Oglala and Brule Indians. Grabill's "Villa of Brule" was made up of some four thousand Indian fugitives seeking a better life outside the confines of the reservation.

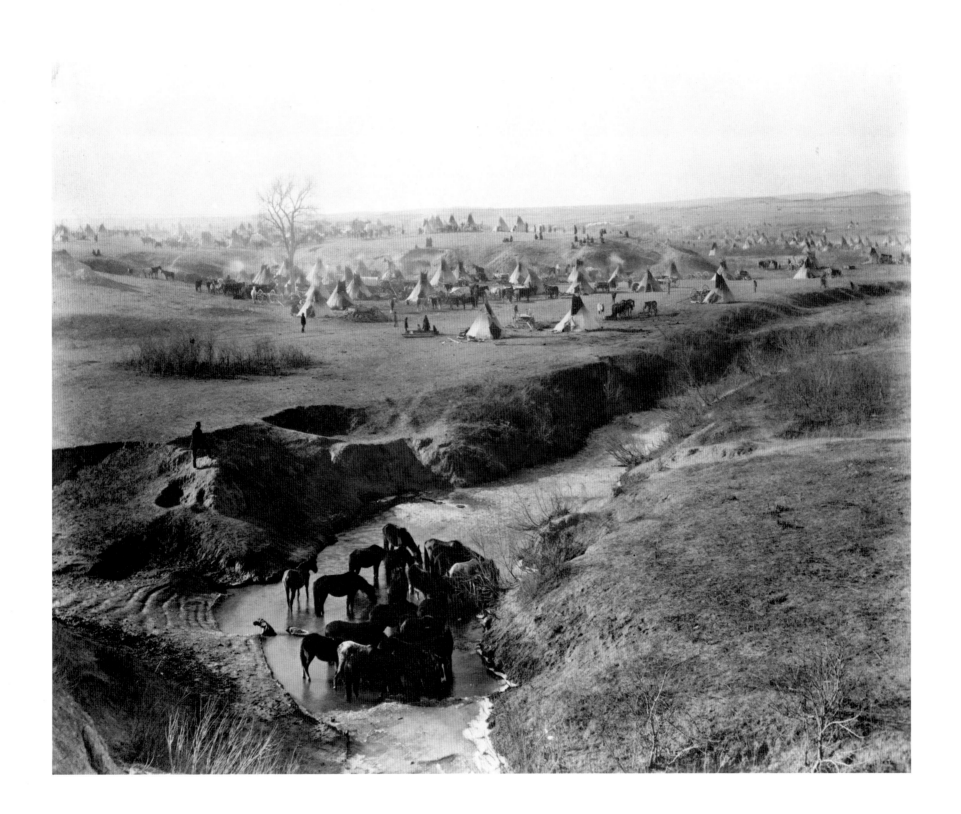

THE SINO-JAPANESE WAR, 1894–1895

Increased rivalry over supremacy in Korea, a Chinese dependency, led
to war between China and Japan. The Chinese forces were routed by
the Japanese, and China was forced to sign a humiliating peace treaty
that recognized Korea's independence and granted significant territo-
rial and commercial concessions to Japan.

29.

SUZUKI SHINICHI, Japanese (born 1835; death date unknown)
A Battalion of Farmer-Militia prior to its Departure for the Chinese Front, 1895
Sino-Japanese War of 1894–1895
Original medium unknown
[10¼ × 13⅛ in.; 26 × 33 cm]
Japan Professional Photographers Society

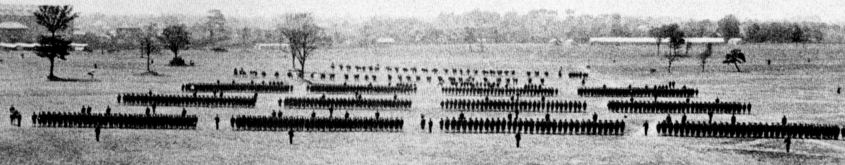

明治二十四年四月臨時第一師團歩兵第七聯隊屯兵大隊清國從軍征途中山東青島に於て撮影

THE SPANISH-AMERICAN WAR, 1898

The mysterious explosion on the U.S. battleship *Maine* in Havana
Harbor on February 15, 1898, with the loss of 272 officers and men,
transformed American sympathy for Cuba's struggle for independence
from Spain into a popular demand for armed intervention. The
United States declared war on Spain, and American forces invaded
Cuba, Spanish territories in the West Indies, and the Philippines.
Spain quickly sued for peace. The Treaty of Paris, signed in 1898,
freed Cuba, ceded Guam and Puerto Rico to the United States, and
transferred control of the Philipines to the United States for $20
million.

30.
PHOTOGRAPHER UNKNOWN
Battleship Maine, 1898
Spanish-American War
Gelatin silver print
6¼ × 9⅛ in.; 15.9 × 23.2 cm
Records of the Office of the Chief Signal Officer, 111-RB-5211
The National Archives, Washington, D.C.

31.
PHOTOGRAPHER UNKNOWN
Battleship Maine, 1898
Spanish-American War
Gelatin silver print
6¼ × 9⅛ in.; 15.9 × 23.2 cm
Records of the Office of the Chief Signal Officer, 111-RB-5212
The National Archives, Washington, D.C.

The *Maine*, a heavily armed battleship, was sent to Cuba to protect
American lives and property from unrest caused by the Cuban Revo-
lution. The ship was received in a friendly manner, and the unrest in
Havana subsided. However, on February 15, 1898, two explosions on
the *Maine* killed 272 officers and men and sank the ship. Americans
concluded that Spaniards were responsible and clamored for war. An
investigation following the explosion revealed that the cause was a
submarine mine, but no evidence was obtained for establishing re-
sponsibility. In 1911 the *Maine* was raised and a second investigation
took place, but no new information regarding responsibility was
discovered.

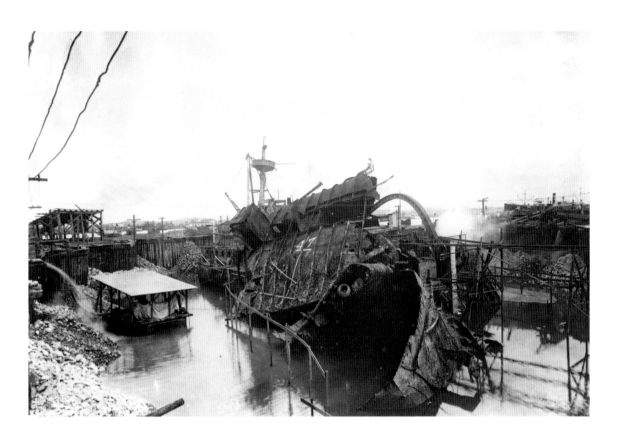

THE PHILIPPINE INSURRECTION, 1899–1901

When, in the aftermath of the Spanish-American War, the United States refused to grant immediate independence to the Philippines, an insurrection followed. Emilio Aguinaldo, a hero of the Philippine struggle for independence from Spain, proclaimed a republic and declared war on the United States. The insurrection was effectively ended by Aguinaldo's capture by American troops in 1901, but skirmishing continued for some time.

32.

PHOTOGRAPHER UNKNOWN
San Pedro Macati: Insurgent with Lower Part of Face and Right Shoulder Shot Away, Still Alive. March 13, 1899
Philippine Insurrection
Gelatin silver print
7⅜ × 9 ½ in.; 18.7 × 24.1 cm
Records of the Office of the Chief Signal Officer, 111-RB-1042
The National Archives, Washington, D.C.

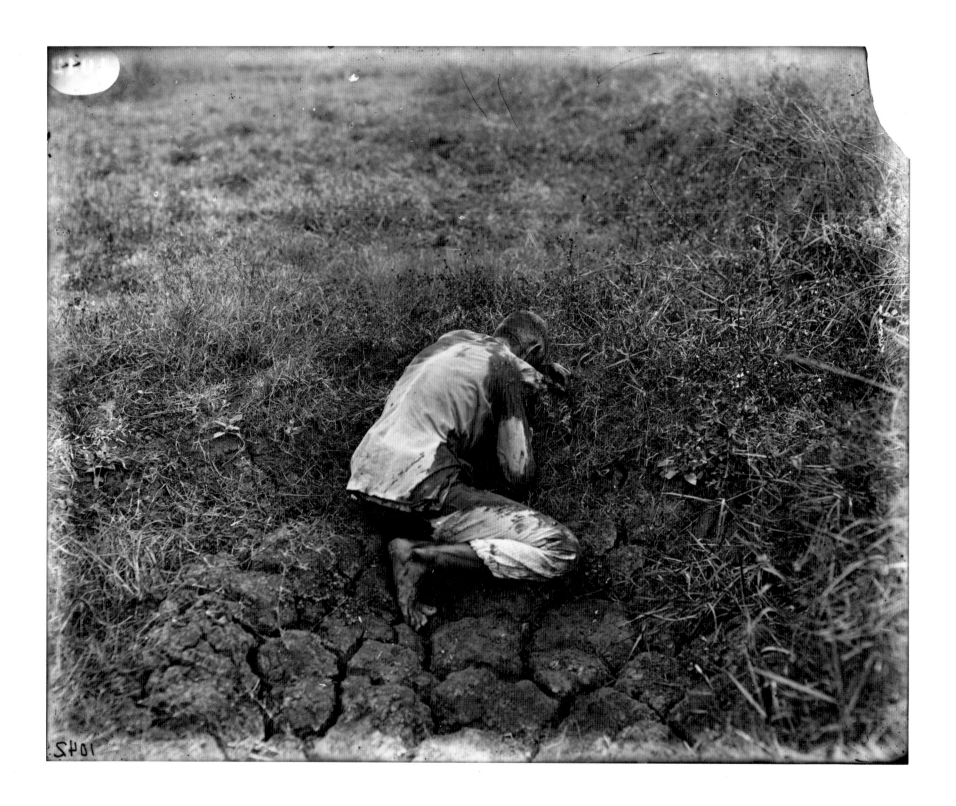

33.
PHOTOGRAPHER UNKNOWN
Private Toolman and His Collection of Curios, no date
Philippine Insurrection
Gelatin silver print
7½ × 8⅝ in.; 19 × 19.9 cm
Records of the Office of the Chief Signal Officer, 111-RB-2513
The National Archives, Washington, D.C.

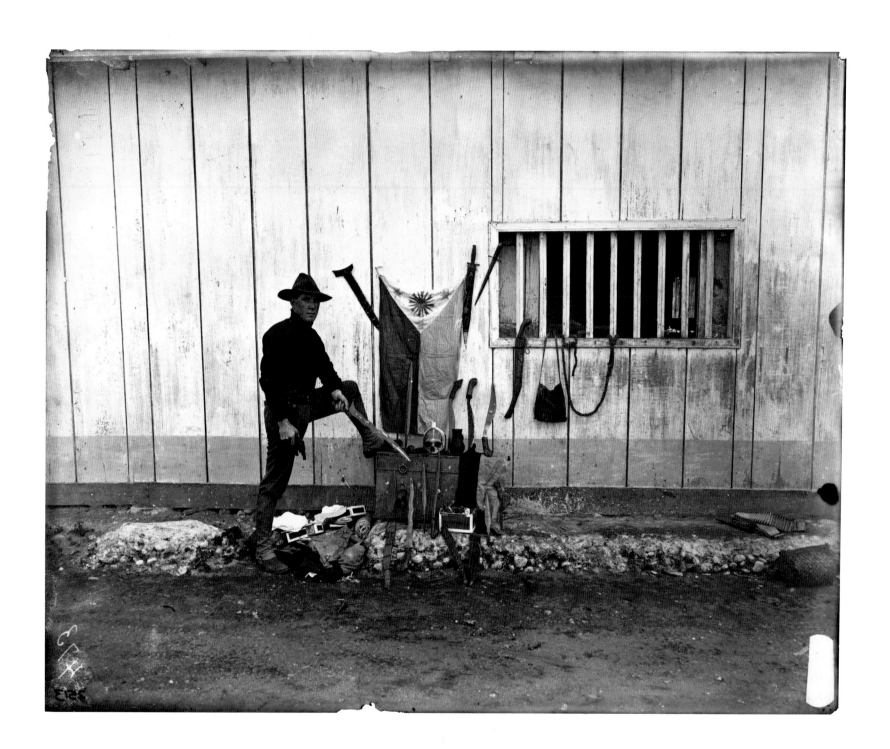

THE SECOND BOER WAR, 1899–1902

Decades of political and social tension between the Boers—the Afrikaans-speaking descendents of the original Dutch, German, and French Hugeunot settlers who had settled in South Africa—and the British, who had formally gained control of the Cape Colony in 1814, led to the Second Boer War. In 1899 the Boer States of the South African Republic and the Orange Free State declared war on Britain to obtain their suzerainty and to halt the flood of gold-hunting *uitlanders* (foreigners) into their territories. The Boers were superb guerilla warriors, but were eventually overwhelmed by the superior numbers of the British. A peace treaty was signed in 1902, bringing the whole of South Africa under the British crown.

34.

REINHOLD THIELE, German (dates unknown)
Canadians Seizing a Kopje at Sunnyside, 1900
Second Boer War
Gelatin silver print
9⅛ × 7⅛ in.; 23 × 18.1 cm
Gernsheim Collection
Harry Ransom Humanities Research Center, The University of Texas at Austin

This photograph shows the C Company of the Royal Canadian Regiment under Captain Barker storming a kopje (small hill). The officers tried to dress as much like privates as possible, because the un-uniformed Boer sharpshooters were known to prefer officers as targets. This shot was taken at Paardeberg, where there were more British casualties than on any other occasion during the war.

Reinhold Thiele was commissioned by *Graphic* to cover the Boer War. His coverage was described in *Photogram*, a contemporary periodical, as "more varied, more accurate, and more complete than anything previously attempted in the field of pictorial war correspondence Every phase of naval and military life . . . has been recorded, and probably no existing set of these subjects is so complete as Mr. Thiele's If war-time photography can be made a success, Reinhold Thiele is just the man to make it so." The goal of the war correspondents was to send home pictures that would raise the patriotic spirits of the British, many of whom were opposed to the war.

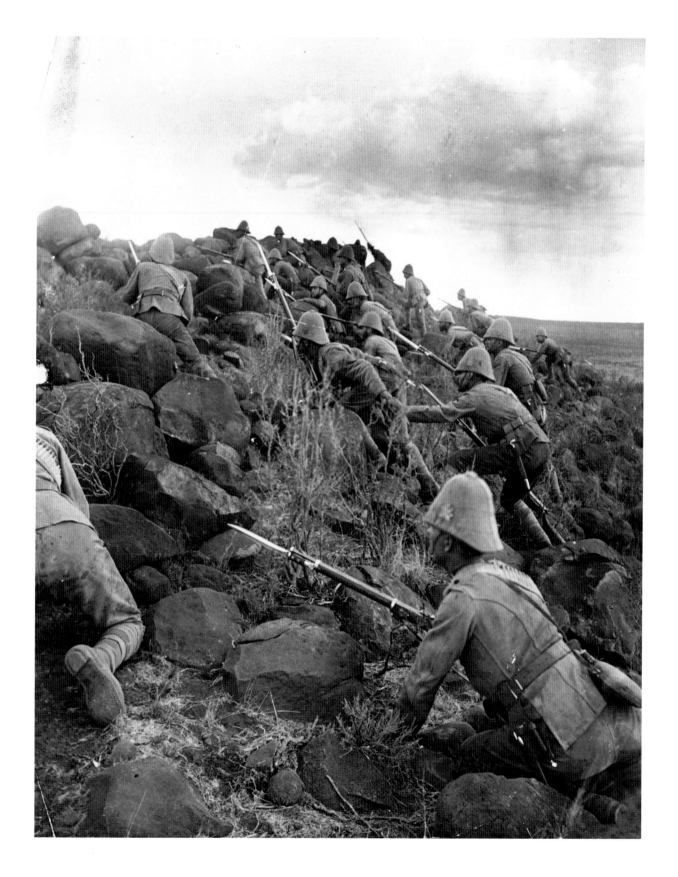

088704

Howard County Library
Big Spring, Texas 79720

The Boxer Rebellion, 1900

The Boxer Rebellion was a violent reaction against both European economic exploitation of China and the growing threat of Western influence to traditional Chinese culture and values. The rebellion erupted in 1900, when the Boxers, members of a fanatically xenophobic secret society, began to attack and kill Europeans and Chinese Christians and to destroy European-owned property. The Boxers were supported by the Dowager Empress, who wanted to restore China's independence, and were joined by the Chinese Imperial Army. The rebellion was suppressed by a multinational army of European, American, and Japanese troops, which took Peking, entered the Forbidden City, and occupied the Imperial Palace. The humiliating peace treaty that ensued guaranteed the continuing foreign domination of China and reduced the imperial authority to a nominal power that could not resist the liberalizing influences of the West, culminating in the Chinese Revolution of 1911.

35.

Photographer Unknown
How Li Hung Chang Deals with the Boxers, Canton Prison, China, c. 1900
Boxer Rebellion
Gelatin silver print
Stereograph
Keystone-Mast Collection
California Museum of Photography, University of California, Riverside

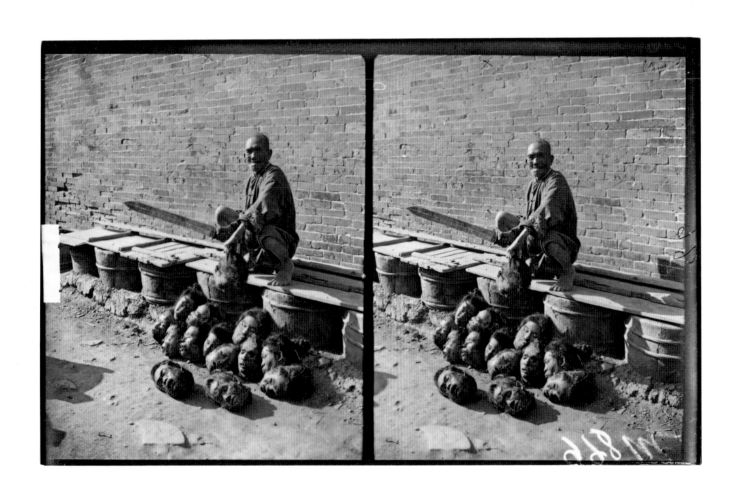

36.

PHOTOGRAPHER UNKNOWN
Soldier's Bed and Locker, Fort Wood, New York, December 1907
Gelatin silver print
6½ × 4⅝ in.; 16.5 × 11.7 cm
Records of the Office of the Chief Signal Officer, 111-RB-3584
The National Archives, Washington, D.C.

The Mexican Revolution of 1911

The seeds of the Mexican Revolution were sown during the dictatorship of Porfirio Díaz. Ruler of Mexico for over thirty years, Díaz had improved the country's economy, mainly to the benefit of the large landowners, bureaucrats, and foreign capitalists. In 1910 Francisco Madero, a liberal landowner, called for revolution. His popular movement overthrew the Díaz regime in 1911, but was unable to establish a stable government. The years following were marked by a series of violent struggles among the warring revolutionary groups, culminating in the accession to power of Venustiano Carranza in 1914. Stability was achieved in 1917, when a new constitution was adopted that recognized unions and redistributed land to the peasants.

37.

JAMES HENRY (JIMMY) HARE, American (born England; 1856–1946)
Watching the Revolution at Ciudad Juárez from El Paso on the American Side of the Rio Grande, 1911
Mexican Revolution
Gelatin silver print
8 × 10 in.; 20.3 × 25.4 cm
Photography Collection
Harry Ransom Humanities Research Center, The University of Texas at Austin

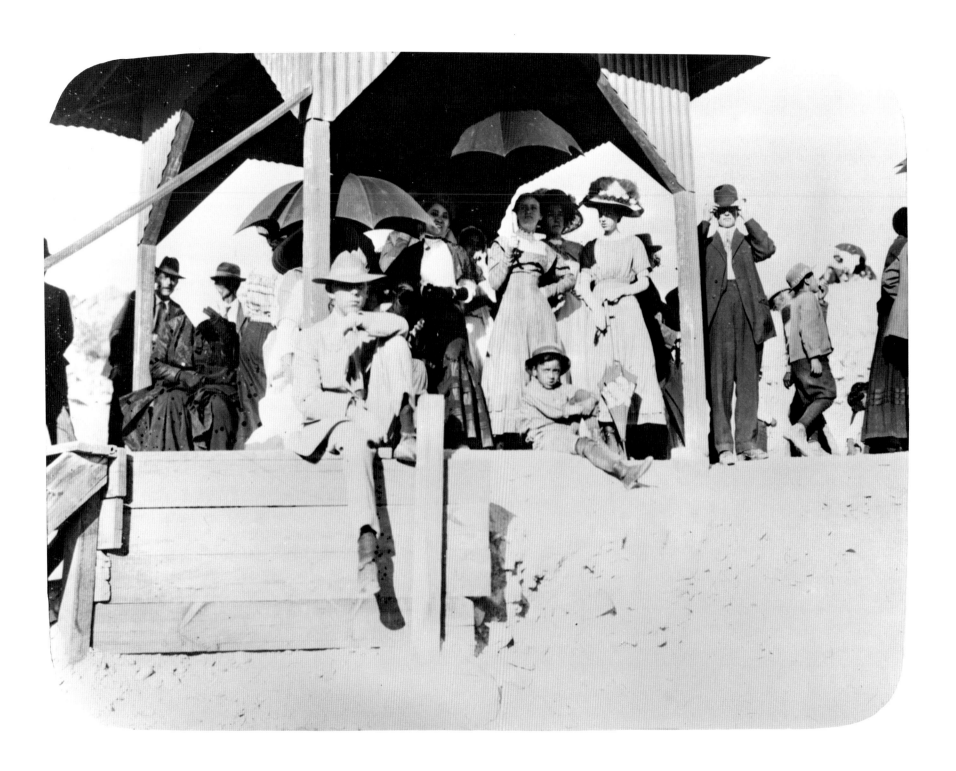

World War I, a global conflict involving thirty-two countries, began with a declaration of war by Austria-Hungary on Serbia. The fighting was the culmination of increased feelings of nationalism among European peoples, economic rivalries, arms races, and the alignment of the European powers into two mutually aggressive alliances. Before the armistice was signed on November 11, 1918, 65 million men would be mobilized into military service; 8.5 million soldiers would die in combat; over 12 million civilian deaths would result from military action, massacre, or starvation; the world's political, economic, and social institutions would be disrupted; and world political geography would be transformed.

On the battlefields of World War I, even more than in the American Civil War, frontal charges were made obsolete by modern weapons with overwhelming firepower. Warfare strategies had not kept up with war technology and, as a result, the conflict settled into a long, hard war of attrition fought from trenches extending from Switzerland to the English Channel. Poison gas, automobiles, tanks, dirigibles, and airplanes were among the technological advancements used to help break the stalemate; none of these innovations effectively countered the combination of the machine gun and barbed wire as defensive weapons. Eventually, the German armies became exhausted and asked for an armistice.

It is believed that the harshness of the demands made upon the defeated Central Powers, particularly Germany, under the terms of the five peace treaties that ended the war, set the stage for the even more devastating conflict of World War II.

38.

PHOTOGRAPHER UNKNOWN
[*Photographer Photographing Dead Horse*], c. 1915
World War I
Postcard
3½ × 5½ in.; 8.7 × 13.7 cm
Courtesy Hans Puttnies

In response to a letter soliciting information, Hans Puttnies, professor of art, Darmstadt, Germany, sent this photograph with the accompanying explanation:

> Personally I cannot share your belief in the moral power of war photographs, but this is not the time and the place to discuss my position. This is your show and I prefer to contribute to your preparation of it with a small gift to you from my collection. It is a postcard taken by a German amateur photographer about 1915 in a French village. It shows another amateur who is just exposing his roll film with a dead horse which was killed by the strike of shell fire. Why is he taking a picture of the creature? And why does his comrade portray him in doing so? If you look carefully over the image with a magnifying glass, you will find another dead horse on the roof behind the quiet soldier. I am sure it was only thrown there by the explosion to show our photographer how useless it is to fix a fragment of war: you can never show the truth of horror. So, alas, he rescued his brain in irony and pressed the button (May 5, 1984).

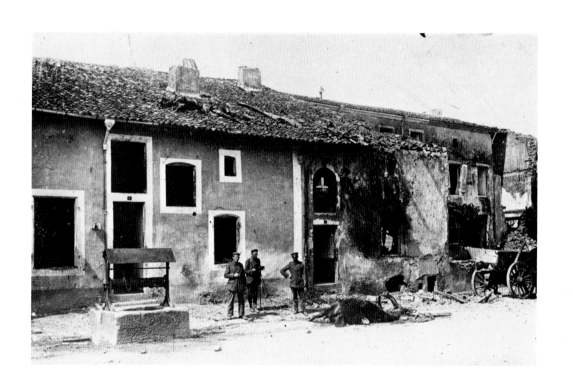

39.

AGUSTIN VICTOR CASASOLA, Mexican (1874–1938)
Fortino Samano Moments before His Execution, 1916
Mexican Revolution
Gelatin silver print
13⅝ × 8⅝ in.; 35.5 × 22.5 cm
Courtesy Prakapas Gallery, New York

Fortino Samano, a cruel and cool-headed rebel leader during the
Mexican Revolution, was killed by the Federal forces in 1916. He
became a famous figure because he stood before his executioners,
unblindfolded, and gave them the order to fire. He was so calm that
not even the long ash of his cigar hit the ground before he did.

40.

PHOTOGRAPHER UNKNOWN
Impression Made in the Ground at Billericay by Commander Falling from Burning Zeppelin, 1915
World War I
Gelatin silver print
Stereograph
Cliff Krainik Collection, Washington, D.C.

41.

PHOTOGRAPHER UNKNOWN
Impression on the Ground of a Member of a Zeppelin's Crew Who Fell when the Airship Was Destroyed, 1915
World War I
Gelatin silver print
[8 × 10 in.; 20.3 × 25.4 cm]
Imperial War Museum, London

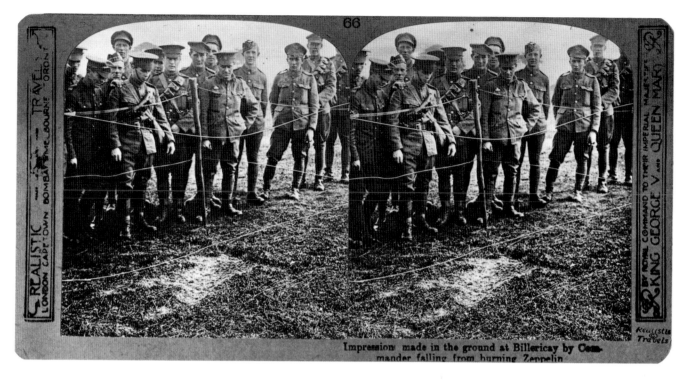

REALISTIC — TRAVEL — LONDON CAPE TOWN BOMBAY MELBOURNE TORONTO

66

BY ROYAL COMMAND TO THEIR IMPERIAL MAJESTIES KING GEORGE V AND QUEEN MARY

Realistic Travels

Impression made in the ground at Billericay by Commander falling from burning Zeppelin.

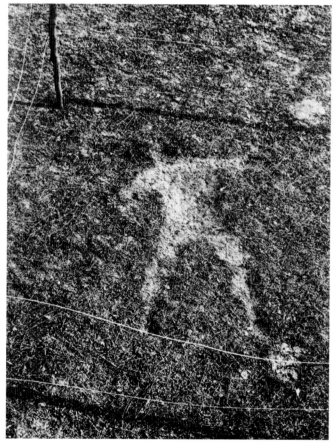

42.

PHOTOGRAPHER UNKNOWN
A Dead German outside His Dugout, Beaumont-Hamel, November 1916
World War I
Gelatin silver print
[11 × 14 in.; 27.9 × 35.6 cm]
Imperial War Museum, London

Much of World War I was fought from trenches. In *The Great War and Modern Memory*, Paul Fussell (1975) recalls Sassoon's observation that "when all is said and done . . . the war was mainly a matter of holes and ditches" (p. 41).

Fussell describes the troglodyte world of the trench scene: "There were normally three lines of trenches. The front-line trench was anywhere from fifty yards or so to a mile from its enemy counterpart. Several yards behind it was its support line. And several hundred yards behind that was the reserve line" (p. 41). It is estimated that the total length of Allied and Central Power trenches measured twenty-five thousand miles.

Fussell continues, "To be in the trenches was to experience an unreal, unforgettable enclosure and constraint, as well as a sense of being unoriented and lost. One saw two things only: the walls of an unlocalized, undifferentiated earth and the sky above As the visible theater of variety, the sky becomes all-important. It was the sight of the sky, almost alone, that had the power to persuade a man that he was not already lost in a common grave" (p. 51).

"Dead horses and dead men—and parts of both—were sometimes not buried for months and often simply became an element of parapets and trench walls. You could smell the front line before you could see it" (p. 49).

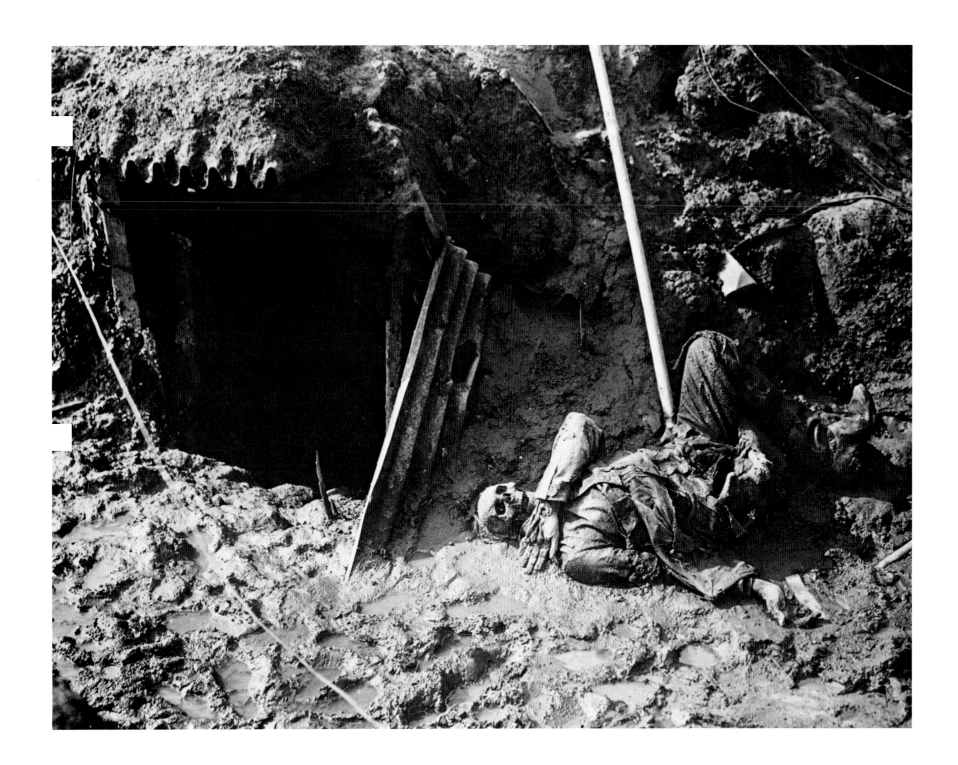

43.

PHOTOGRAPHER UNKNOWN
A Military Photographer at Work in a Trench on the Western Front, June 1917
World War I
Gelatin silver print
[11 × 14 in.; 27.9 × 35.6 cm]
Imperial War Museum, London

44.

PHOTOGRAPHER UNKNOWN
British Troops in the Thiepval Woods, Somme, and Ancre Area - British
Front Line Showing "Funk Holes," no date
World War I
Gelatin silver print
6 × 8 in.; 15.2 × 20.3 cm
Records of the War Department General and Special Staffs, 165-BO-1211
The National Archives, Washington, D.C.

45.

PHOTOGRAPHER UNKNOWN
[*Soldier with Rifle*], no date
World War I
Gelatin silver print
7³⁄₈ × 9⁵⁄₈ in.; 18.8 × 24.5 cm
The Bettmann Archive, New York

"A soldier is defending a comrade who has been wounded, and at the
same time obtaining a firmer support for his rifle."

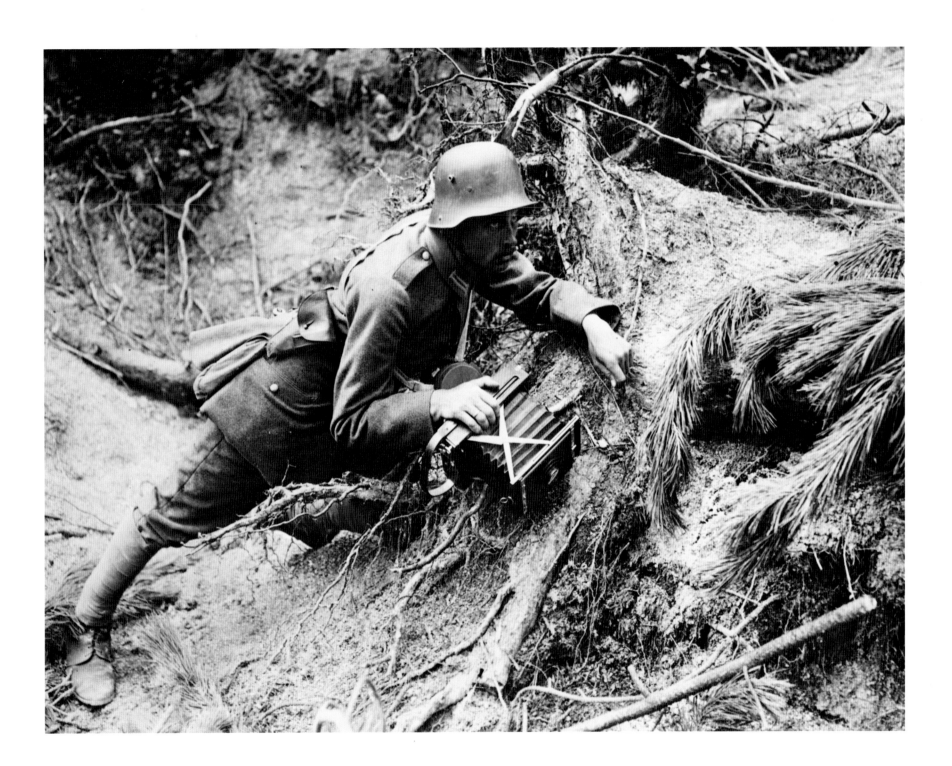

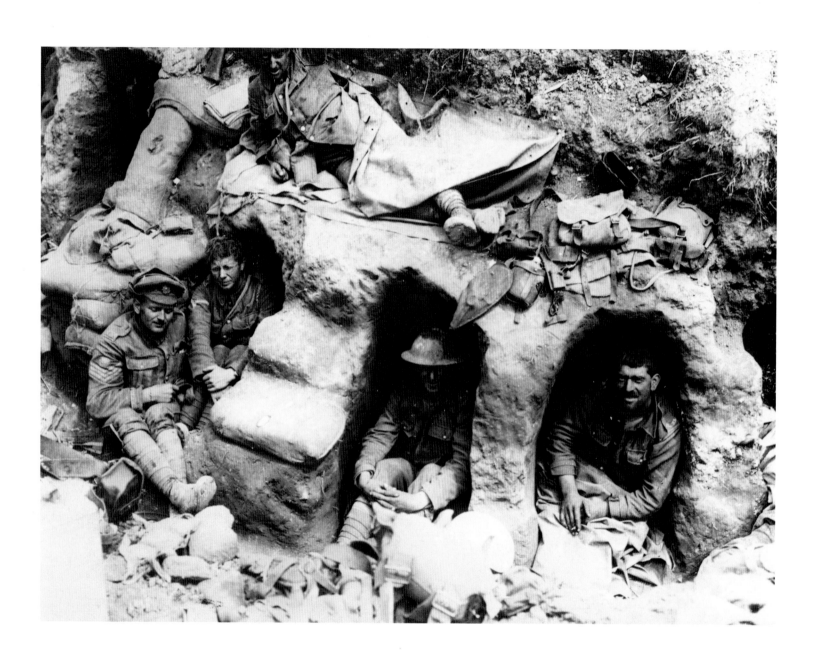

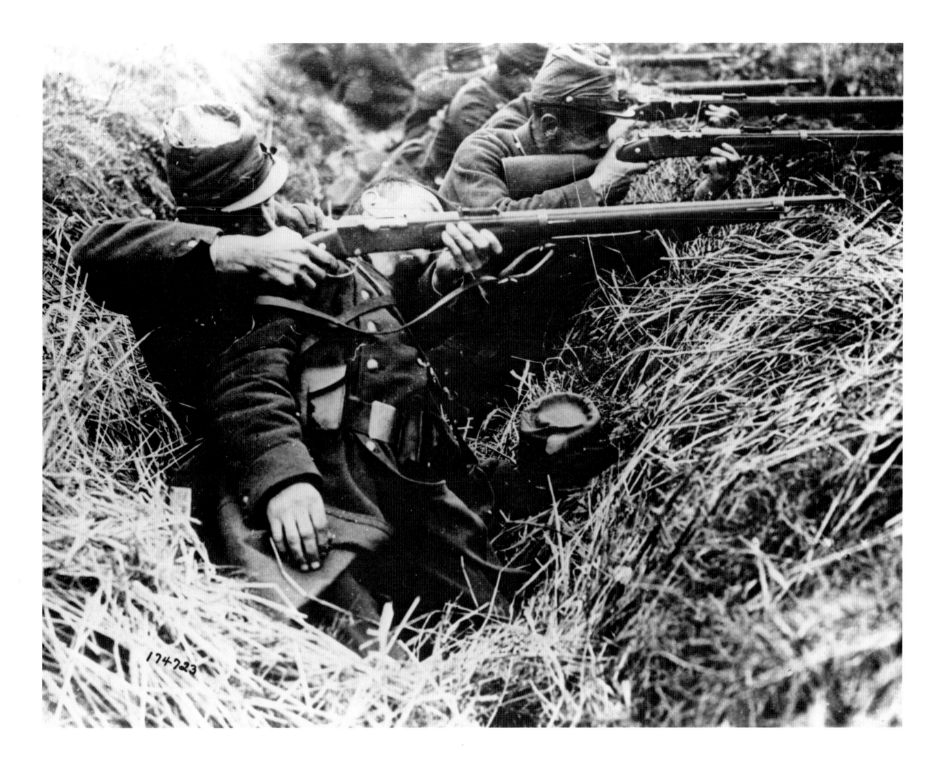

THE RUSSIAN REVOLUTION, 1917

The almost bloodless revolution of March 1917 led to the abdication
of Czar Nicholas II and the end of the three-hundred-year rule by the
Romanov dynasty. In November 1917 the Soviets took power with-
out significant opposition, and a new government was formed under
Lenin. The defeated survivors of the old regime waged war against
the Soviets for three years, with military aid from fourteen other
nations. Their attempt to create a counterrevolution failed, and the
Communist political system continued the process of reconstruction
with the "New Economic Policy" of 1921, surviving Lenin's death in
1924, and establishing what was to become a worldwide ideological
division.

46.
PHOTOGRAPHER UNKNOWN
Scene in Russian Revolution; July Troubles in Petrograd, 1917
Gelatin silver print
[11 × 14 in.; 27.9 × 35.6 cm]
Records of the War Department General and Special Staffs, 165-WW157D-1
The National Archives, Washington, D.C.

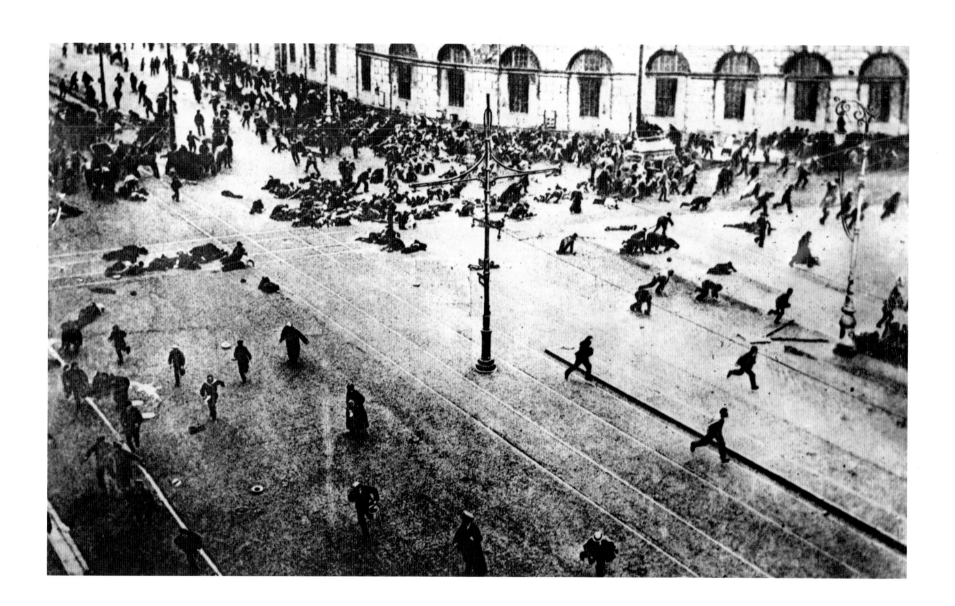

47.

Sgt. R. Sullivan, U.S. Signal Corps, American (dates unknown)
[*Corey Home for Convalescent Officers*], 1918
World War I
Gelatin silver print
6 × 8 in.; 15.2 × 20.3 cm
Records of the Office of the Chief Signal Officer, 111-SC-23400
The National Archives, Washington, D.C.

"Mrs. W. E. Corey playing cards with the wounded officers on the porch. Corey Home for Convalescent Officers, Château de Villegenis at Palaiseau, France. Mrs. Corey, or Mabelle Gilman, an actress, was the wife of the President of Carnegie Steel Co. and U. S. Steel. World War I. 9/18/18."

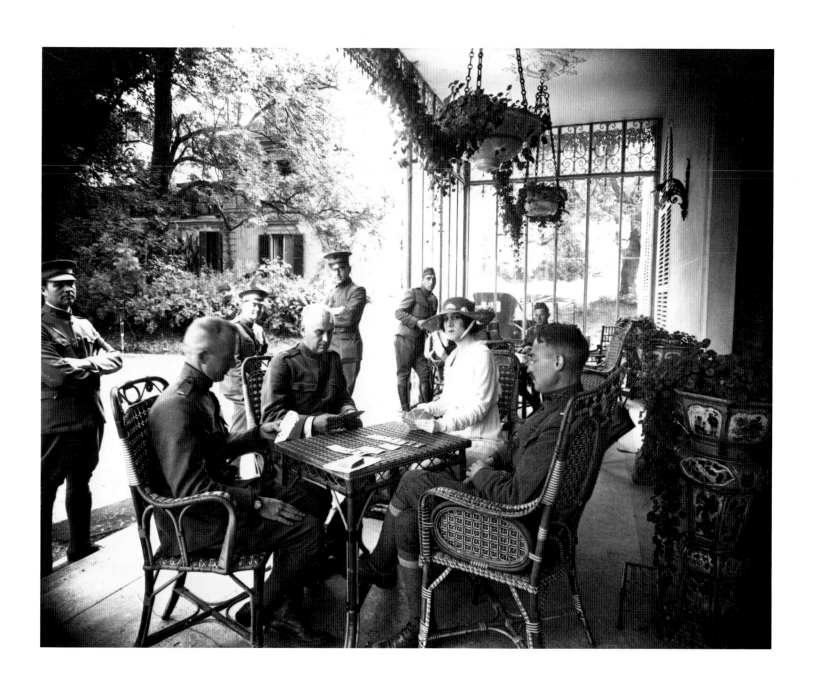

48.

PHOTOGRAPHER UNKNOWN
British tank captured and used by the Germans but blown up on one of our mines. Champagne, 1918 (from 1914-1919—La Guerre—150 Planches Artistiques de la Collection Personnelle du Commandant Tournassoud)
World War I
Photogravure
6⅛ × 8¾ in.; 15.5 × 22 cm
Courtesy John Ptak, Alexandria, Virginia

Commander Tournassoud was the director of the French Photographic and Cinematic Services along the French Front during World War I. Of the photographs taken under his command during this period, he chose 150 and published the collection in 1920 as a souvenir for World War I veterans.

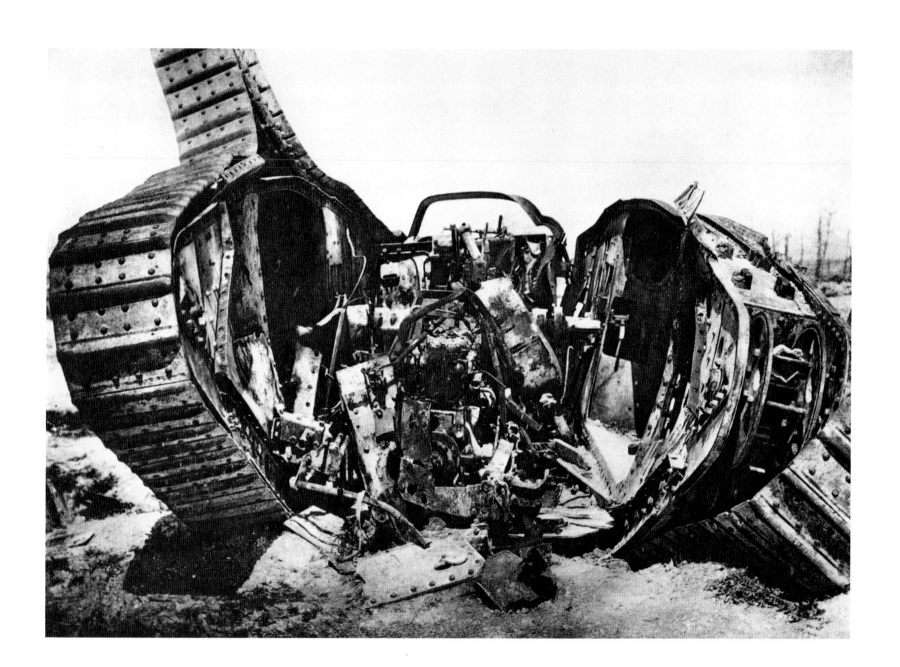

49.

Sgt. James L. McGarrigle, U.S. Signal Corps, American (dates unknown)
Outfitting Recruits at Camp Meade, Maryland, October 4, 1918
World War I
Gelatin silver print
6 × 8 in.; 15.2 × 20.3 cm
Records of the Office of the Chief Signal Officer, 111-SC-21000
The National Archives, Washington, D.C.

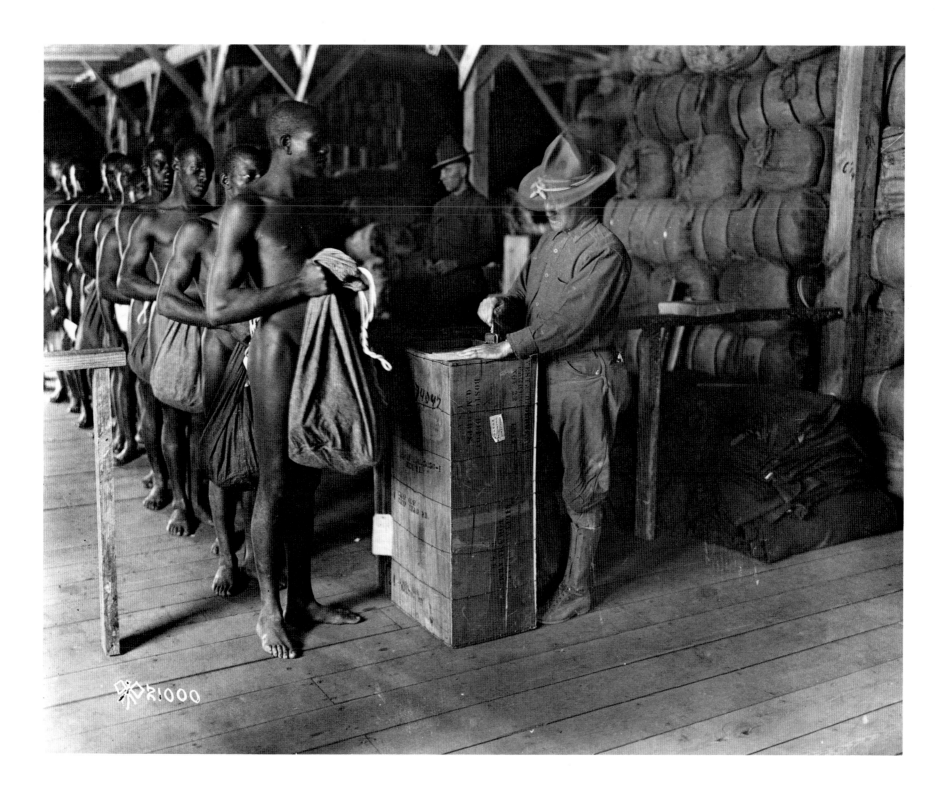

50.

ARTHUR S. MOLE, American (born England, 1889; death date unknown)
JOHN D. THOMAS, American (birth date unknown; died c. 1940)
The Human U.S. Shield, 1918
World War I
Gelatin silver print
13 × 10⅜ in.; 32.9 × 26.3 cm
The Minneapolis Institute of Arts, The Kate and Hall J. Peterson Fund

Following the choreographic directions of Arthur Mole and John
Thomas, thousands of soldiers would arrange themselves in forma-
tions of patriotic symbols such as the Liberty Bell, the Statue of
Liberty, and Woodrow Wilson's profile. Arthur Mole first began
using this technique of collective portraiture in a religious context,
when—as a member of a religious community—he photographed
large groups of his fellow church members assembled in the shape of
various religious symbols. With America's involvement in World War
I, Mole and Thomas devoted themselves to patriotic themes. *The
Human U.S. Shield*, the largest composition by Mole and Thomas,
was composed of thirty thousand men.

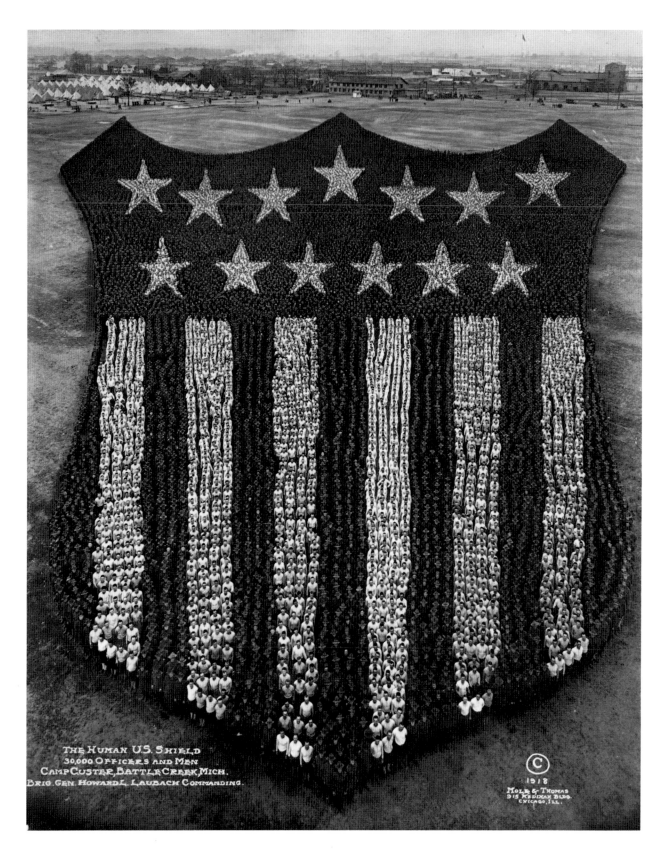

THE HUMAN U.S. SHIELD
30,000 OFFICERS AND MEN
CAMP CUSTER, BATTLE CREEK, MICH.
BRIG. GEN. HOWARD L. LAUBACH COMMANDING.

© 1918

MOLE & THOMAS
915 MEDINAH BLDG.
CHICAGO, ILL.

51.

Lt. Reid, U.S. Signal Corps, American (dates unknown)
*Physical Examination of Aviation Recruits at the Episcopal Hospital,
Washington, D.C., Bones, Joints, Flat Feet*, April 1918
World War I
Gelatin silver print
6 × 8 in.; 15.2 × 20.3 cm
Records of the Office of the Chief Signal Officer, 111-SC-8217
The National Archives, Washington, D.C.

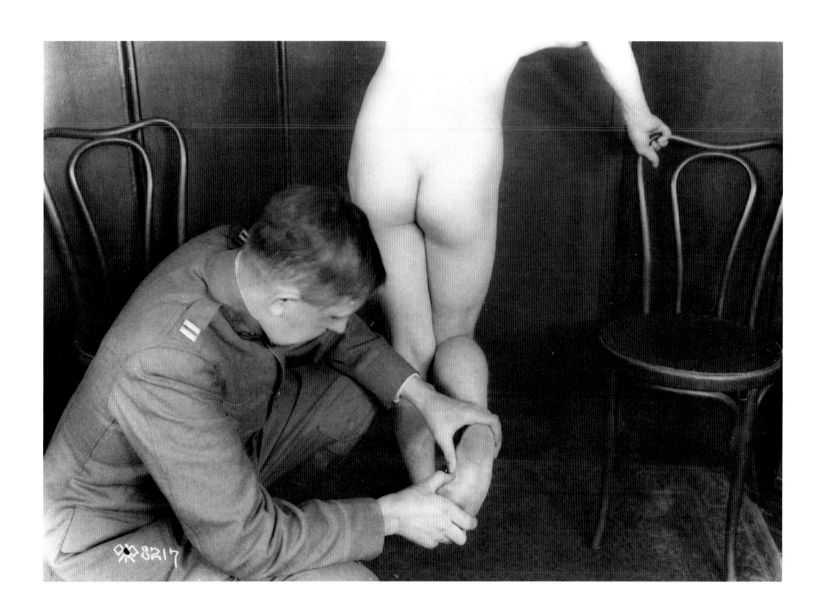

52.
Joseph J. Pennell, American (1866-1922)
Harvey Muenzenmayer, 1918
World War I
Gelatin silver print
7 × 5 in.; 17.8 × 12.7 cm
J. J. Pennell Collection, Kansas Collection
University of Kansas Libraries, Lawrence

"Pennell's photographic subjects were the people and events of Junction City, Kansas, and nearby Fort Riley Fort Riley, during the early part of Mr. Pennell's career, was a cavalry and light artillery post. During World War I, it was site of Camp Funston, one of the great military centers of the country" (from a promotional brochure published by University of Kansas Libraries).

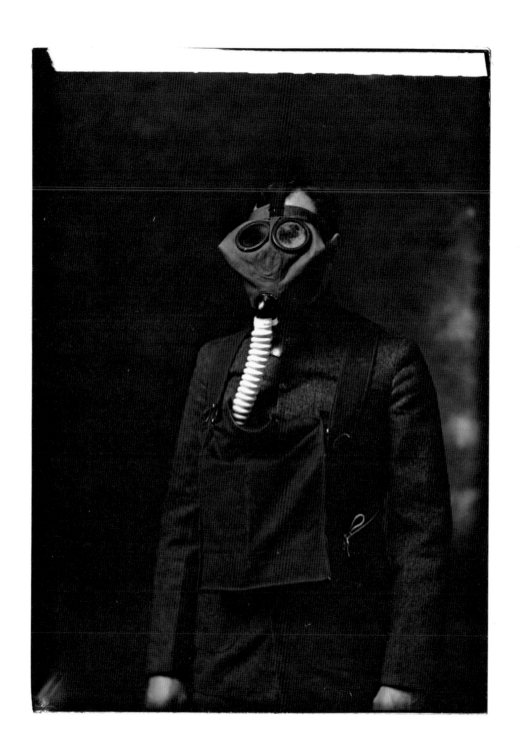

53.

PHOTOGRAPHER UNKNOWN
[*Officers Studying Enlarged Photograph*], c. 1919
World War I
Gelatin silver print
4⅝ × 6⅞ in.; 11.7 × 17.5 cm
Courtesy Paul Tillinghast, New York

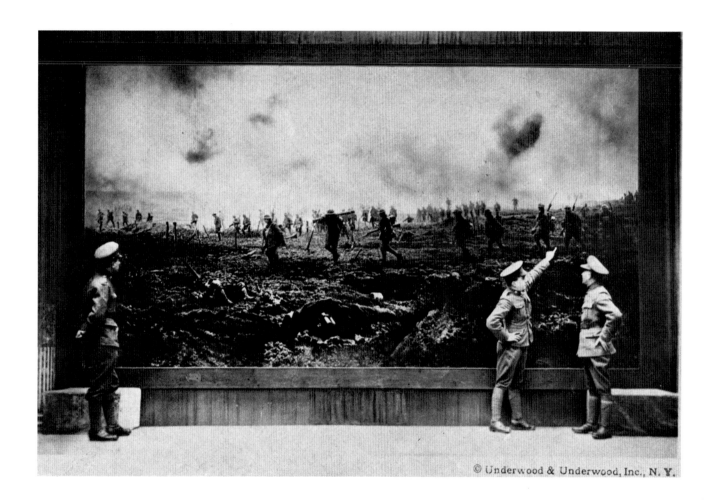

© Underwood & Underwood, Inc., N. Y.

54.

PHOTOGRAPHER UNKNOWN
Grand Place, Ypres, Belgium, no date
World War I
Gelatin silver print
5¾ × 7⅝ in.; 14.6 × 19.4 cm
Records of the War Department General and Special Staffs, 165-BO-1188
The National Archives, Washington, D.C.

"Ruins on the Grand Place, Ypres, Belgium, near the end of the Great War. The square tower at the left is the remains of the Cloth Hall, a masterpiece of Gothic architecture. The tall pointed tower is what remains of St. Martin's Cathedral" (Paul Fussell, letter to the author, December 10, 1984).

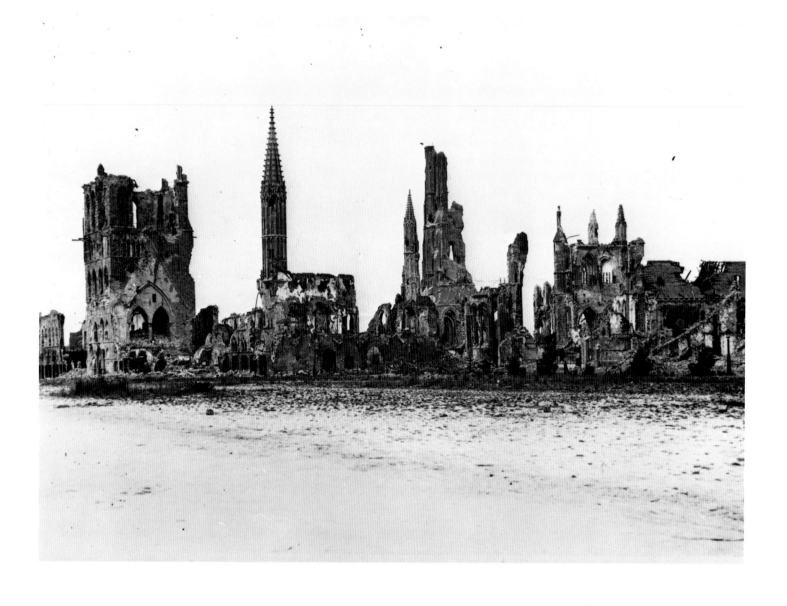

55.

LEWIS WICKES HINE, American (1874–1940)
[*Italian Soldier*], 1919
World War I
Gelatin silver print
3½ × 4½ in.; 8.9 × 11.4 cm
Library of Congress, Washington, D.C.

"American Red Cross Balkan Survey, Belgrade. Giuseppi Ugesi, Italian soldier in the 223rd infantry, was prisoner in an Austrian camp at Milowitz (reported to be very bad) for ten months. Now confined to his bed in the hospital with Tuberculosis. Jan. 25, 1919."

Lewis Hine is known as the "spiritual father of 'concerned photography' " (Gutman 1974); he used the medium to effect social reform. During World War I he joined the American Red Cross and recorded the plight of refugees from Italy and Serbia. He defined his objectives as a photographer: "There were two things I wanted to do. I wanted to show the things that had to be corrected; I wanted to show the things that had to be appreciated" (quoted in Gutman, in "Introduction" by Cornell Capa 1974, 5).

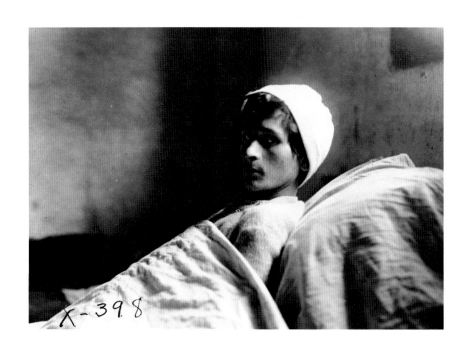

56.

WILFRED DUDLEY SMITHERS, American (born Mexico; 1895–1981)
[*First Cavalry's Camp at San Felipe, near Del Rio, Texas*], 1922
Gelatin silver print
8 × 10 in.; 20.3 × 25.4 cm
Photography Collection
Harry Ransom Humanities Research Center, The University of Texas at Austin

Working as a teamster on a pack-mule train in 1916, Wilfred Smithers saw the Rio Grande's Big Bend for the first time. During the next several decades he returned a number of times to witness and record the activity in the Big Bend. His eye-witness accounts described the U.S. Cavalry Patrol looking for "bandits" along the border, and also documented the smuggling and liquor-running operations that accompanied Prohibition. His experiences in the Big Bend resulted in a photographic record of the border way of life during the early twentieth century.

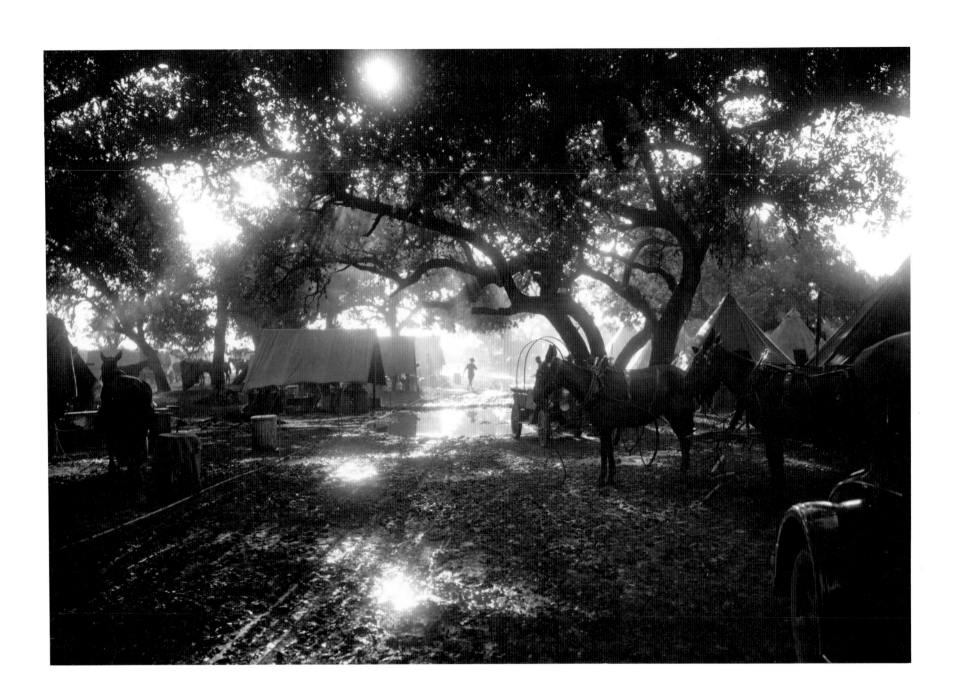

57.

WILFRED DUDLEY SMITHERS, American (born Mexico; 1895–1981)
Four Officers. Ojinaga, Mexico, 1926
Gelatin silver print
10 × 8 in.; 25.4 × 20.3 cm
Photography Collection
Harry Ransom Humanities Research Center, The University of Texas at Austin

"The four men in the photograph . . . in front of the Cuartel at Ojin-
aga, Mexico, were army officers but not in uniforms. Some of the
soldiers [were] from the Seventh Regiment The walls of the
Cuartel show scars of bullets of the 1914 battle between Gen. Villa's
forces and Federals of Huerta."

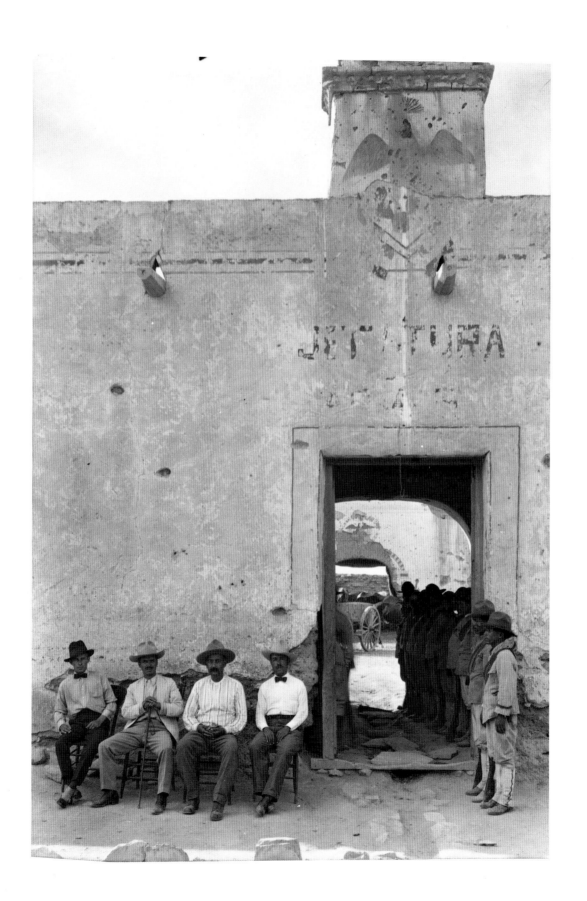

The origins of World War II, a conflict between the Allied Powers (led by Great Britain, France, the Soviet Union, and the United States) and the Axis Powers (led by Germany, Italy, and Japan) were rooted in the economic, social, and political chaos that characterized the European recovery from World War I. In Germany, Adolf Hitler rose to power partially in reaction to the punitive restrictions and losses mandated by the treaties ending World War I. In Italy, Benito Mussolini became premier on a pledge to restore national pride and prosperity. Dictatorships in Europe were further fueled by the threat of Communist movements and the worldwide depression. Pursuing a policy of military aggression, Hitler invaded Poland in 1939, resulting in a declaration of war by Britain and France. Initially, the Axis Powers had the military advantage over their opponents. In 1942, however, the tide turned when the Axis Powers were confronted with the combined forces of the United States, the Soviet Union, Great Britain, and resistance fighters from conquered nations.

What began as a localized conflict in Eastern Europe grew to be the most expansive and destructive war of all time. World War II was fought in Europe, Asia, Africa, and the Pacific Islands. The loss of human lives, military and civilian, is estimated at 45 million, including six million Jews, victims of Hitler's liquidation program, and others who died in Nazi death camps. Total property damage amounted to approximately $231 billion, and the total cost of the war exceeded $1 trillion. Technological innovations changed the nature of combat: the airplane became an important weapon both on land and sea; the first guided missiles used in combat were introduced by Germany; and the atomic bombs dropped by the United States on Japan ushered in the age of nuclear warfare.

58.

PHOTOGRAPHER UNKNOWN
After the Night Blitz at Coventry, November 16, 1940
World War II
Gelatin silver print
9½ × 7⅜ in.; 24.1 × 18.7 cm
The Photo Source-Fox, London

59.

PHOTOGRAPHER UNKNOWN
After the Night Blitz at Coventry, November 16, 1940
World War II
Gelatin silver print
9⅜ × 7⅜ in.; 23.8 × 18.7 cm
The Photo Source-Fox, London

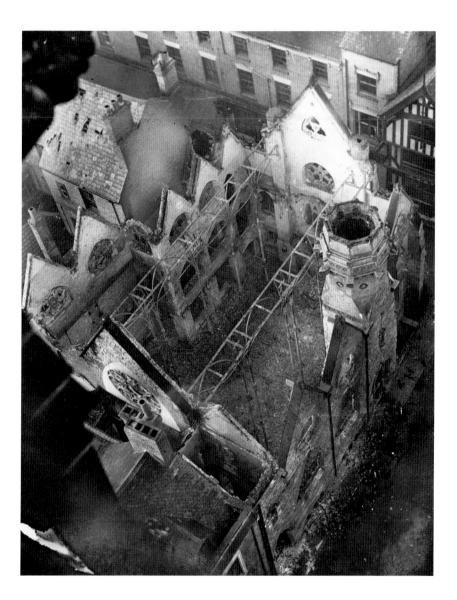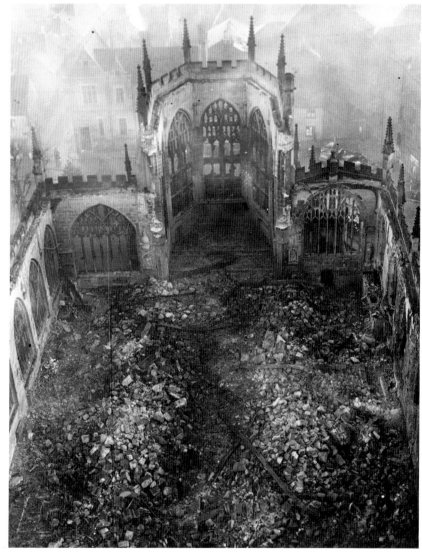

60.

SERGUEI STRUNNIKOV, Soviet (dates unknown)
Zoya Kosmodemyanskaya, "Tania," A Partisan Tortured by Fascists, December 1941
World War II
Gelatin silver print
17⅝ × 23½ in.; 44.7 × 59.7 cm
Courtesy Union of Journalists of the USSR

Zoya Kosmodemyanskaya was a partisan who was captured by the
Germans during World War II. Although she was brutally tortured
and hanged, she refused to reveal any information—including her real
name. She was known only as "Tania." To honor her memory, the
village Kosmodemyanskoye in the Majayskiy Region near Moscow
was named after this heroic figure, who was awarded the title "Hero
of the Soviet Union," the highest military award of the USSR.

"World War II is a constant presence in contemporary Soviet life.
Russians call it 'the Great Patriotic War'; reminders of it and memor-
ials to it are everywhere" (Kaiser and Kaiser 1980, 140).

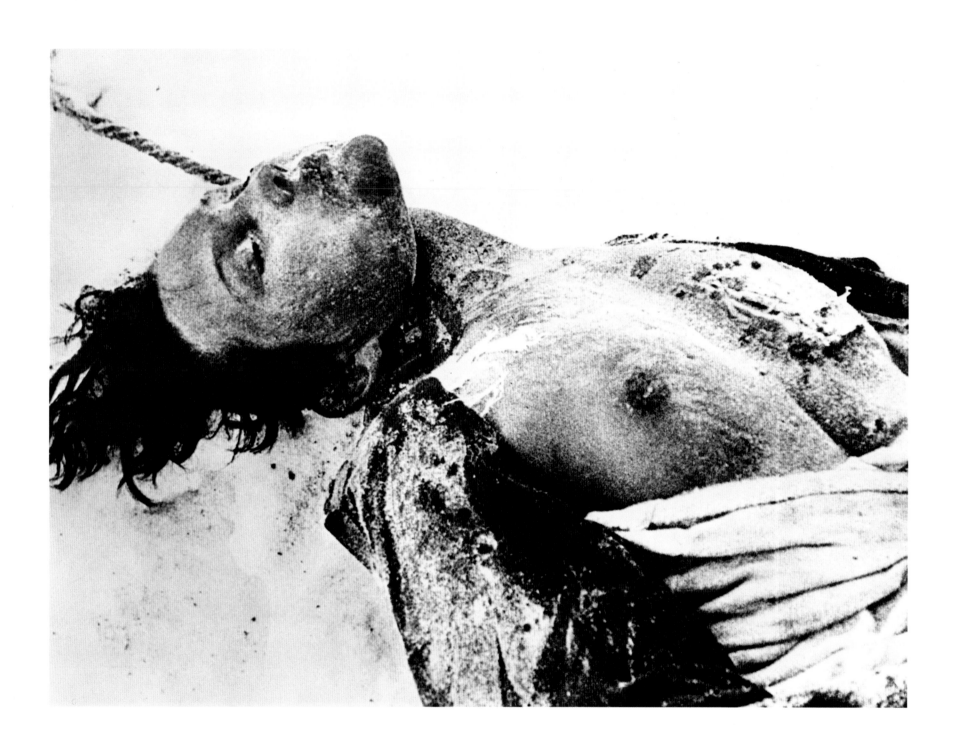

61.

DMITRI BALTERMANTS, Soviet (born 1912)
Attacking the Enemy, 1941
World War II
Gelatin silver print
6¾ × 10 in.; 17 × 25.5 cm
Citizen Exchange Council, New York

From 1934 to 1938 Dmitri Baltermants was a photo-reporter with the Red Army for *Izvestia* and *Na Razgrom Vagara*. He is best known for his World War II trench reportage of the Russian Front. Baltermants was a pacifist before and after the war, and his photographs often communicate his pacifist leanings.

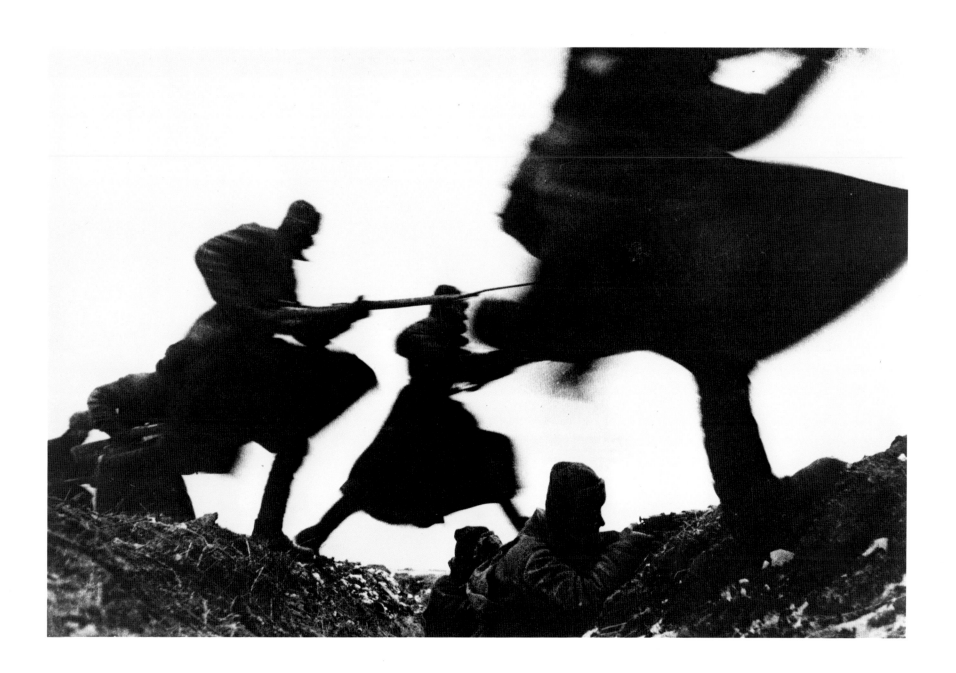

62.

Hanns Hubmann, German (born 1910)
Sowjetunion, 1941
World War II
Gelatin silver print
9 × 6⅞ in.; 22.8 × 17.5 cm
Courtesy Benteler Galleries, Houston, Texas

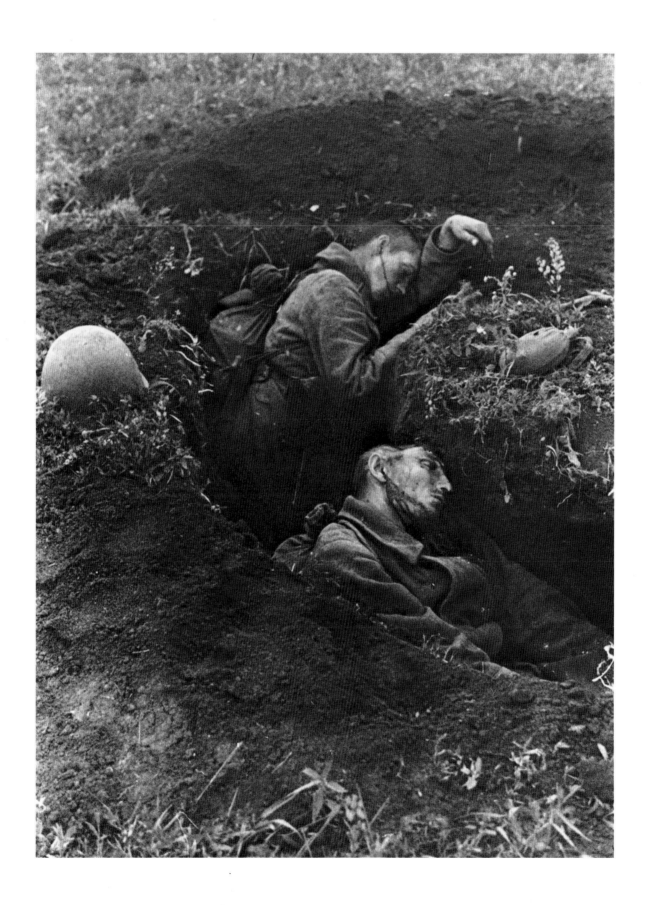

63.

EDWARD CLARK, American (born 1911)
Soldiers on Leave, Nashville, Tenn., 1941
World War II
Gelatin silver print
9 × 13 in.; 22.8 × 32 cm
Courtesy the Photographer

64.

KELSO DALY, American (dates unknown)
Pearl Harbor Inhabitant Watches Bombing by Japanese Planes, 1941
World War II
Gelatin silver print
[11 × 14 in.; 27.9 × 35.6 cm]
Kelso Daly, LIFE Magazine, © 1942, 1970, Time Inc.

65.

Dmitri Baltermants, Soviet (born 1912)
Grief, Kerch, 1942
World War II
Gelatin silver print
7 × 8¼ in.; 18 × 21 cm
Citizen Exchange Council, New York

Baltermants was on his way to another assignment when he was stopped by a confrontation between the Soviet and German armies in 1942. *Grief* is one of a series of photographs he took of the aftermath of a Nazi massacre of one hundred and seventy-six thousand civilians in Kerch, a Crimean town.

Of the estimated 45 million deaths resulting from World War II, approximately 20 million were Soviet citizens.

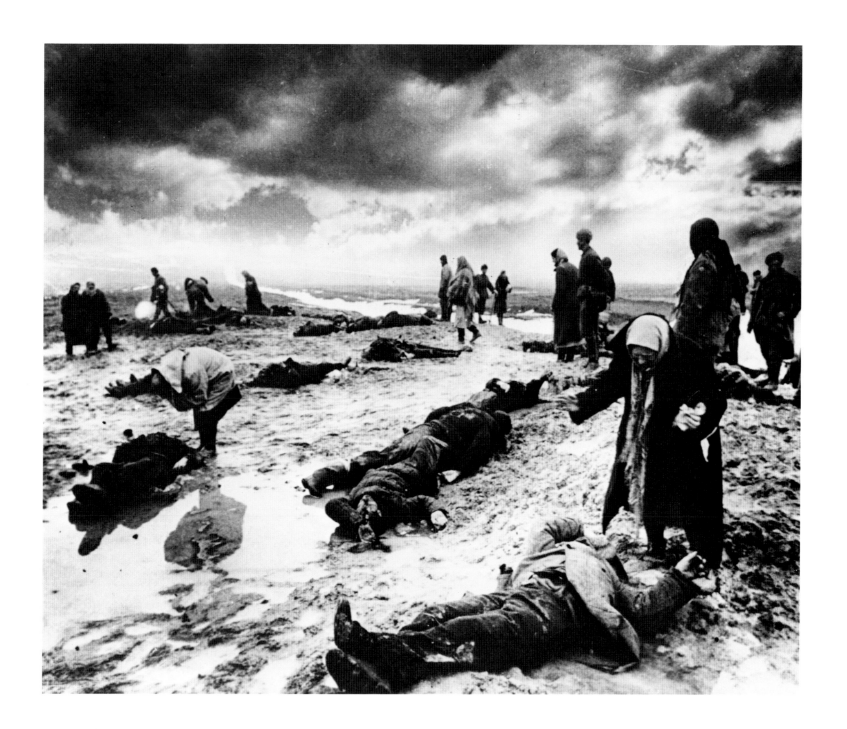

66.

PHOTOGRAPHER UNKNOWN
[*Aircraft Recognition Room*], no date
World War II
Gelatin silver print
6 × 6 in.; 15.2 × 15.2 cm
Black Star

"The officer, a commercial artist in peacetime, points out distinguishing features of a model. The girls are sitting in the aircraft recognition room. England, World War II."

67.

DMITRI KESSEL, American (born Russia, 1902)
Navy Air Cadets and Their Training Instructor, 1942
World War II
Gelatin silver print
[20 × 16 in.; 50.8 × 40.6 cm]
Dmitri Kessel, LIFE Magazine, © Time Inc.

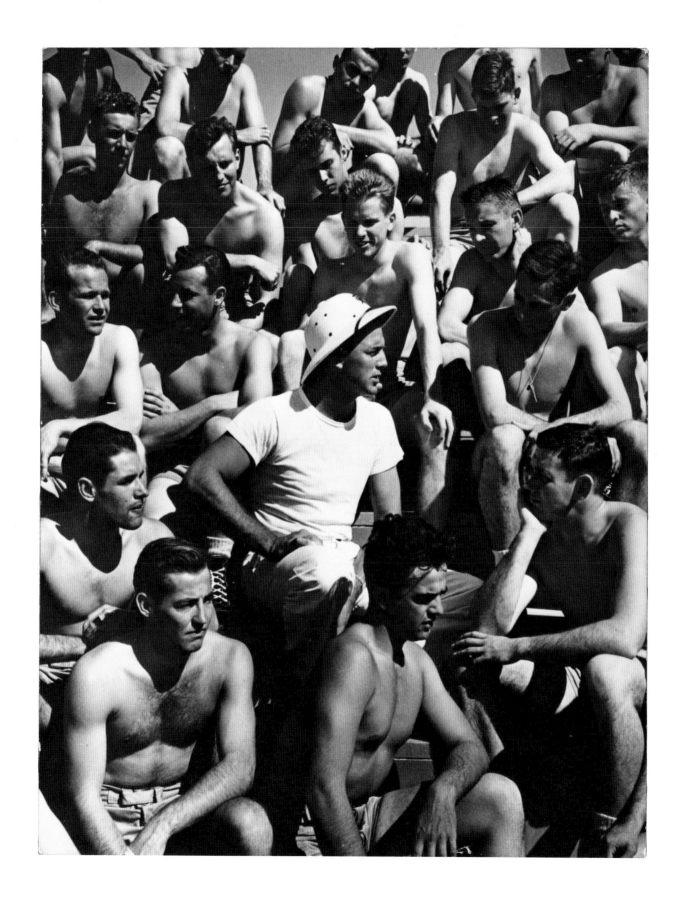

68.

JACK DELANO, American (born Russia, 1914)
Air Service Command. Early Morning Mass Calisthenics. Daniel Field,
Georgia. July 1943
World War II
Gelatin silver print
[16 × 20 in.; 40.6 × 50.8 cm]
Library of Congress, Washington, D.C.

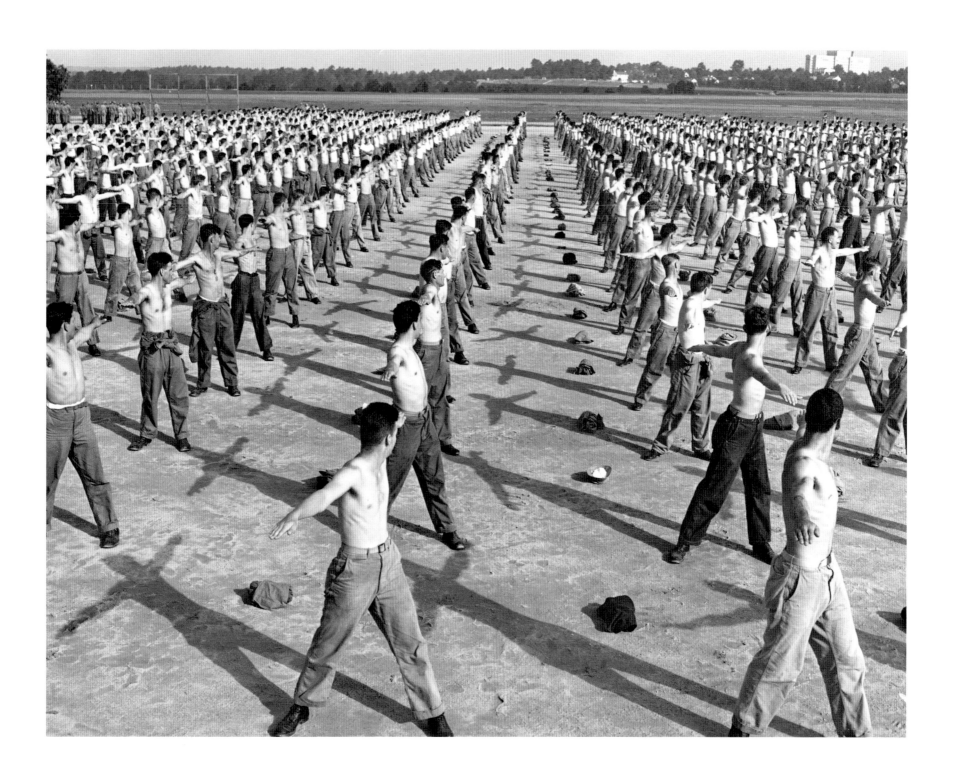

69.
PHOTOGRAPHER UNKNOWN
"Cub 12" Aerographers Enlisted Men Unit (on Benika, the Russell Islands,
sixty miles from Guadalcanal), 1943
World War II
Gelatin silver print
4½ × 6½ in; 11.6 × 16.5 cm
Courtesy George Bridgman, Richmond, Virginia

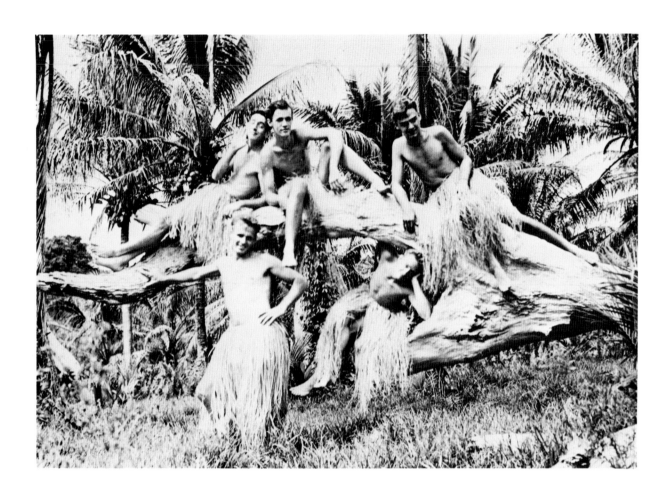

70.

PHOTOGRAPHER UNKNOWN/U. S. Air Force
[*S/Sgt. Joe Louis, Italy*], no date
World War II
Gelatin silver print
[10½ x 13½ in.; 26.5 x 34.2 cm]
U.S. Department of Defense, Washington, D.C.

"S/Sgt. Joe Louis and Troop give a hearty answer to chow call while visiting a heavy bomber base in Italy. Joe waited until all the combat crews had returned from their day's mission over Germany before he put his act in a hastily built ring. Then he put on a complete show sparring a few rounds, refereeing a few bouts and acting as general master of ceremonies. There's something about a combat zone that gives everybody an appetite and the heavy champ and his gang are no exception."

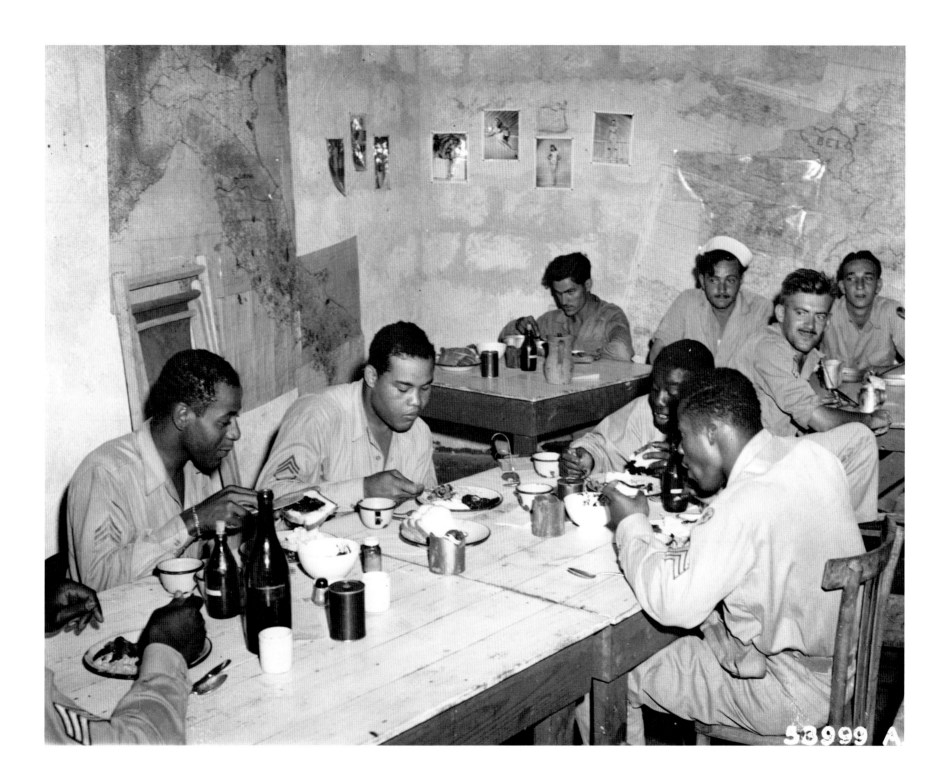

71.
MAX ALPERT, Soviet (1899–1980)
Battalion Commander Gives Forward Command, no date
World War II
Gelatin silver print
19⅛ × 22 in.; 48.6 × 55.9 cm
Courtesy Union of Journalists of the USSR

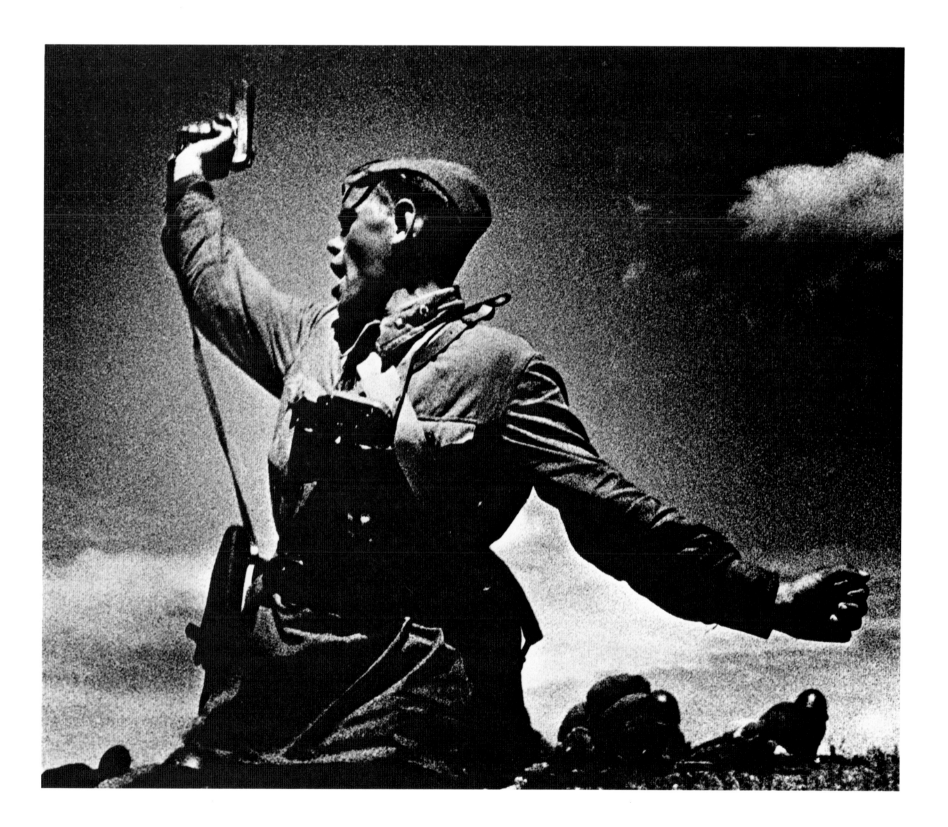

72.
EMMANUEL EVZERIKHIN, Soviet (dates unknown)
Fight to the Death, Battle of Kursk, 1943
World War II
Gelatin silver print
22 × 19 ¼ in.; 55.8 × 48.5 cm
Courtesy Union of Journalists of the USSR

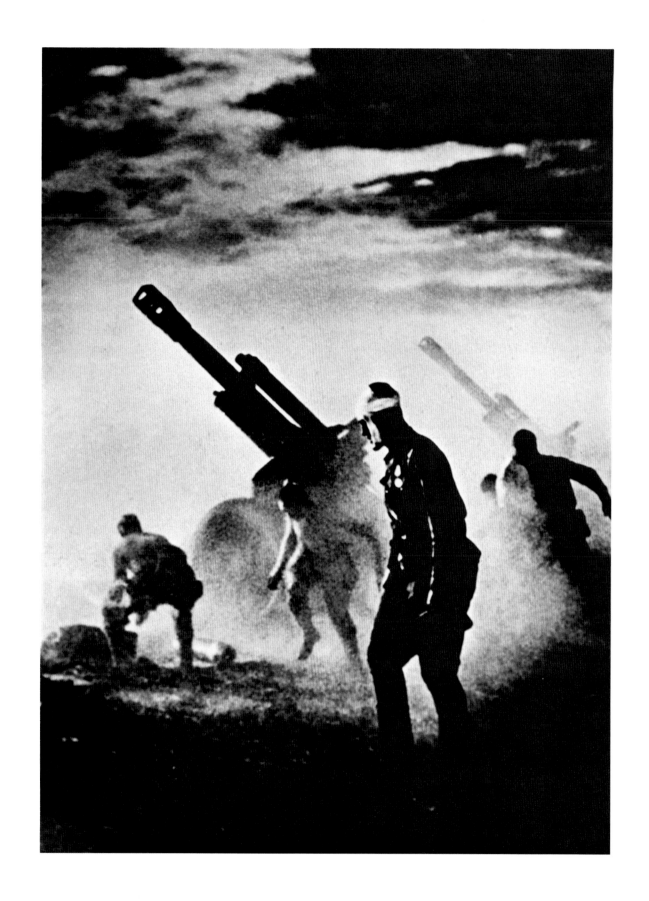

73.

PHOTOGRAPHER UNKNOWN
[*Destroyed Flying Fortress*], no date
World War II
Gelatin silver print
8 × 10 in.; 20.3 × 25.4 cm
Records of the Office of War Information, 208-YE-142
The National Archives, Washington, D.C.

"Cannon fire from a Messerschmidt chopped off the wing of the Fortress just below me on that raid on Berlin. I didn't see any parachutes open. Not many got home. There were more than 1,300 heavies and at least 850 Mustangs and Thunderbolts along on this raid and we made hash out of 7 fields for jet-propelled aircraft just outside Berlin. We set a new record—April 10 it was—by destroying 305 German planes in one day. We lost 10 bombers and 4 fighters."

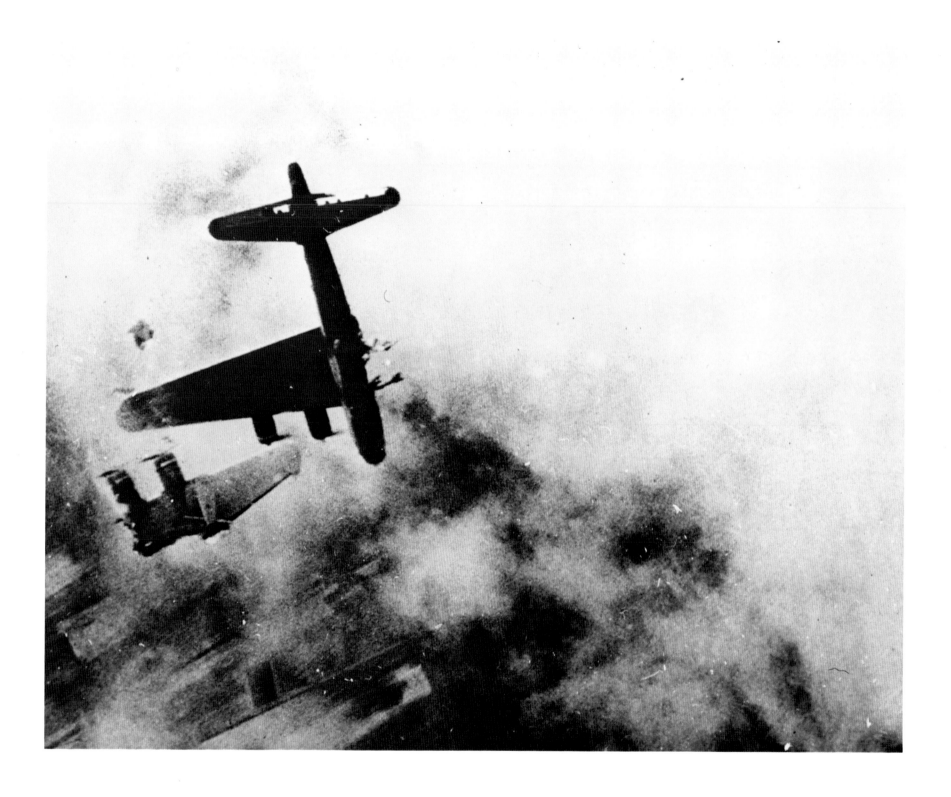

74.

PHOTOGRAPHER UNKNOWN
Fight to the Bitter End, 1943
World War II
Gelatin silver print
12¼ × 10⅛ in; 31.2 × 25.7 cm
Courtesy Japan Professional Photographers Society

This is a composite photograph made from originals by Kanamaru Shigene, first displayed as a billboard in 1943.

75.

PHOTOGRAPHER UNKNOWN
Tokyo Billboard, 1943
World War II
Gelatin silver print
[13¾ × 10⅞ in.; 34.9 × 27.7 cm]
Courtesy Asahi Shimbun, Tokyo

Japanese troops charge into battle across the huge billboard of a Tokyo theater in 1943. The billboard bears the slogan, "We won't stop shooting."

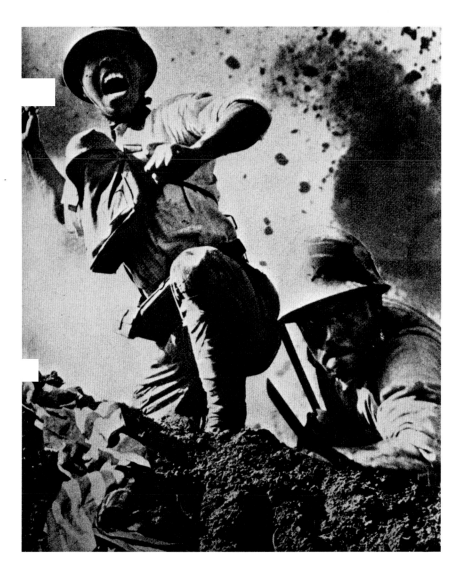

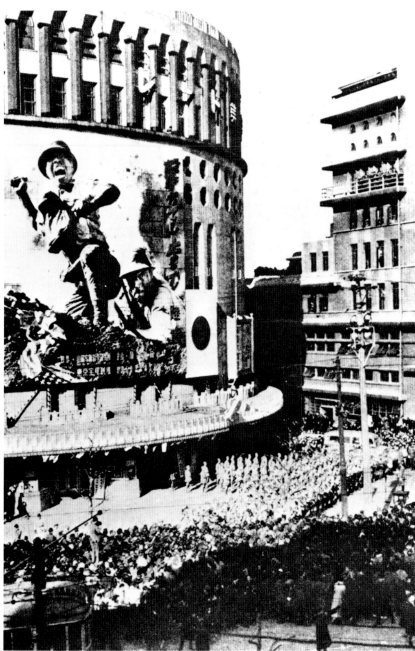

76.
WOLF STRACHE, German (born 1910)
Berlin, Kurfurstendamm—After a Bomb Attack, November 1943
World War II
Gelatin silver print
12 × 8⅝ in.; 30.2 × 21.9 cm
Courtesy Benteler Galleries, Houston, Texas

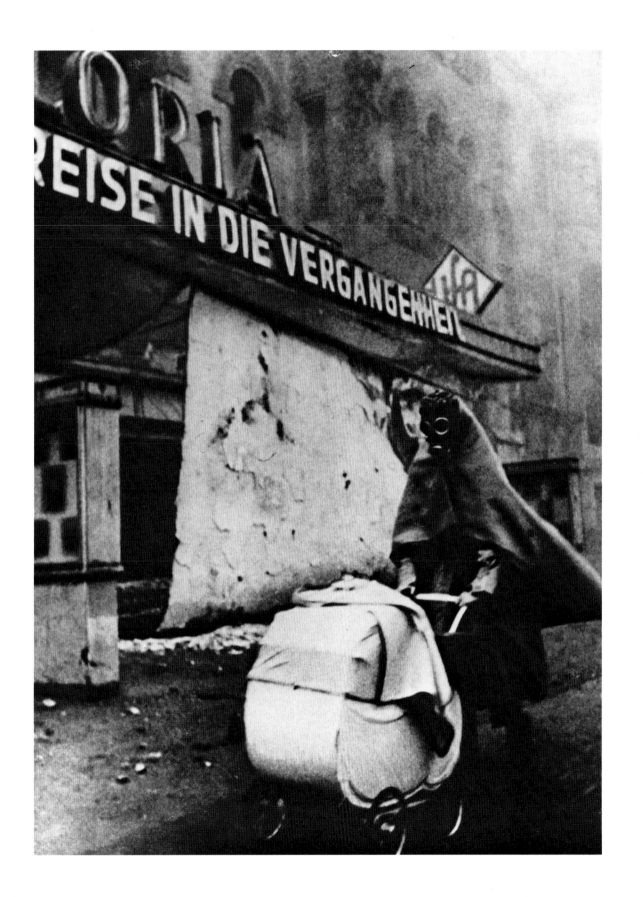

77.

Hansel Mieth, American (born Germany, 1909)
Japanese Relocation Center—Oriental Style Apartment, 1943
World War II
Gelatin silver print
[16 × 20 in.; 40.6 × 50.8 cm]
Hansel Mieth, LIFE Magazine, © Time Inc.

Amidst strong antioriental racism at the outbreak of World War II,
President Franklin D. Roosevelt signed Executive Order 9066 on
February 19, 1942, authorizing the evacuation of Japanese-Americans
from the West Coast. One hundred and twenty-seven thousand Japa-
nese-Americans were rounded up and shipped inland to isolated bar-
racks cities. All but two of the camps were situated in barren desert
country. Each family was assigned a one-room apartment measuring
twenty by twenty-five feet. This photograph shows a typical camp
dwelling, decorated with great care to make it more livable.

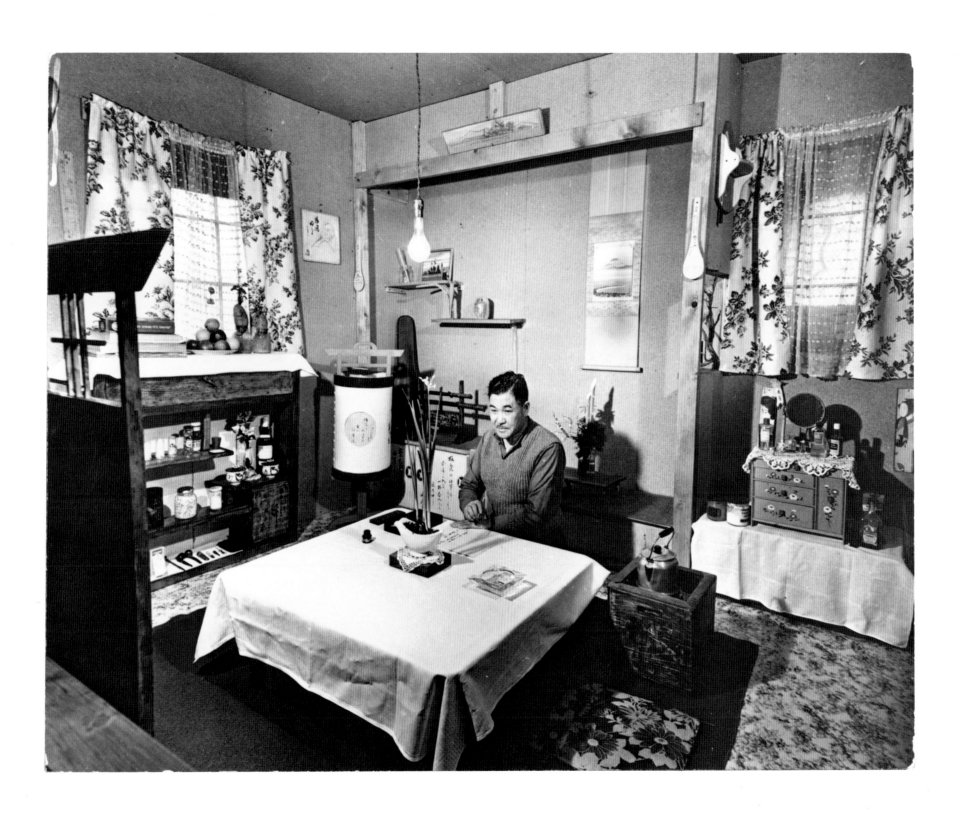

78.

CHARLES FENNO JACOBS, American (1904–1975)
U.S. Navy pilots relax and enjoy feminine companionship, sports and entertainment at Chris Holmes Rest Home, maintained on Hawaii for pilots on leave from combat. March 1944
World War II
Gelatin silver print
16 × 16 in.; 40.6 × 40.6 cm
General Records of the Department of the Navy, 1798–1947, 80-G-475095
The National Archives, Washington, D.C.

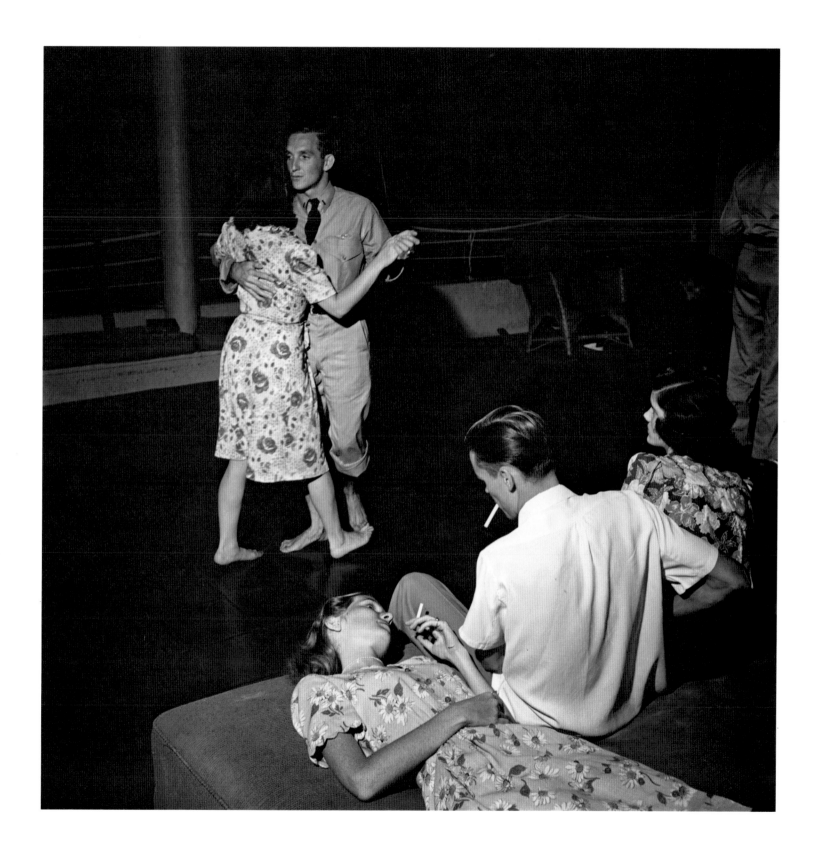

79.

Constance Stuart Larrabee, American (born England, 1914)
Collaborator, St. Tropez, South France, August 27, 1944
World War II
Gelatin silver print
12 × 12 in.; 30.5 × 30.5 cm
Courtesy the Photographer

"This morning went to St. Tropez in a battalion Jeep. Discovered it was D-Day for seven women in St. Tropez who had associated with the enemy. The local barber was shaving their heads. An effective reprisal for collaborating with German soldiers. Their heads shaven, clutching their hair in their arms, they were paraded through the streets to the delight of loyal villagers and the children. The crowd cheered as I climbed on the hood of a car to get these shots" (from Larrabee's published diary, *Jeep Trek*, 1946).

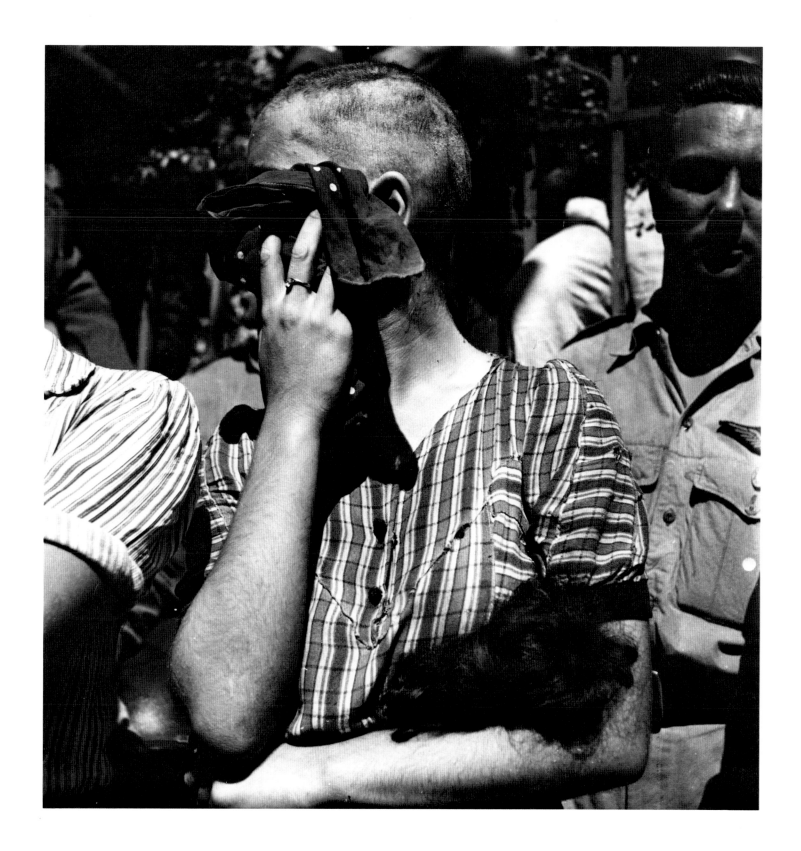

80.

Carl Mydans, American (born 1907)
Execution of Unfaithful French Youth, Grenoble, France, August 1944
World War II
Gelatin silver print
20 × 16 in.; 50.8 × 40.6 cm
Carl Mydans, LIFE Magazine © Time Inc.

The boys' eyes darted and their bodies tensed. It was as though all had been too swiftly done and there had been no time for them to realize how short the road from court to stake.

I followed them to the stakes as the cries from the crowds rose higher and higher. The boys' hands were shaking. And I saw that mine were also. What, among men, is more frightening than the cry for death which rises from the crowd? . . .

I tried to hold my camera steady as I stepped up to them, one by one. I was not in good control. But each in his turn surprised me: for as each saw the camera coming in toward him, his body straightened and he threw back his shoulders and a look of courage came into his face. Inexplicably, that last picture gave strength to the condemned men (Mydans 1959, 175–176).

Carl Mydans worked as a war correspondent for Life magazine, covering the Russo-Finnish Winter War, World War II in Europe and the Pacific, the Korean War, and the war in Vietnam. He and Shelley Mydans wrote *The Violent Peace: A Report on Wars in the Postwar World* (1968), in which they suggest the importance of war photography: "We cannot hope to control what we do not understand, nor to confront our adversary, war, with our eyes averted" (p. VI).

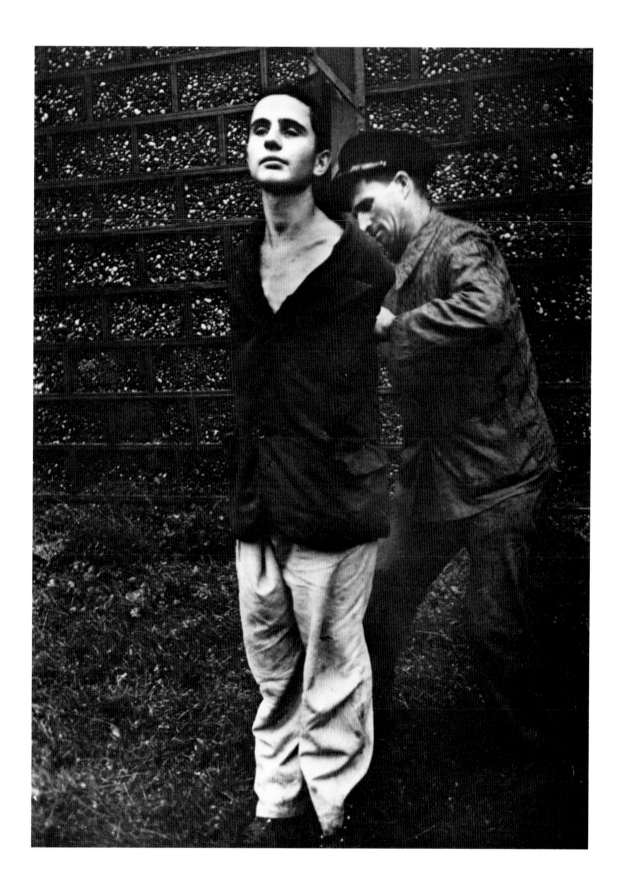

81.

PHOTOGRAPHER UNKNOWN
[*Nazi Death Chamber in Paris*], no date
World War II
Gelatin silver print
[16 × 20 in.; 40.6 × 50.8 cm]
Records of the Office of War Information, 208-AA-128H-4
The National Archives, Washington, D.C.

"French policemen and members of the French Forces of the Interior examine the bullet-chipped posts where French hostages were executed by the Germans. The blindfolds which covered the eyes of the victims are draped over the posts. New posts for use when a set became too splintered for further use are propped up against the wall of the execution hall. The torture chambers were found in a building after the liberation of the French capital August 25, 1944. Formerly a rifle range, it was converted into a fireproof and soundproof structure where prisoners were either burned alive or tied to these posts and shot. The Germans first lashed their victims to a grille like a wire fence which was electrified but not enough to kill."

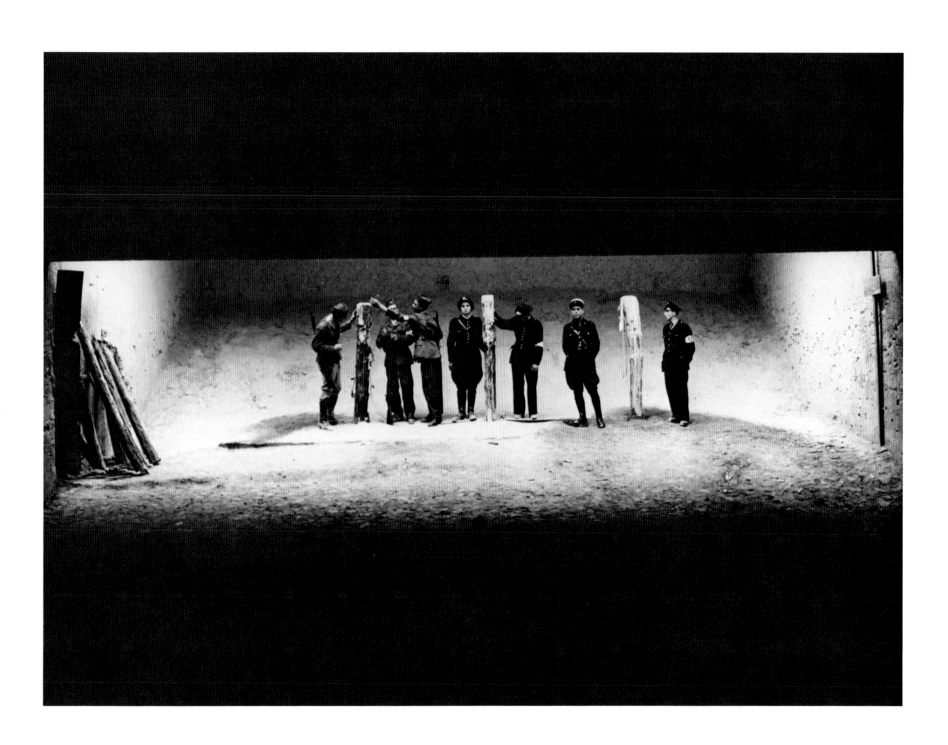

82.

HIMES, U.S. Army, American (dates unknown)
[*Bullets' Impact*], 1944
World War II
Gelatin silver print
6⅞ × 9¼ in.; 17.5 × 23.5 cm
U.S. Department of Defense, Washington, D.C.

"Photo taken at the instant bullets from a French firing squad hit a Frenchman who collaborated with the Germans. This execution took place in Rennes, France. The collaborator is falling as the rope which held him to the stake flies free, severed by bullets, and splinters fill the air. 11/21/44."

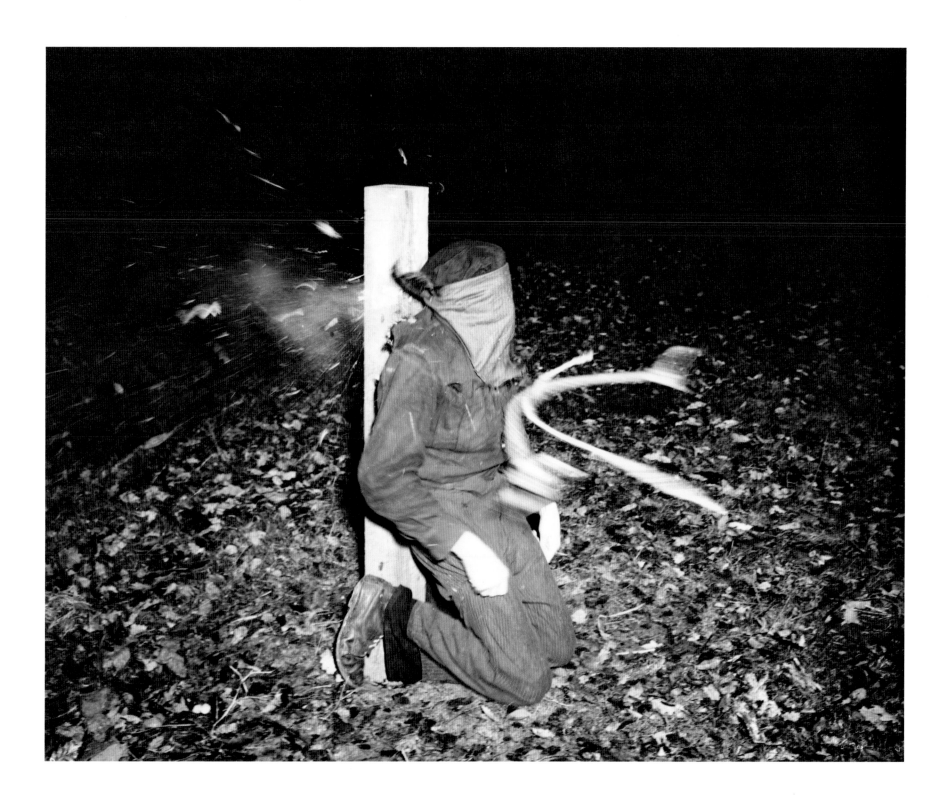

83.

PHOTOGRAPHER UNKNOWN
Tortured by razor slashes on the back. Found Sept. 7, 1944 at
Raneauville St. Agru (Hte. Garonne)
World War II
Gelatin silver print
8 × 10 in.; 20.3 × 25.4 cm
Records of the Office of War Information, 208-YE-1A-53
The National Archives, Washington, D.C.

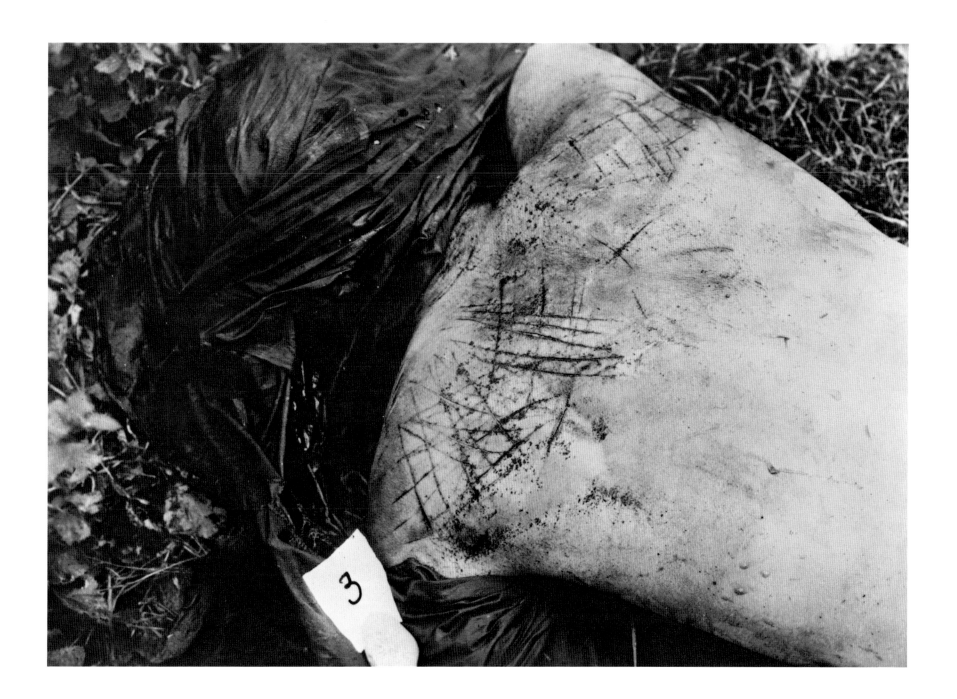

84.
PHOTOGRAPHER UNKNOWN
[*Leyte Gulf, Philippine Islands*], 1944
World War II
Gelatin silver print
8 × 10 in.; 20.3 × 25.4 cm
General Records of the Department of the Navy, 1798–1947, 80-G-432481
The National Archives, Washington, D.C.

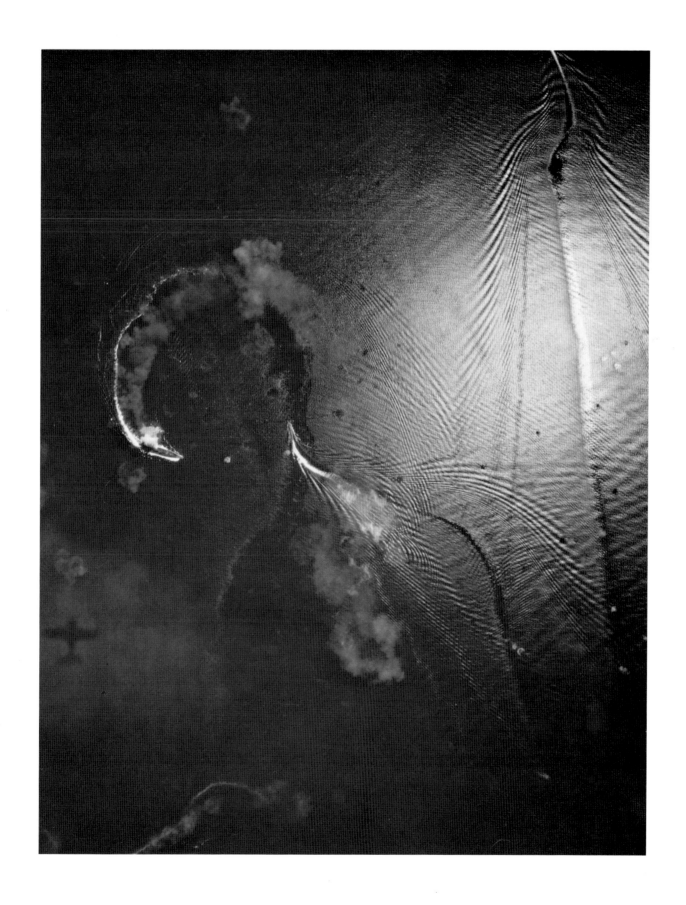

85.

BARRETT GALLAGHER, American (born 1913)
Burial at Sea for the Officers and Men of the USS Intrepid Who Lost
Their Lives during the Battle for Leyte Gulf in the Philippines, November 26, 1944
World War II
Gelatin silver print
[11 × 10¾ in.; 27.9 × 27.3 cm]
Courtesy the Photographer

The Steichen Unit: In 1942 the photographer Edward Steichen tried to
enlist in the U. S. Navy. Although at sixty-two he was older than most
enlisted men, Rear Admiral Arthur W. Radford recognized the potential
for a photographic documentation of Navy maneuvers in the Pacific. He
created the Naval Aviation Photographic Unit with the main mission to
photograph the activities of aircraft carriers. Steichen picked a crew of
professional photographers, including Fenno Jacobs, Barrett Gallagher,
Charles Kerlee, and Paul Dorsey. These men joined the carriers and
recorded the battles against the Japanese in the Pacific. At Steichen's
urging, they focused on the sailor and showed the war close up. The
result was countless rolls of film showing powerful images of the war.

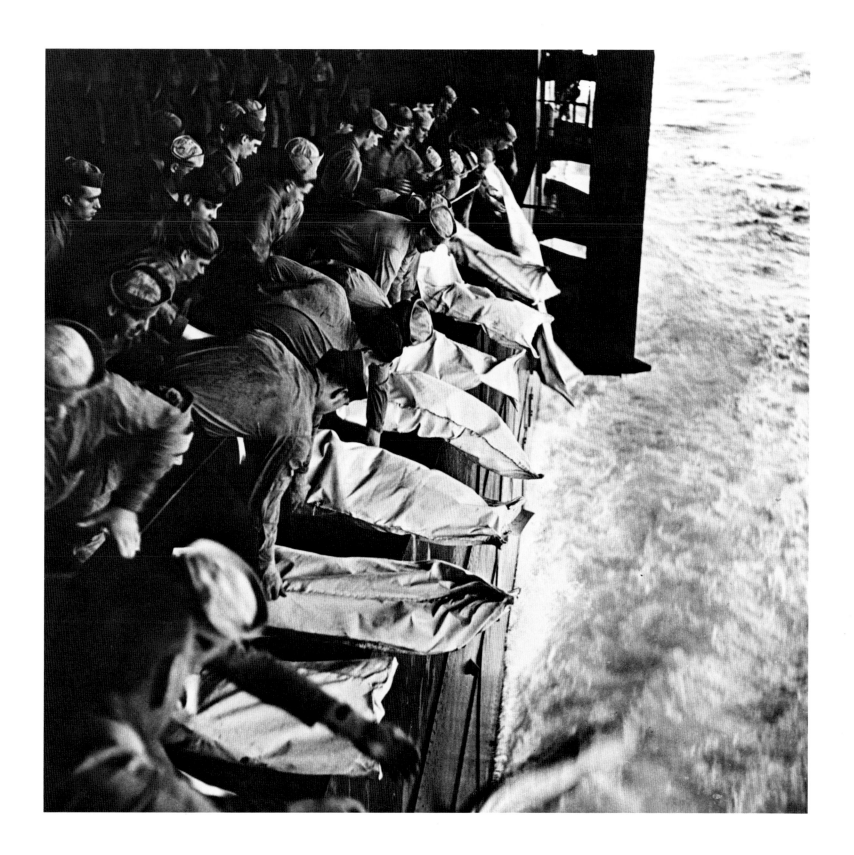

86.

CHARLES FENNO JACOBS, American (1904–1975)
Japanese Prisoner Bathing on the U.S.S. New Jersey, December 1944
World War II
Gelatin silver print
[16 × 16 in.; 40.6 × 40.6 cm]
General Records of the Department of the Navy, 1798–1947, 80-G-469956
The National Archives, Washington, D.C.

"Japanese prisoners of war are bathed, clipped, 'deloused,' and issued GI clothing as soon as they are taken aboard the U.S.S. New Jersey, December 1944."

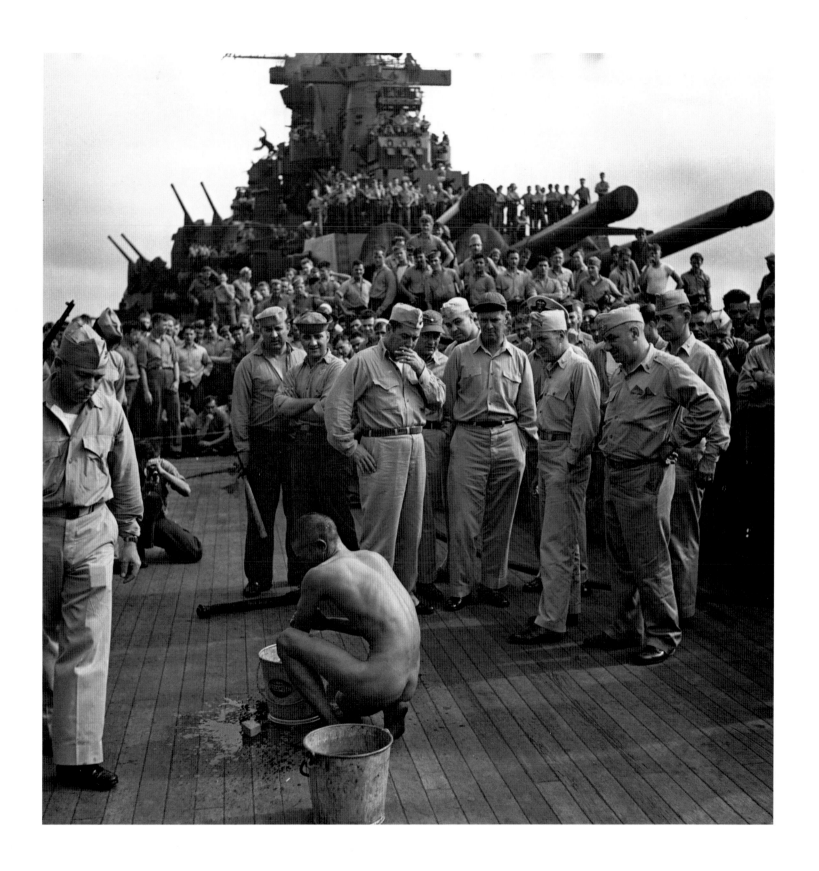

87.
W. Eugene Smith, American (1918–1978)
Saipan, June 1944, (Saipan civilian)
World War II
Gelatin silver print
11¾ × 10¼ in.; 30 × 26 cm
© 1944 W. Eugene Smith, from The Center for Creative Photography, Tucson, Arizona

In June 1944 U.S. forces landed on the island of Saipan in their sweep through the Pacific toward Japan. In a bloody two-week battle the enemy troops stationed there were annihilated. From 1919 on, over eighteen thousand Japanese civilians had settled on Saipan. According to William Manchester (1979), "propaganda officers had been lecturing them [the civilians] since Pearl Harbor, describing the Americans as sadistic . . . monsters who committed unspeakable atrocities before putting all Nipponese, including women and infants, to the sword." After their protectors were gone, despite American attempts at intervention, most of the Japanese gathered on two heights on the northern coast and jumped to their death. "Their parents dashed babies' brains out on limestone slabs and then clutching the tiny corpses . . . jumped off the brinks of the cliffs and soared downward" (pp. 270–271).

 Eugene Smith was motivated by a wish to speak to people, to report honestly on what he saw: "Through the passion I have put into my photographs—no matter how quiet those photographs—I want to call out, as teacher and surgeon and entertainer" (quoted in Browne and Partnow 1983, 569).

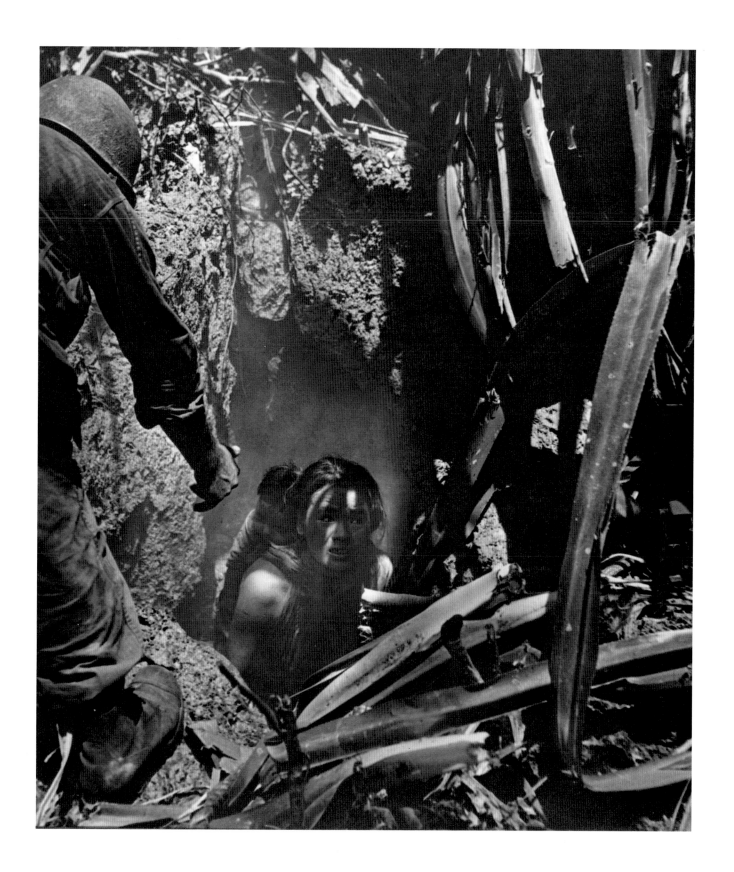

88.
T. SGT. W. G. BRUNK, U.S. Marine Corps, American (dates unknown)
Night Firing, Bougainville, 1944
World War II
Gelatin silver print
10½ × 13½ in.; 26.5 × 34.2 cm
U.S. Department of Defense, Washington, D.C.

"The flash from a 155 mm gun lights up the area, as a Marine gun crew throws some shells at Japanese gun positions which have been shelling American airstrips on Bougainville. 16 Mar. 44."

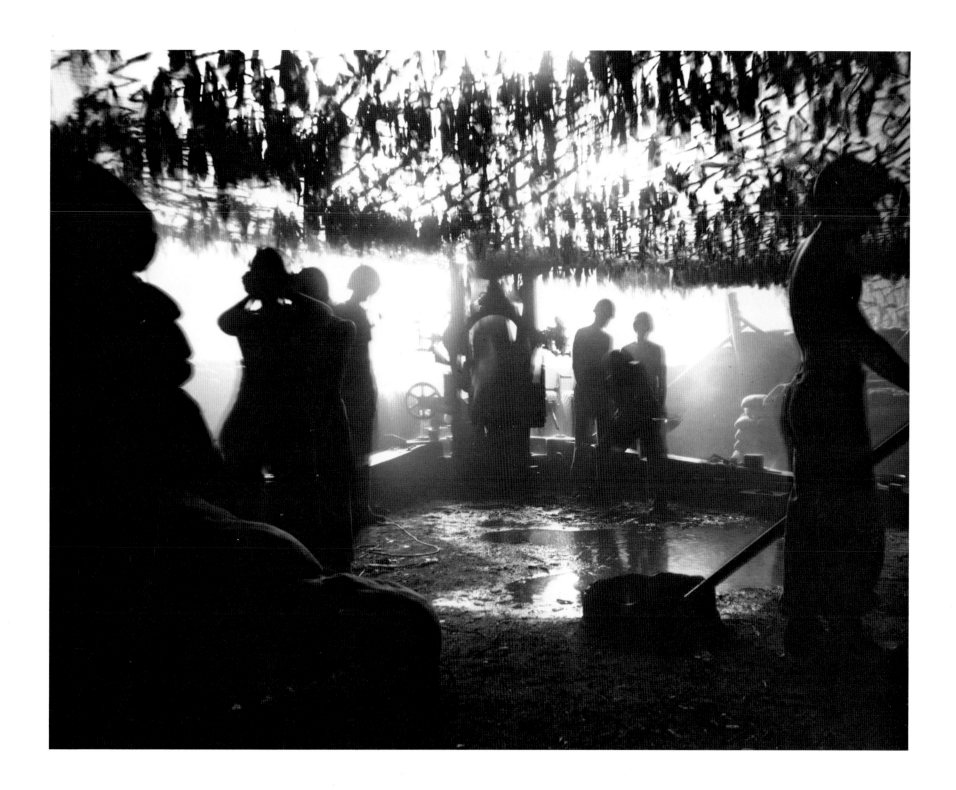

89.

LEE MILLER, American (1907–1978)
Dead German SS Prison Guard, Dachau, 30th April 1945
World War II
Gelatin silver print
6¼ × 6 in.; 15.9 × 15.2 cm
Lee Miller Archives, East Sussex, England

Rainbow Company of the 45th Division of the U.S. Army liberated
Dachau concentration camp on the afternoon of April 29. Lee Miller
entered the camp with Dave Sherman (of Time-Life) the following
day. Her caption for this photograph reads: "The small canal bound-
ing the camp was a floating mess of SS in their spotted camouflage
suits and studded boots. They slithered along in the current with a
dead dog or two and smashed rifles."

 Lee Miller, an accredited war correspondent during World War II,
was with the American liberating forces from the time of the siege of
Malo until the burning of the Bertchesgaden.

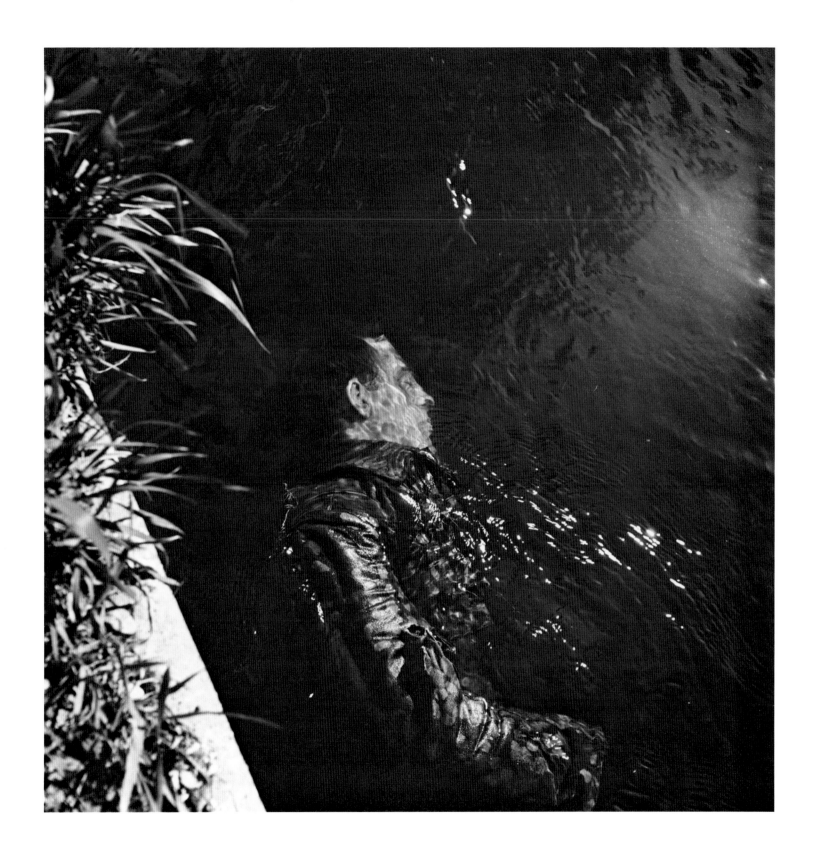

90.
HAYAKAWA HIROSHI, Japanese (dates unknown)
Girl Students Seeing Off Kamikaze Pilots at Chiran Airfield with Flags and Branches of Cherry Blossoms, May 1945
World War II
Gelatin silver print
8¼ × 13 in.; 20.7 × 33.2 cm
Courtesy Japan Professional Photographers Society

According to the Japan Professional Photographers Society, this propaganda photograph was composed with two negatives.

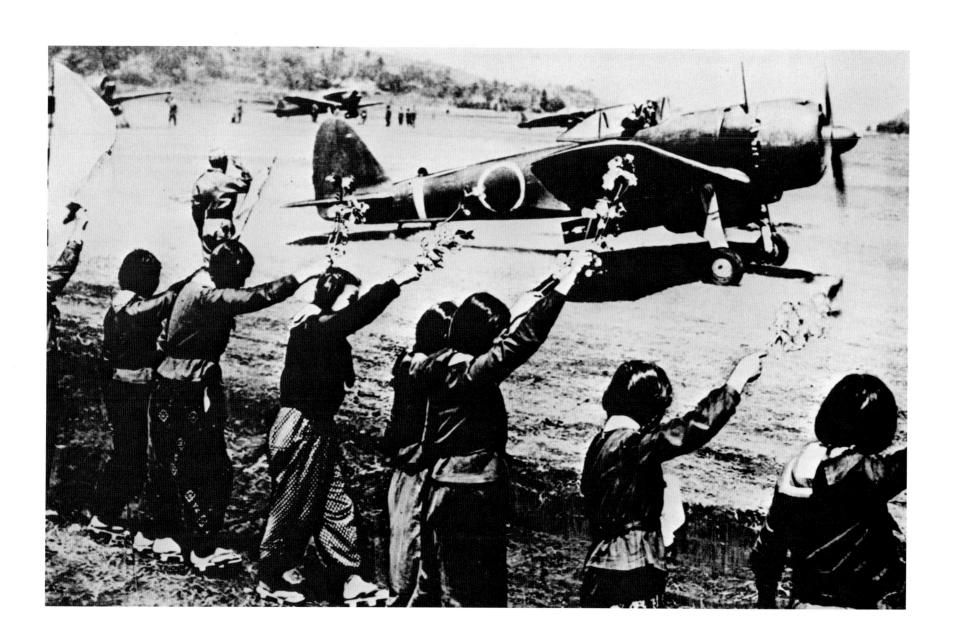

91.

PHOTOGRAPHER UNKNOWN

Oswiecim Prison Camp Clean-up. (Glasses) Krakow, Poland, Post-WWII, Oct. 1945
Gelatin silver print
6¾ × 9½ in.; 17.2 × 24.1 cm
American Red Cross, Washington, D.C.

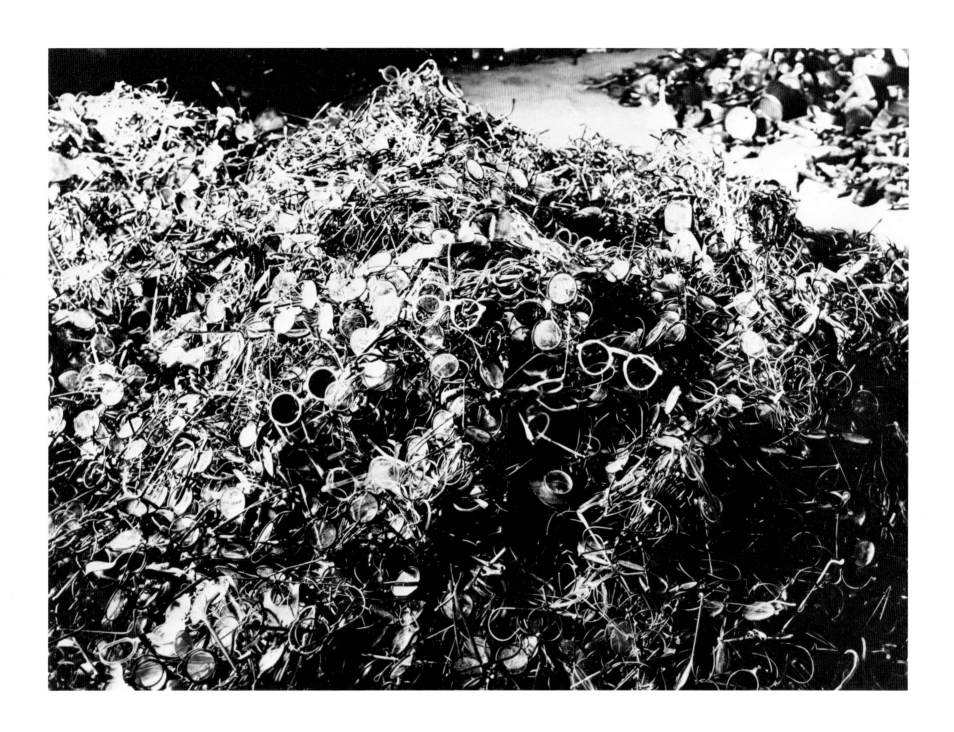

92.
MARGARET BOURKE-WHITE, American (1904–1971)
Dr. Kurt Lisso, Leipzig's city treasurer, and his wife and daughter (Red Cross uniform) took poison as American tanks rolled into the city, 1945
World War II
Gelatin silver print
[8 × 10 in.; 20.3 × 25.4 cm]
Margaret Bourke-White, LIFE Magazine, © 1945, 1973 Time Inc.

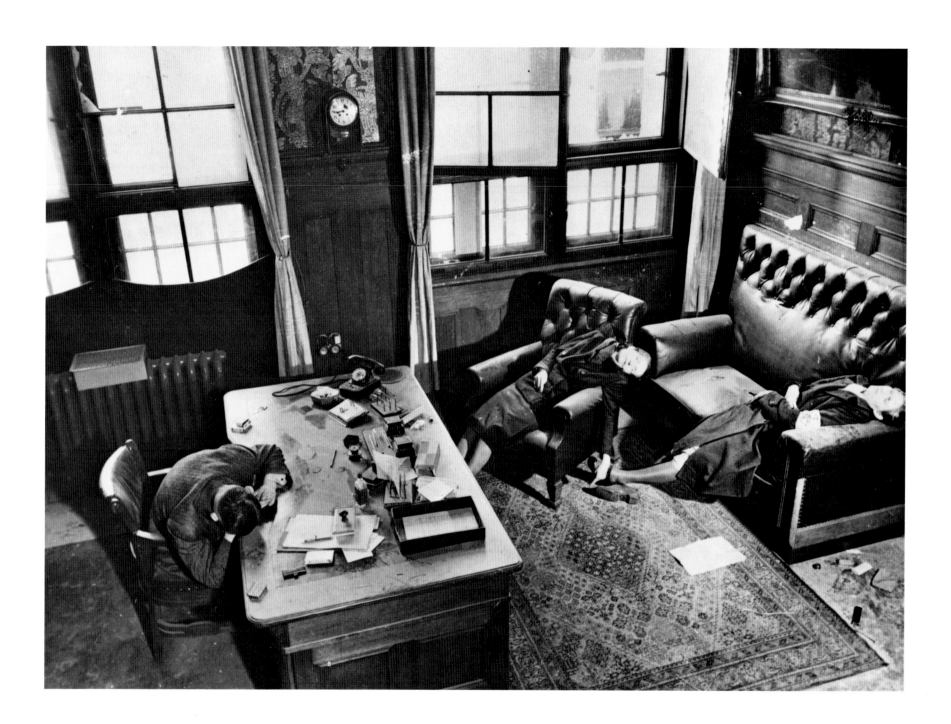

93.

EUGENE KHALDEY, Soviet (dates unknown)
Victory Flag over Reichstag, 1945
World War II
Gelatin silver print
17¼ × 23⅝ in.; 43.9 × 60 cm
Courtesy Union of Journalists of the USSR

The Berlin Reichstag was the symbolic victory prize for the Soviets
during their 1945 spring advance on Germany. After a 1933 fire, for
which the Nazis had blamed Communist agents, the former legislative
house had been abandoned and allowed to crumble, a symbol of
German vulnerability to the Red Menace. Now, ironically, the Soviets
chose the Reichstag as their talisman for German defeat. In this
photograph, soldiers position the Soviet flag atop the Reichstag. The
date is April 30, 1945, and it took another two days of fighting to
clear the building.

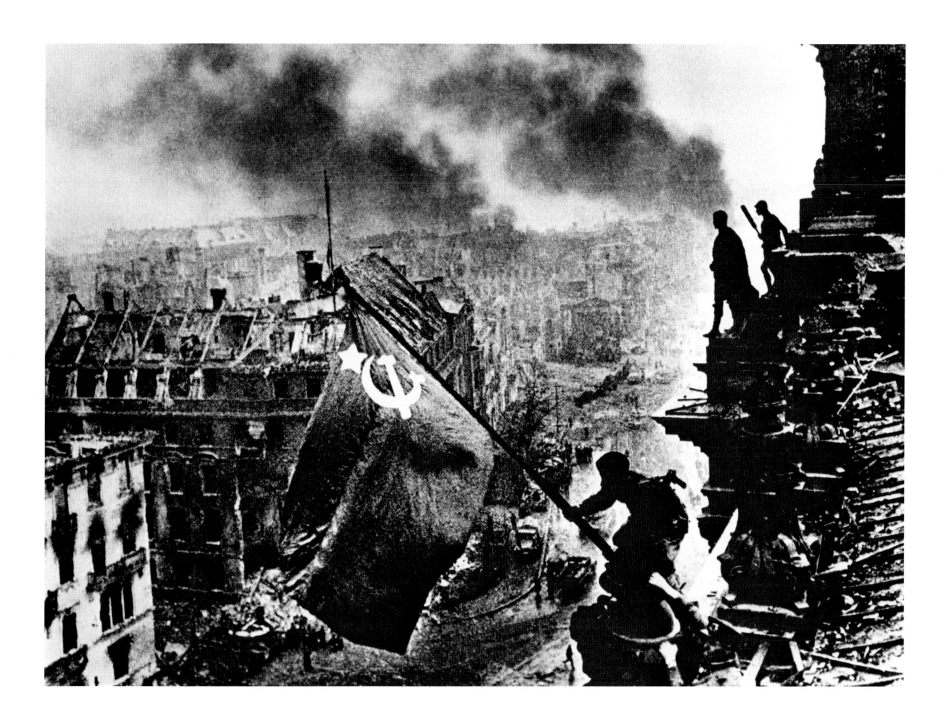

94.

Photographer Unknown
Kamikaze Pilots Sit for Memorial Picture, no date
World War II
Gelatin silver print
8 × 10 in.; 20.3 × 25.4 cm
Keystone Press, London

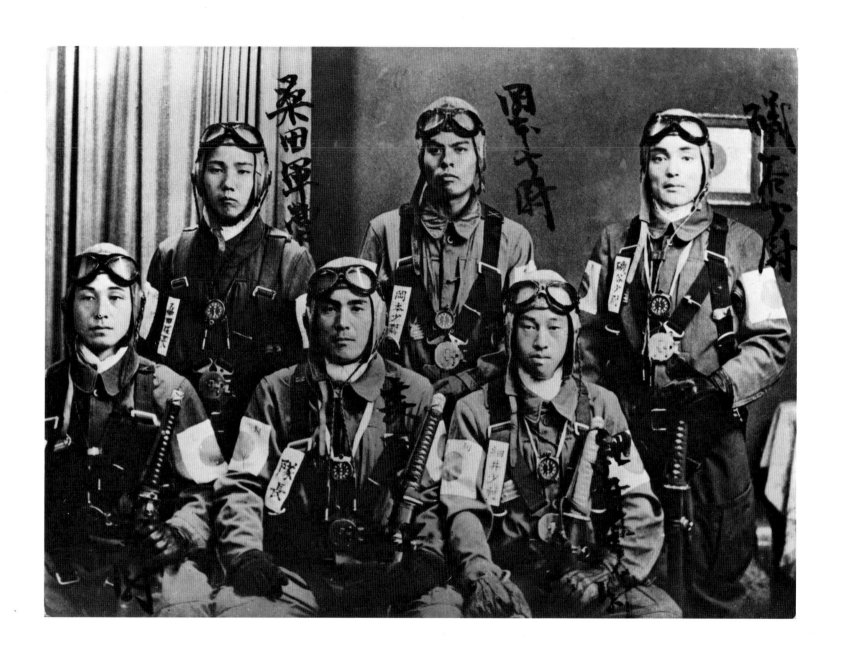

95.

Shomei Tomatsu, Japanese (born 1930)
Beer Bottle after the Atomic Bomb Explosion, 1960–1966
World War II
Gelatin silver print
17¾ × 15⅜ in.; 45.1 × 39 cm
Courtesy the Photographer

Shomei Tomatsu is coauthor of *Hiroshima-Nagasaki Document '61*, published by an antinuclear league, and author of *11:02-Nagasaki* (1966). Since completing these projects, he has returned to Nagasaki regularly to photograph the city and its citizens. Nagasaki, he says, "is a monument to people's forgetfulness, their capacity to gloss over past events even while living out the consequences of those events" (*American Photographer*, May 1984, p. 63).

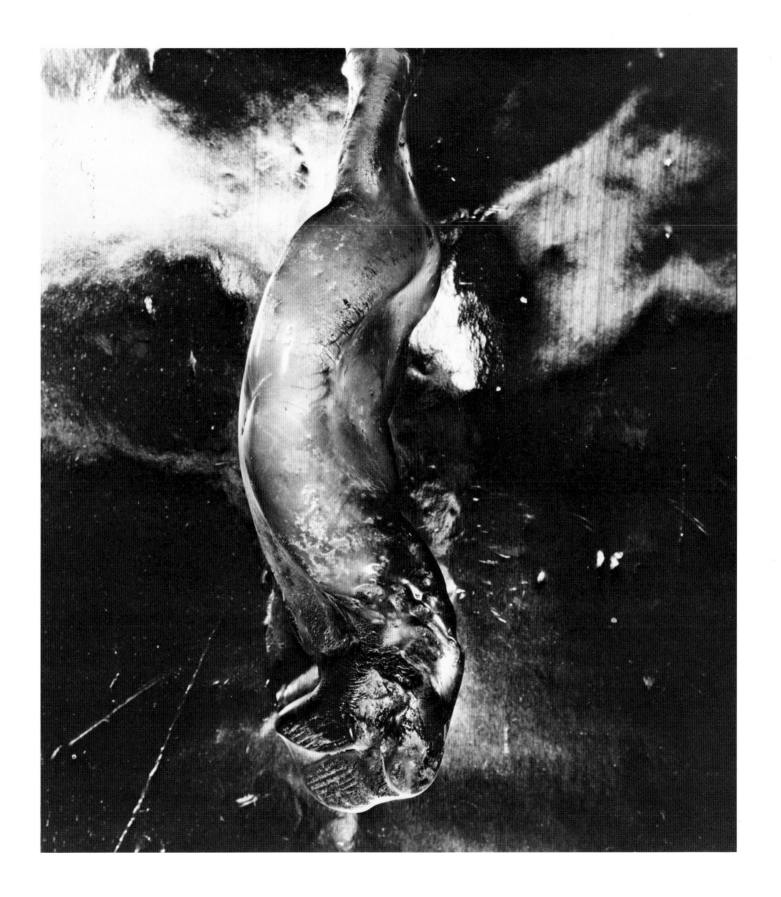

96.

KIMURA KENICHI, Japanese (1905–1973)
*The patient's skin is burned in a pattern corresponding to the dark
portion of a kimono worn at the time of the explosion. Hiroshima, 1945*
World War II
Gelatin silver print
8½ × 7¾ in.; 21.6 × 19.2 cm
Records of the Chief of Engineers, 77-MDH-6.55b
The National Archives, Washington, D.C.

This photograph was used to illustrate a report prepared by the
Adjutant General's Office in 1948 depicting the devastating effects of
the atomic bombs in Hiroshima and Nagasaki.

 As an Army photographer, Kimura Kenichi began to document the
condition of Hiroshima a few days after the atomic bomb blast. He
photographed the city's wounded at the request of an investigating
team from the Tokyo Medical Army Museum. Kimura Kenichi was a
native of Hiroshima; his wife did not survive the atomic blast.

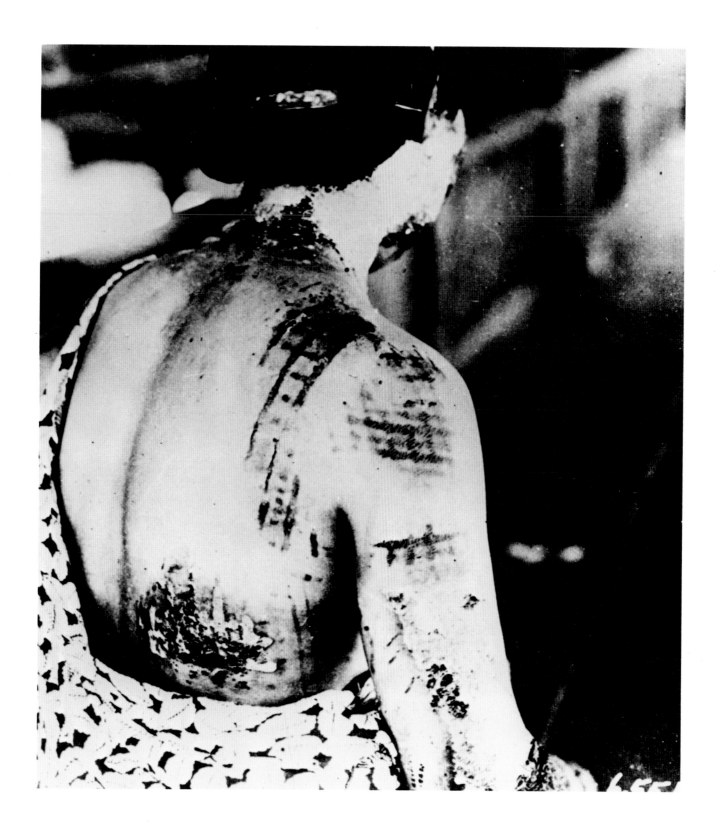

97.
SIDNEY JACKSON BARTHOLOMEW, American (born 1922)
Fiji Islands—Summer 1944
World War II
Gelatin silver print
4 images, each 2¾ × 1⅞ in.; 7 × 4.8 cm
Courtesy Sidney J. Bartholomew, Jr., New York

G.I.s (l. to r.) John Hill (Harlan County, Kentucky), Harold Peebles (Finley, Ohio), and Mac McDowell (Los Angeles) show off muscles and gas masks in front of their pup tents for Pfc. Sidney Bartholomew's Kodak 126 camera. Bartholomew remembers that "pretty soon after I made these pictures we threw the damned gas masks away! We kept the canvas bags though, and filled them up with extra C rations."

98.

DAVID SEYMOUR ("CHIM"), American (born Poland; 1911–1956)
Young War Victims, Rome, 1948
following World War II
Gelatin silver print
6½ × 8⅜ in.; 16.5 × 21.1 cm
International Center of Photography, New York
International Fund for Concerned Photography, Purchase

As a freelance photographer, David Seymour photographed pre–
World War II France and the Spanish Civil War. After World War II,
"Chim" worked on assignment for UNESCO, traveling through Eu-
rope to photograph the maimed and orphaned children left in the
war's wake.

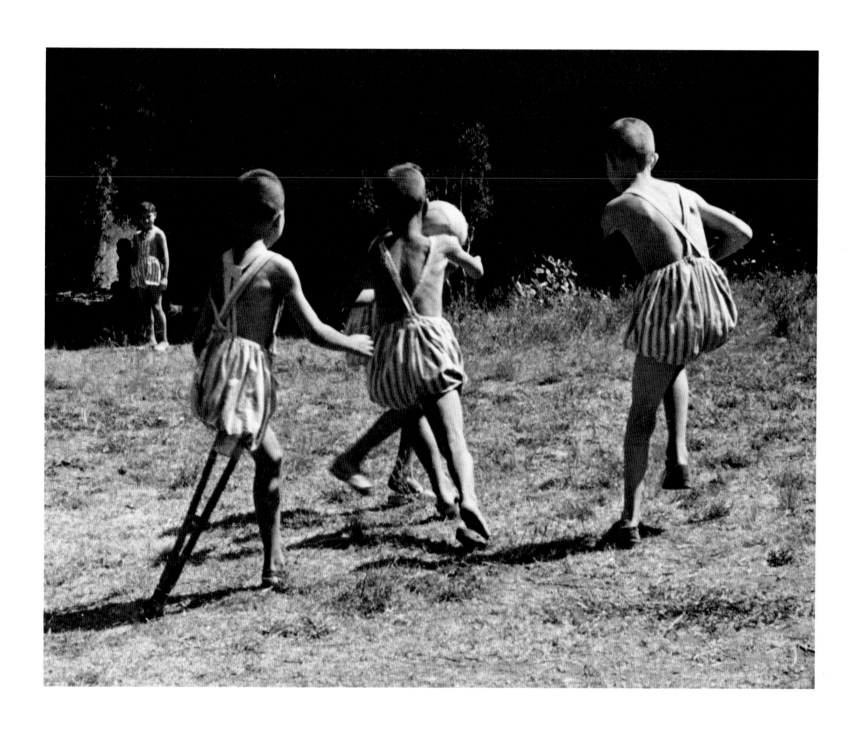

THE KOREAN WAR, 1950–1953

The Korean War, initially a conflict between North and South Korea, was the first war in which a world organization, the United Nations, played a military role. After World War II, Korea had been divided at the thirty-eighth parallel, with Soviet forces occupying the territory to the north, where a Communist government was established, and U.S. forces occupying the south, where a pro-Western government emerged. When North Korea invaded South Korea in 1950, the United States, supported by the United Nations, sent forces to aid South Korea. Viewed in the context of the "Cold War," the Korean War was an example of the rivalries between the Communist and non-Communist systems throughout the world. Peace in Korea was restored by a truce signed by North Korea and the United Nations in 1953. No permanent peace treaty has ever been signed.

99.
PHOTOGRAPHER UNKNOWN/U.S. Marine Corps
North Korean prisoners, taken by the Marines in a foothills fight, march in an open formation, no date
Korean War
Gelatin silver print
[10½ × 13½ in.; 26.5 × 34.2 cm]
U.S. Department of Defense, Washington, D.C.

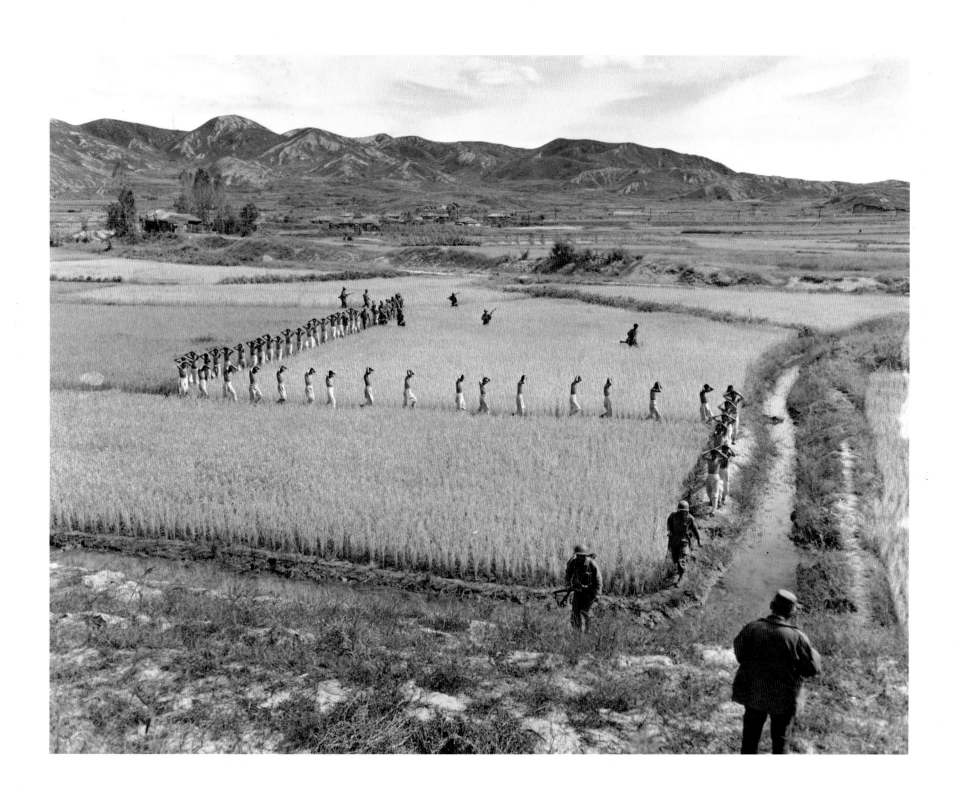

100.

PHOTOGRAPHER UNKNOWN
[*Observers, Yucca Flat, Nevada*], no date
Gelatin silver print
[13⅛ × 19¼ in.; 33.3 x 48.9 cm]
© UPI/Bettmann Archive, Records of the United States Information Agency

"Yucca Flat, Nevada—This unusual photo shows observers on 'News Knob,' just seven miles from the atomic detonation. The picture was taken in the dark of the pre-dawn, lighted entirely by the flash of atomic blast. Since total blindness would probably result if observers did not take precautions, they are wearing special goggles. Others turned their backs to the flash."

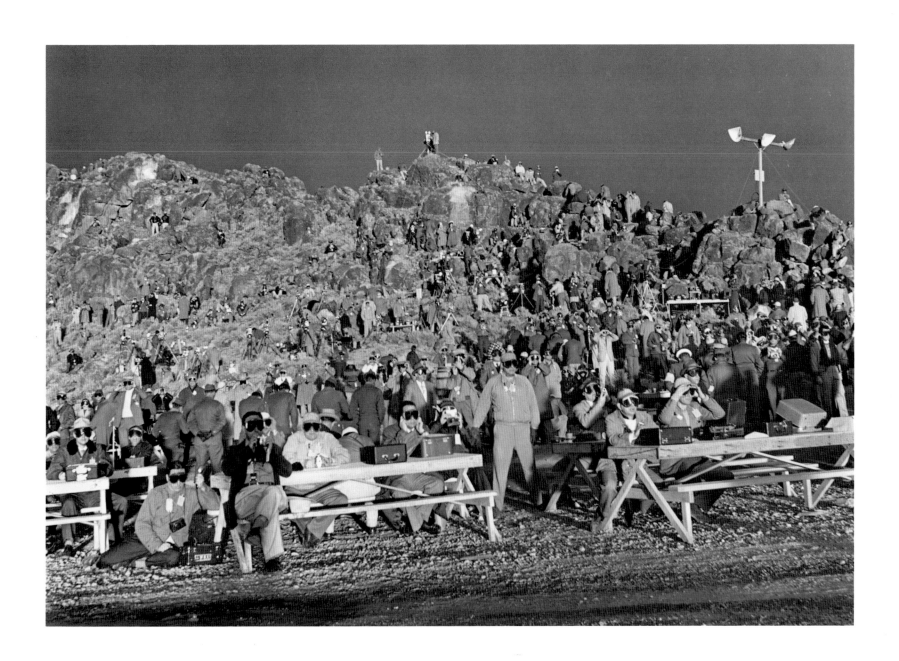

French intervention in Vietnam began in the 1840s. The country came completely under French control in 1883. Eventually, Indochina (Vietnam, Cambodia, and Laos) became France's richest colony. It was occupied by Japan during World War II. After the defeat of Japan, under the leadership of Ho Chi Minh, the Communists and Vietnamese Nationalists secured control in the north and the French reestablished control in the south. Hostilities between the two sides steadily increased. Ultimately, France withdrew in 1954 after a decisive defeat at Dien Bien Phu.

Having supported France in Vietnam since 1950, the United States became seriously committed to the defense of South Vietnam in 1961. By 1969 there were five hundred and forty-three thousand American troops in Vietnam. The war had no clear front lines. Enemy soldiers were indistinguishable from civilians. Political repercussions divided Americans for a decade. In January 1973 an agreement calling for a cease-fire was signed, and by March of that year most U.S. forces had withdrawn. North and South Vietnam continued fighting until 1975, when the South Vietnamese resistance collapsed and the capital city of Saigon fell to the Communists.

101.

PHOTOGRAPHER UNKNOWN
Paratroopers aid wounded comrades as one GI guides a medical evacuation helicopter into a jungle clearing, April 1968
Vietnam War
Gelatin silver print
[23¼ × 19½ in.; 59 × 49.5 cm]
AP/Wide World

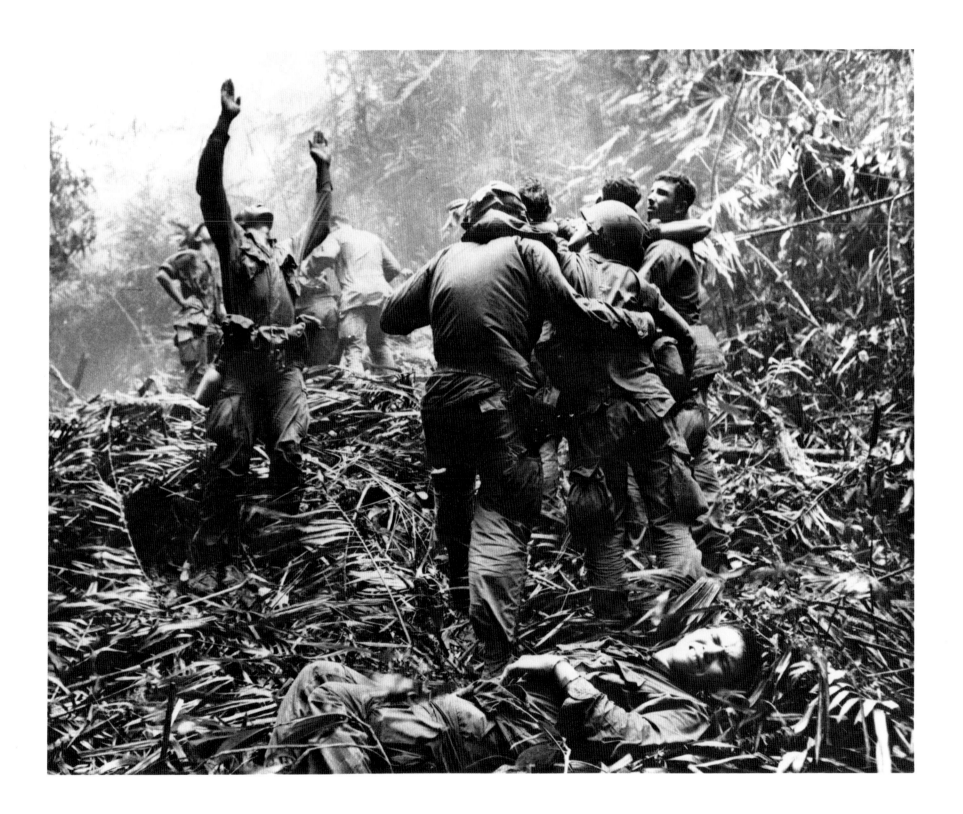

102.

LARRY BURROWS, British (1926–1971)
Yankee Papa 13, Farley with Jammed Gun, 1965
Vietnam War
Gelatin silver print
20 × 16 in.; 50.8 × 40.6 cm
Courtesy Russell Burrows, New York

"Yankee Papa 13's crew chief, James Farley, frustrated by his jammed gun, moves to aid two wounded crewmen from another helicopter which had been downed. S. Vietnam, 1965."

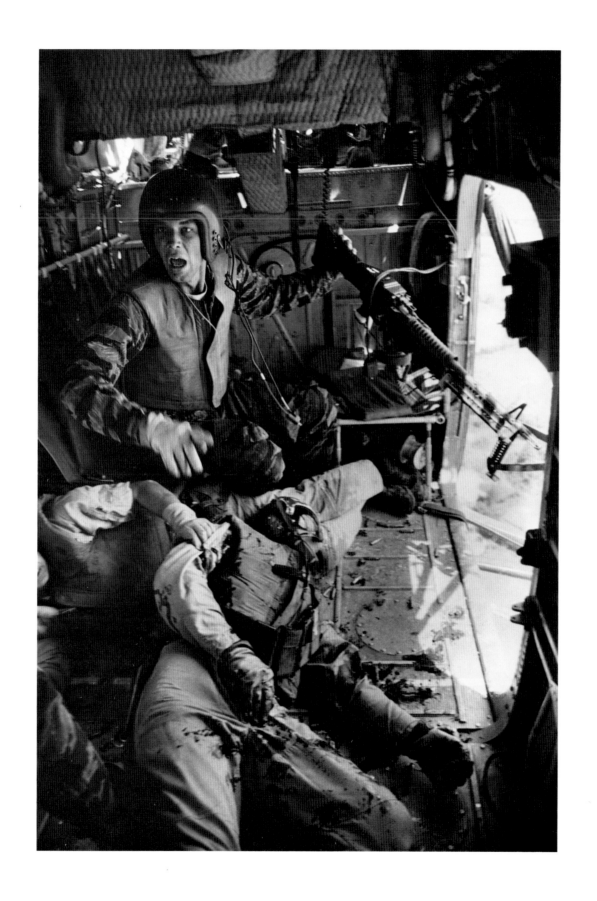

103.

PHILIP JONES GRIFFITHS, British (born 1936)
Vietnam Red Mt.—Civilians Rounded Up by American Troops in Quang Ngai Province, 1967
Vietnam War
Gelatin silver print
[8 × 10 in.; 20.3 × 25.4 cm]
© Philip Jones Griffiths/Magnum

"Mother and child shortly before being killed. A unit of the American Division operating in Quang Ngai Province six months before My Lai. The resentment is already there. This woman's husband, together with the other men left in the village, had been killed a few moments earlier because he was hiding in a tunnel. After blowing up all the tunnels and bunkers where people could take refuge, GIs withdrew and called in artillery fire on the defenseless inhabitants" (Griffiths 1971, 59).

Philip Jones Griffiths spent three years taking photographs of the war in Vietnam, many of which were published in his book *Vietnam Inc*. His coverage of this war includes the points of view not just of the American soldier but also of the Vietnamese civilian.

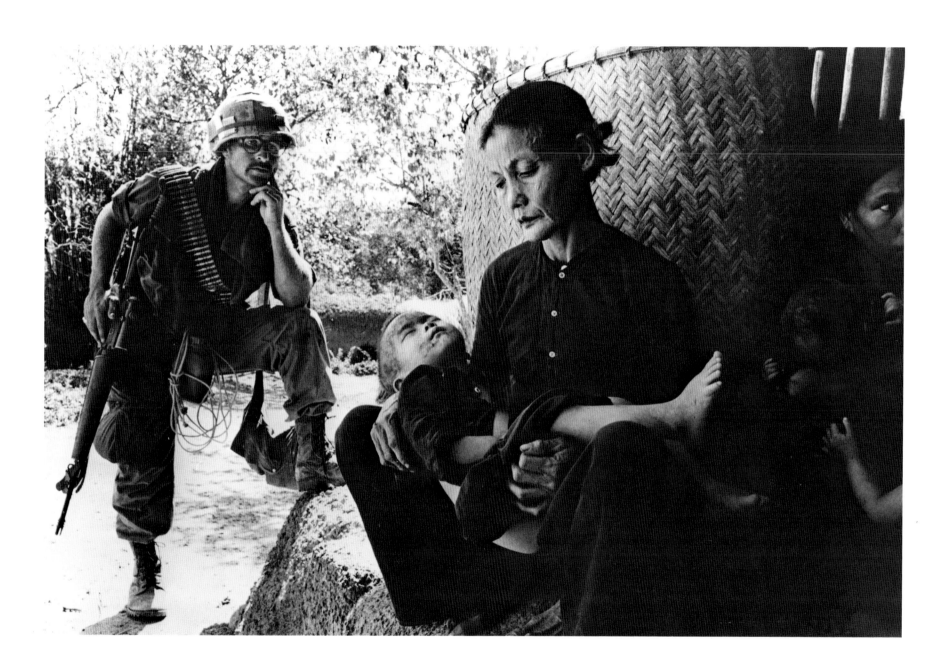

104.

PHOTOGRAPHER UNKNOWN
[*Snapshots Removed from Body*], no date
Vietnam War
Gelatin silver prints
Snapshots
Courtesy James H. Pickerell, Bethesda, Maryland

These snapshots are believed to have been removed from the body of a North Vietnamese soldier. Normally, they would have been turned over to U.S. Army Intelligence Officers who might have used them to identify other North Vietnamese soldiers.

Mừng Xuân Quí Mão
- 1.963 -

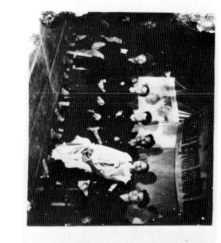

105.

Thomas Daniel, American (born 1948)
*Vietcong, Dead Approximately 28 Hours, Found after Attack on
Long Binh during Burn and Sweep, 1968 Tet Offensive*
Vietnam War
Gelatin silver print
8½ × 8 in.; 21.5 × 20.3 cm
Courtesy the Photographer

After serving eighteen months in the field in Vietnam, Thomas Daniel—with little experience in photography—talked his way into a job as an Army photographer. Daniel's experience in Vietnam inspired him to pursue a photographic career: "You start seeing all of this madness, so it's got to have an effect on you When I saw those kids [in orphanages] I knew how I felt, and I began to wonder if I could make anybody else feel those things. And I think then it became evident to me that maybe I had something to say as a photographer" (*Throttle*, April 1984, 15).

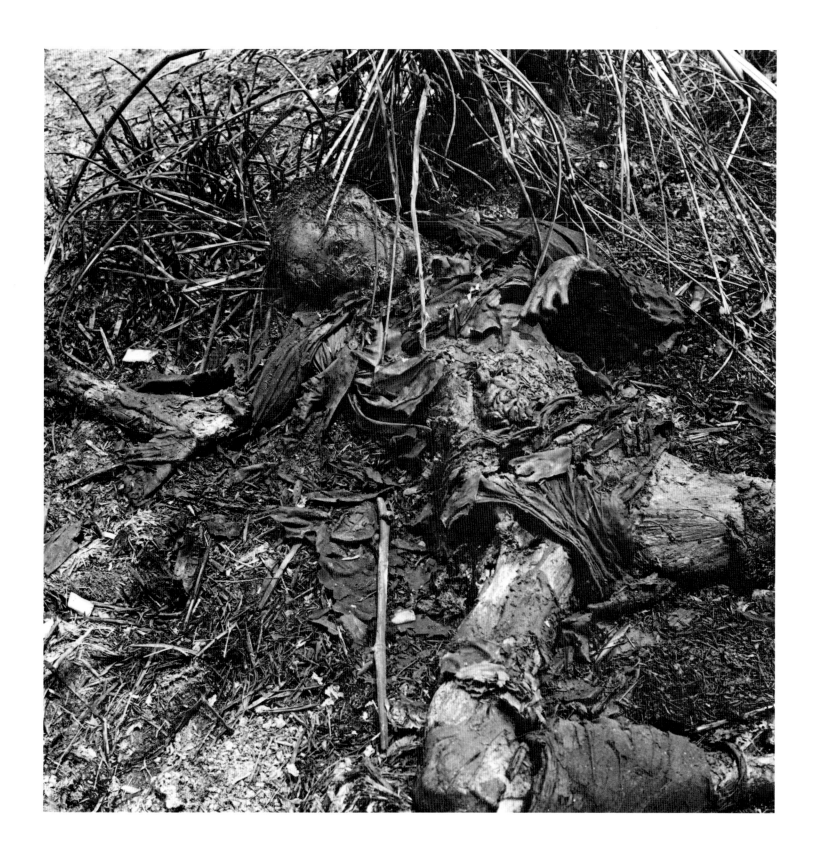

106.

PHOTOGRAPHER UNKNOWN
Lieut. Commander, U.S. Navy, sits in prison cell, North Vietnam, 1969
Vietnam War
Gelatin silver print
8 × 6 in.; 20.3 × 15.2 cm
American Red Cross, Washington, D.C.

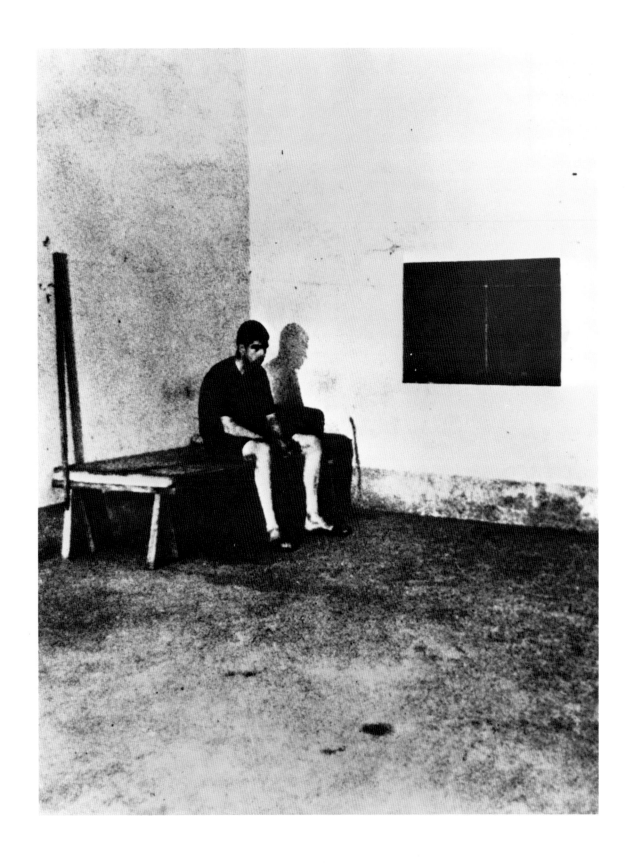

THE INDO-PAKISTANI WAR, 1971

When the Muslim State of Pakistan was created in 1947, it comprised two distinct geographic and cultural units separated by predominantly Hindu India. In 1971 East Pakistan seceded and proclaimed itself the independent nation of Bangladesh. West Pakistan troops attempted to suppress the rebellion, but India supported the independence movement and sent its army to intervene. Within two weeks of the invasion, Indian troops controlled the country, and the Bangladesh government was installed in the capital of Dacca.

107.

PENNY TWEEDIE, British (born 1940)
Bangladesh, 1971
Indo-Pakistani War
Gelatin silver print
[6¾ × 10 in.; 17 × 25.3 cm]
Courtesy the Photographer

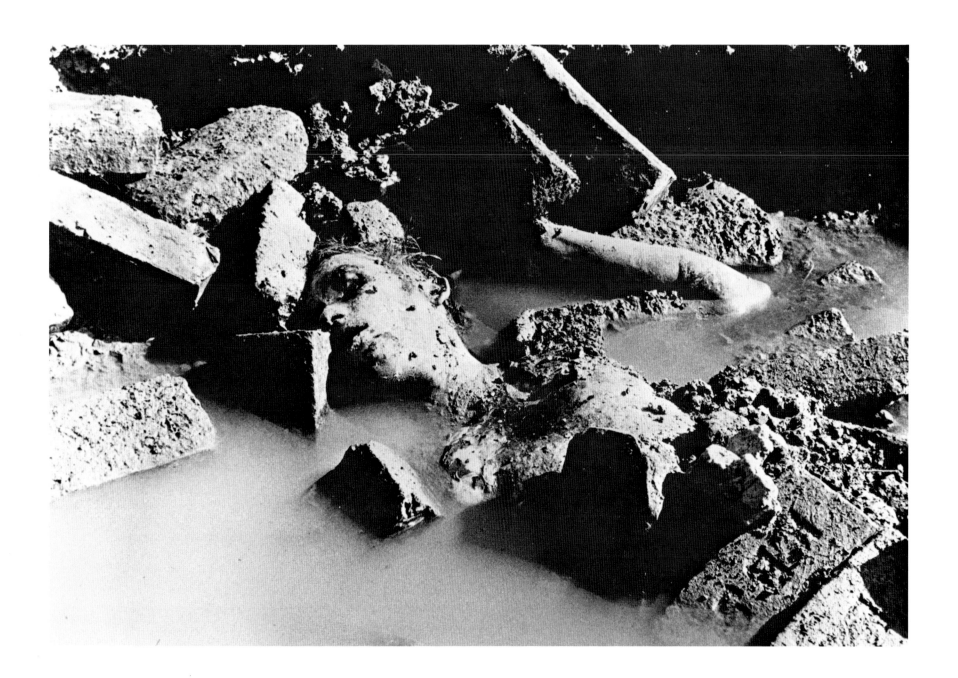

108.
MANFRED KREINER, American (born Germany, date unknown)
Mutilated Child in American-Run Clinic for Plastic Surgery. Saigon, Vietnam. December 1972
Vietnam War
Gelatin silver print
9¾ × 6½ in.; 24.8 × 16.5 cm
Black Star

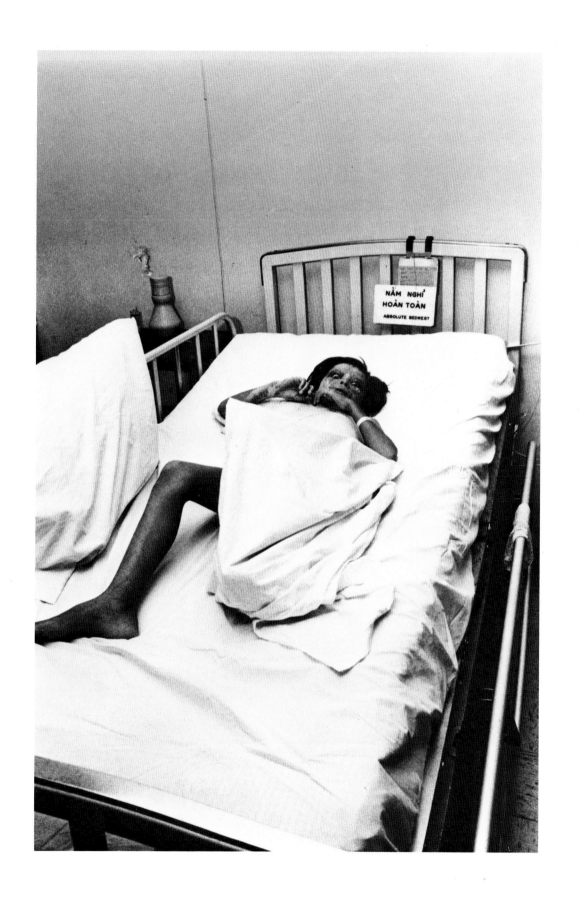

NORTHERN IRELAND

The roots of violence in Northern Ireland are buried beneath four centuries of bitter conflict. The general atmosphere of intolerance and fear that has dominated life in Northern Ireland results from extremely complex, ongoing differences over questions of national identity, political allegiance, and social and economic difference, all of which are manifested in the conflict between Catholics, who are in a minority in the North, and Protestants, who are in an overall minority in both the North and the Republic of Ireland. The Catholics want a separation from British government, a united Ireland, and freedom from what they see as Protestant control; the Protestants fear the loss of that control and the probable recriminations that would follow independence from Britain. The most recent phase of widespread violence and terror began in 1969 and continues its tragic course, with no solution becoming apparent.

109.

GILLES PERESS, French (born 1946)
Northern Ireland, 1972
Gelatin silver print
[11 × 14 in.; 27.9 × 35.6 cm]
Courtesy the Photographer

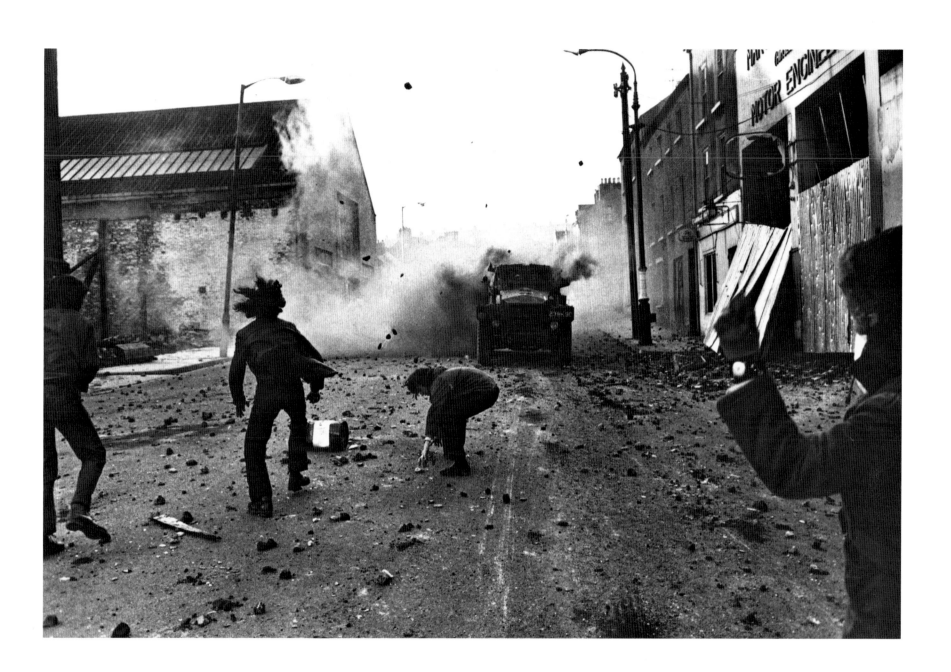

110.

Leif Skoogfors, Swedish and American (born United States, 1940)
North Street, Belfast, following a Bombing, 1972
Northern Ireland
Gelatin silver print
[16 × 20 in.; 40.6 × 50.8 cm]
Courtesy the Photographer

"My husband said to me the other night, 'Come on, it's our anniversary and I'll take you out for a nice meal.' It was his idea of a strange joke, of course. None of the restaurants are open at night. Indeed there are few left that haven't been bombed, it seems. Anyway, who'd find any pleasure in eating somewhere where you think you might get killed on your next forkful?" (a Belfast housewife, in Skoogfors 1974, unpaginated).

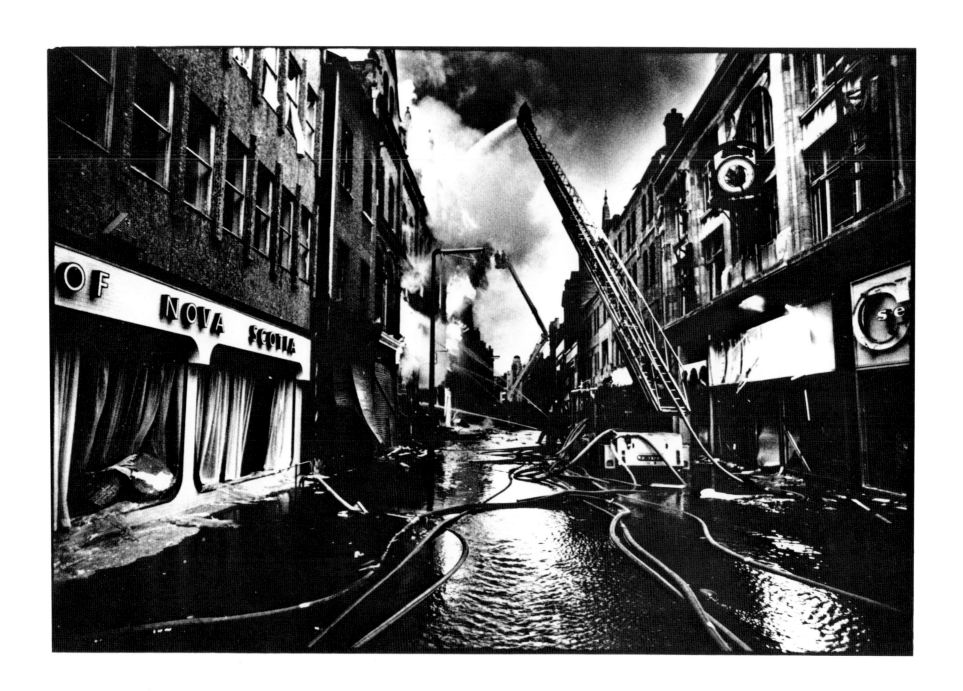

The ancient land of Palestine is equally sacred to Judaism, Christianity, and Islam. These faiths are built on love and brotherhood, but in the twentieth century their holy birthland has been a scene of hatred and violence on a scale unknown since the Crusades. Following the partition of Palestine by the United Nations, Israel emerged in 1948 as the first Jewish state to be established in nearly two thousand years. Israel represented the arrival of a modern European state into an underdeveloped, insular area. Hostile relations with her neighboring Arab states, who looked on her as a forcibly established, unacceptable alien presence, have prevailed from the outset, with Israel obtaining victories over the Arabs after battles fought in 1948–1949, 1956, and 1967. The psychological and political defeat of the Arab governments gave a powerful impetus to the Palestine guerilla movement. Following the 1967 war, Palestine Liberation Organization (PLO) guerillas intermittently raided Israel and its occupied territories, causing Israel to attack PLO host countries, Lebanon and Jordan, in retaliation. Egypt and Syria attacked Israel in 1973 on Yom Kippur, the holiest day of the Jewish year. Egypt and Syria effectively countered Israeli tanks with Soviet-supplied precision guided munitions (PGM) in the first large-scale use of these revolutionary, small, computerized missiles with nonnuclear warheads. The Yom Kippur War lasted only a few weeks on the Egyptian front, and a successful cease-fire between Egypt and Israel followed. Egypt, in a move violently opposed by the other Arab states, signed a peace treaty with Israel in 1979.

111.

Micha Bar-Am, Israeli (born Germany, 1930)
Egyptian POWs, 1973
Yom Kippur War
Gelatin silver print
[16 × 20 in.; 40.6 × 50.8 cm]
© Micha Bar-Am/Magnum

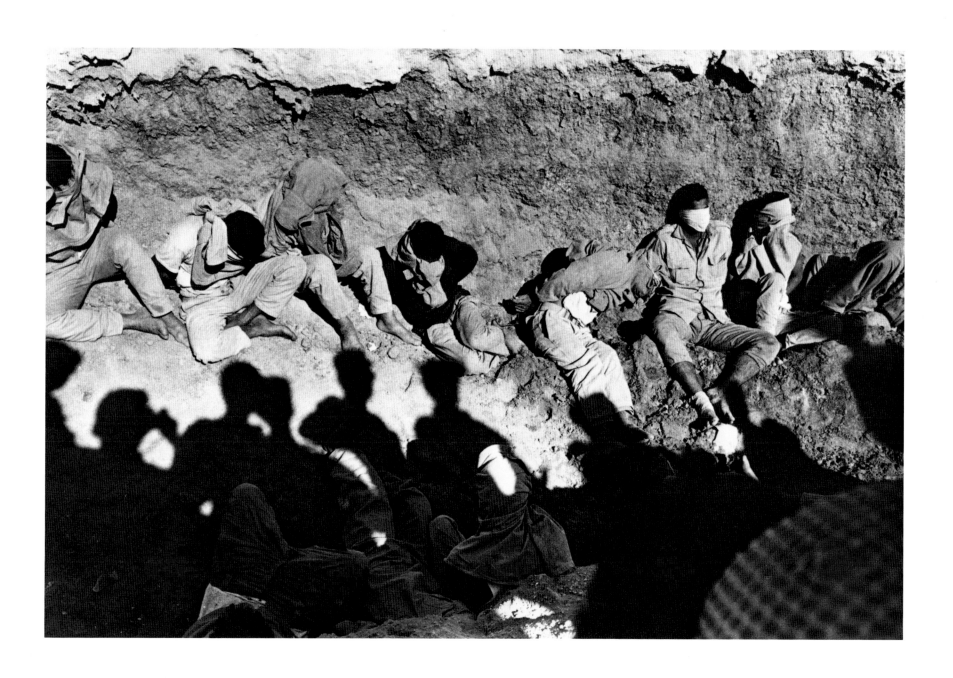

THE LEBANESE WAR, 1975–

Tensions over the distribution of power between Muslim left-wing groups and the right-wing Christian Phalangist Party erupted in Lebanon in 1975. By the time a cease-fire plan was ratified by the Arab League in 1976, thirty-five thousand Lebanese were dead. Fighting began again in southern Lebanon in 1977, with Syria supporting the leftist guerillas and Israel supporting the Lebanese government. In 1982 Israel invaded Southern Lebanon, in reaction to a Palestine Liberation Organization buildup. Within two weeks, Israeli troops had reached Beirut, the Lebanese capital. By August 1982 an international peacekeeping force was introduced in Beirut and evacuated many of the PLO and Syrian troops from the city. By 1983 the country was partitioned and occupied by foreign forces. The Lebanese Army controlled Beirut, Israeli forces occupied southern Lebanon, and Syrian Palestinian forces held the Beka Valley in East Lebanon. Efforts by French and Americans to organize a withdrawal of all foreign troops from Lebanon suffered setbacks when terrorist bombings of the American Embassy and the French and American compounds resulted in severe loss of life. Peace negotiations and terrorist attacks continue simultaneously.

112.
DON McCULLIN, British (born 1935)
Christian militia mock the body of a young Palestinian girl killed in the Battle of Karantina. Beirut, 1976
Lebanese War
Gelatin silver print
10 × 15¼ in.; 25.4 × 38.8 cm
Victoria and Albert Museum, London

In his book *Is Anyone Taking Any Notice?* Don McCullin says of himself: "I don't make any protest other than take photographs and show how bad it is." (1971, unpaginated).

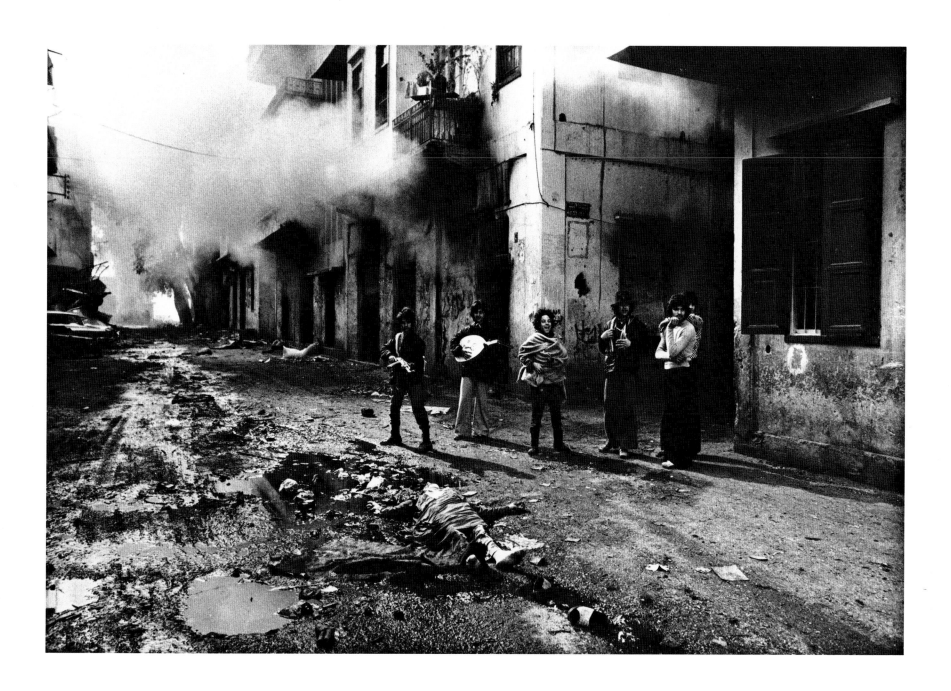

113.

RAYMOND DEPARDON, French (born 1942)

Christian Phalangist militiaman fires to cover himself as he races for
a new position in the shattered streets of Beirut, 1978

Lebanese War
Gelatin silver print
[16 × 20 in.; 40.6 × 50.8 cm]
© Raymond Depardon/Magnum

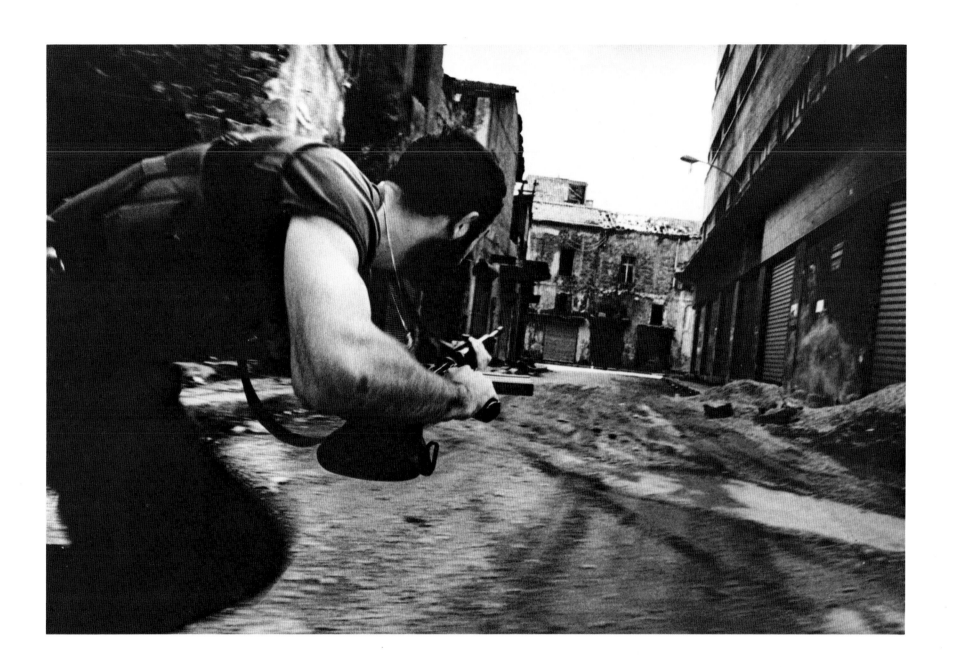

AFGHANISTAN, 1978–

Beginning in 1978, by a series of bloody coups, three Marxist leaders in succession took over Afghanistan. The third, Babrak Karmal, became president on December 17, 1979, with the support of a massive invasion of Soviet armed forces. The Soviets still occupy the country, fighting a war of attrition against a force of resistance fighters.

114.
RAYMOND DEPARDON, French (born 1942)
Afghanistan 1979
Gelatin silver print
[16 × 20 in.; 40.6 × 50.8 cm]
© Raymond Depardon/Magnum

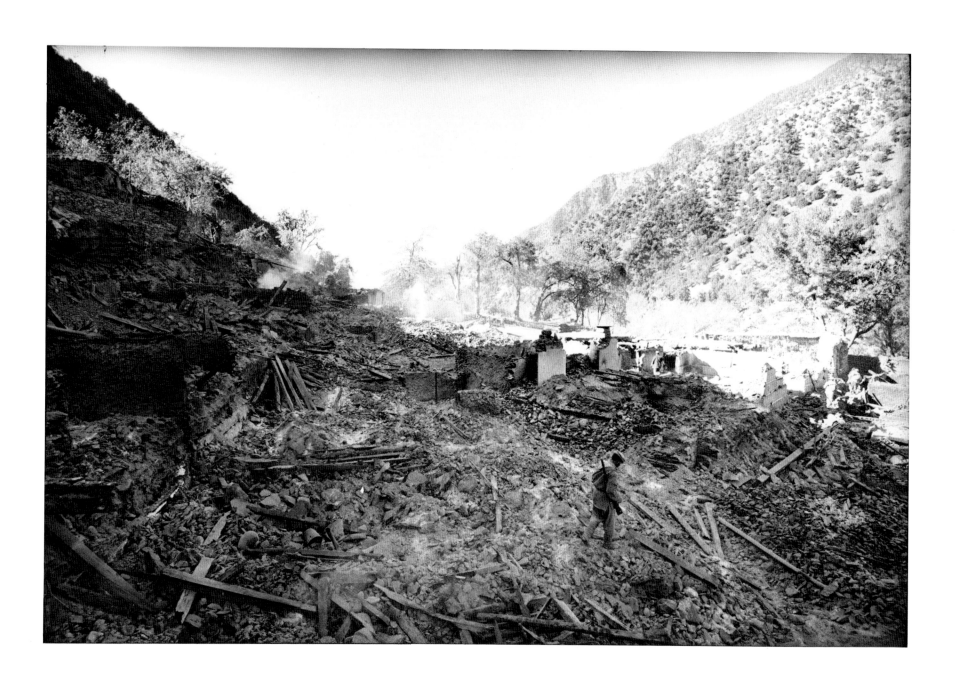

EL SALVADOR, 1980–

In 1980 a Christian Democrat military-civilian junta took power in El Salvador, intending to launch a comprehensive reform program, including the redistribution of land and the nationalization of banks. This program broke the power of the privileged elite, but caused the flight of currency from the country. Opposition groups responded in May 1980 by forming a revolutionary directorate to coordinate guerilla activities. Archbishop Oscar Arnulfo Romero, the most outspoken critic of the government, was assassinated, and later four American women, three of them nuns, were murdered by government soldiers. The government, unwilling to negotiate with the guerillas, is still unable to suppress them, even with military and economic aid from the United States, which maintains that the rebels are receiving aid from Cuba and the Soviet Union through Nicaragua.

115.
HARRY MATTISON, American (born 1948)
Interior of the Cathedral, Oct. 1979
El Salvador
Gelatin silver print
[9 × 13¼ in.; 22.8 × 33.7 cm]
Courtesy the Photographer

More than eighty thousand people gathered for the funeral of Archbishop Oscar Arnulfo Romero on March 30, 1980, in front of the Metropolitan Cathedral in San Salvador. Thirty-nine died and over two hundred were wounded after explosions and shooting caused the crowd to panic. A communiqué from priests and bishops attending the funeral blamed the outbreak of violence on snipers positioned on the roof of the National Palace. Thousands sought sanctuary in the interior of the cathedral; the bodies of the dead and wounded crowded the entrance. (Harry Mattison, pers. com. 1985)

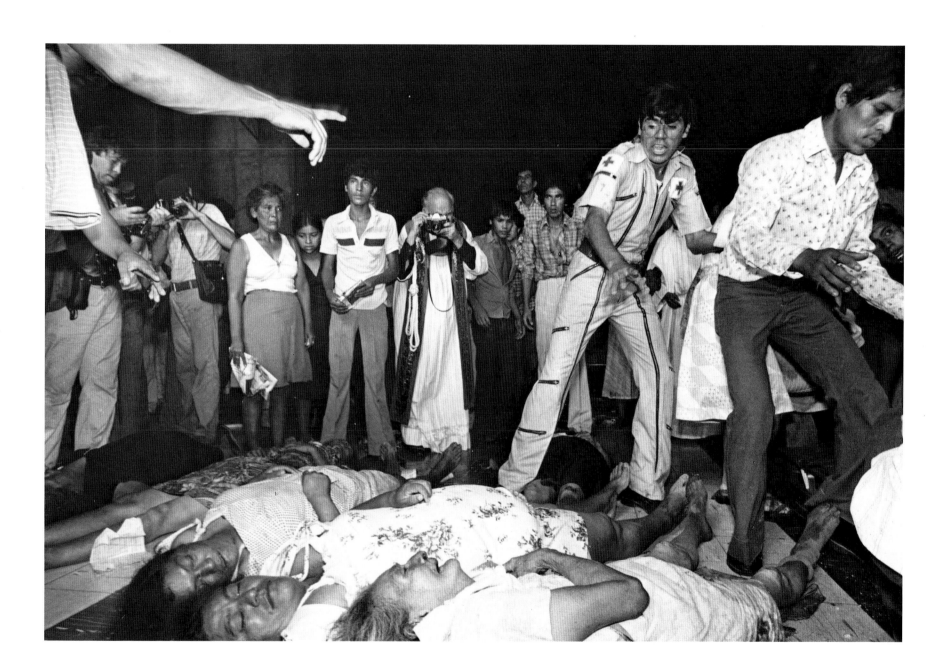

116.
Susan Meiselas, American (born 1948)
Firing Range Used by U.S.-trained Atlacatl Battalion, 1982
El Salvador
Original in color
[11 × 14 in.; 27.9 × 35.6 cm]
© Susan Meiselas/Magnum

117.

Eugene Richards, American (born 1944)
Retarded Child in Mental Institution, Beirut, Lebanon, July 1982
Lebanese War
Gelatin silver print
17½ × 11⅞ in.; 44.4 × 30.2 cm
Courtesy Sandra Berler Gallery, Chevy Chase, Maryland

An angry doctor positions a retarded child's head for the photographer, exclaiming, "This is a child of War!" (Eugene Richards, pers. com. 1985).

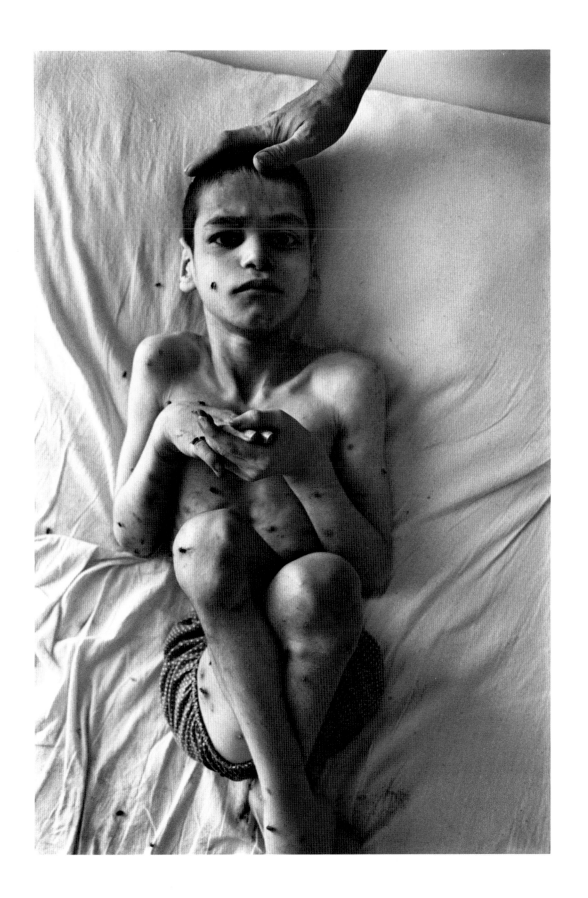

118.
Ed Grazda, American (born 1947)
Commander Anwar, Jegdaleg, Afghanistan, 1983
Gelatin silver print
14 × 17 in.; 35.6 × 43.2 cm
Courtesy the Photographer

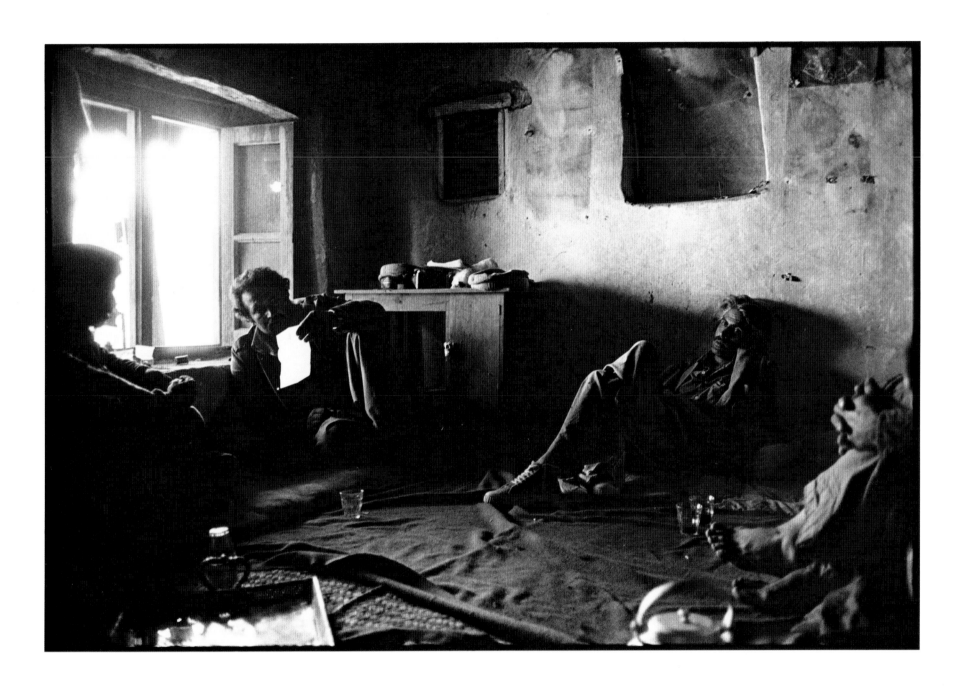

119.
CHRIS STEELE-PERKINS, British (born Burma, 1947)
Gaza Palestinian Hospital—Beirut, 1982
Lebanese War
Gelatin silver print
9 × 13¼ in.; 22.8 × 33.7 cm
© Chris Steele-Perkins/Magnum

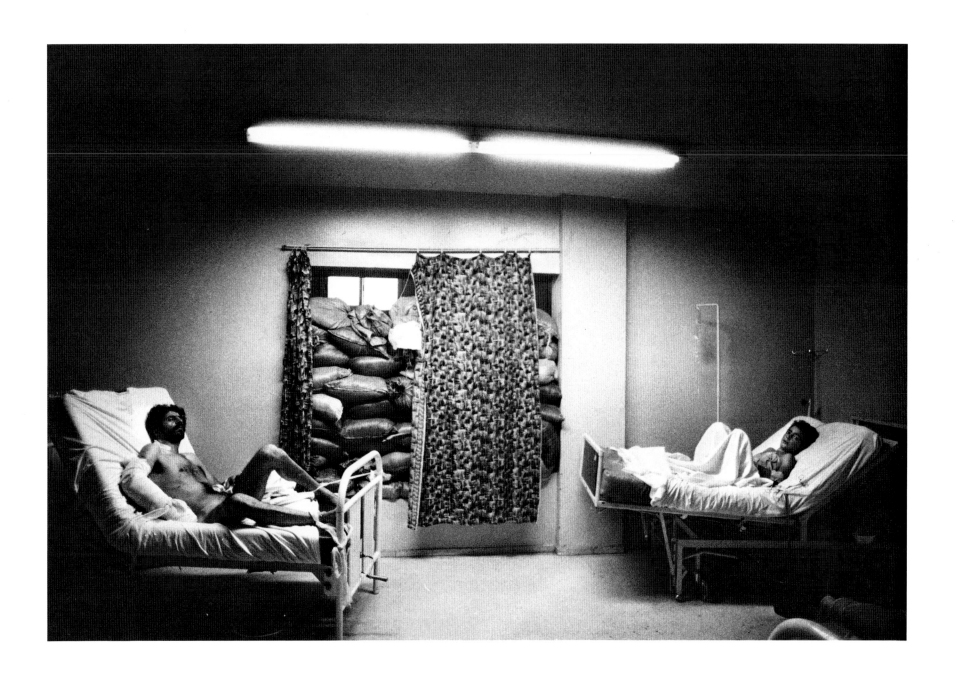

120.

Larry Burrows, British (1926–1971)
A Wounded GI Reaches Out to a Stricken Comrade, 1966
Vietnam War
Dye transfer print
20 × 30 in.; 50.8 × 76.2 cm
Courtesy Russell Burrows, New York

On photographing wars, Larry Burrows once said, "You can't photograph bullets flying through the air, so it must be the wounded, or people running with ammunition, and the expressions on their faces" (quoted in Doyle and Lipsman 1982, 159). Having lived with fighting men in Vietnam, Burrows thought the hardest part was "to keep *feeling*, in an endless succession of terrible situations. Yet if you feel too much . . . you'd crack." His greatest wish was "to be around to photograph Vietnam in peaceful days when all the trouble's over" (quoted in Walsh, Naylor, and Held 1982, 118). Larry Burrows died when his helicopter was shot down over Laos.

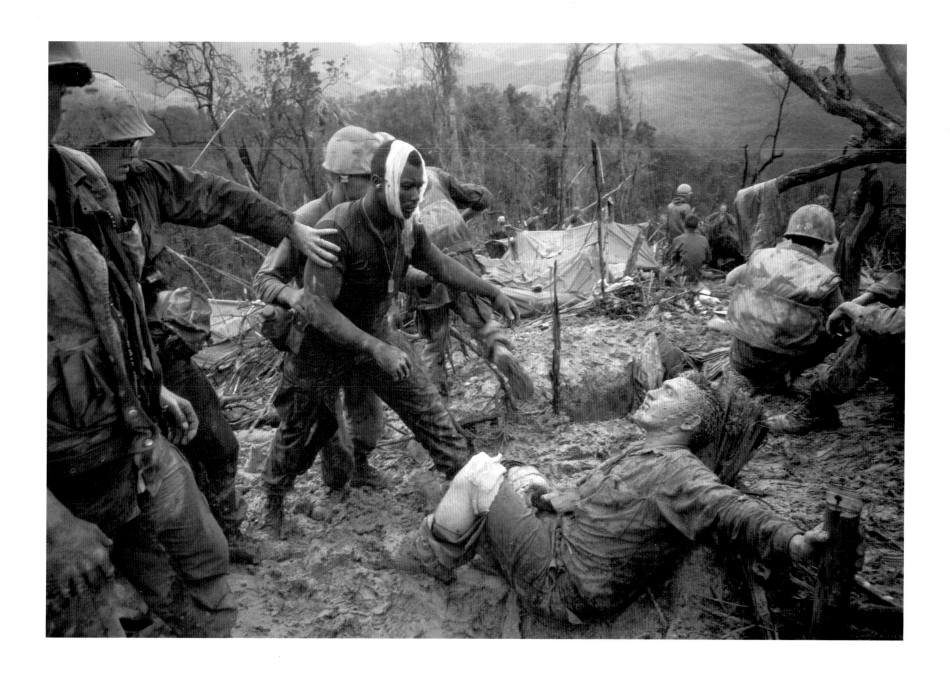

121.

JAMES H. PICKERELL, American (born 1936)
Vietnamese Civilians under Fire, 1964
Vietnam War
Chromogenic color print
10 × 12 in.; 25.4 × 30.5 cm
Courtesy the Photographer

During James Pickerell's three-year stay in Vietnam, from 1963 to 1967, his photographs appeared on the cover of *Newsweek* and in other major news magazines. In 1967 he published the book *Vietnam in the Mud*, in which he talks about his coverage of the war. He operated, he says, "at the level of the foot soldier, as all photographers must, because this is where the pictures are While I may not have clearly understood the high-level plans, I have been closely associated with the men who have tried to make these plans work" (p. XVI).

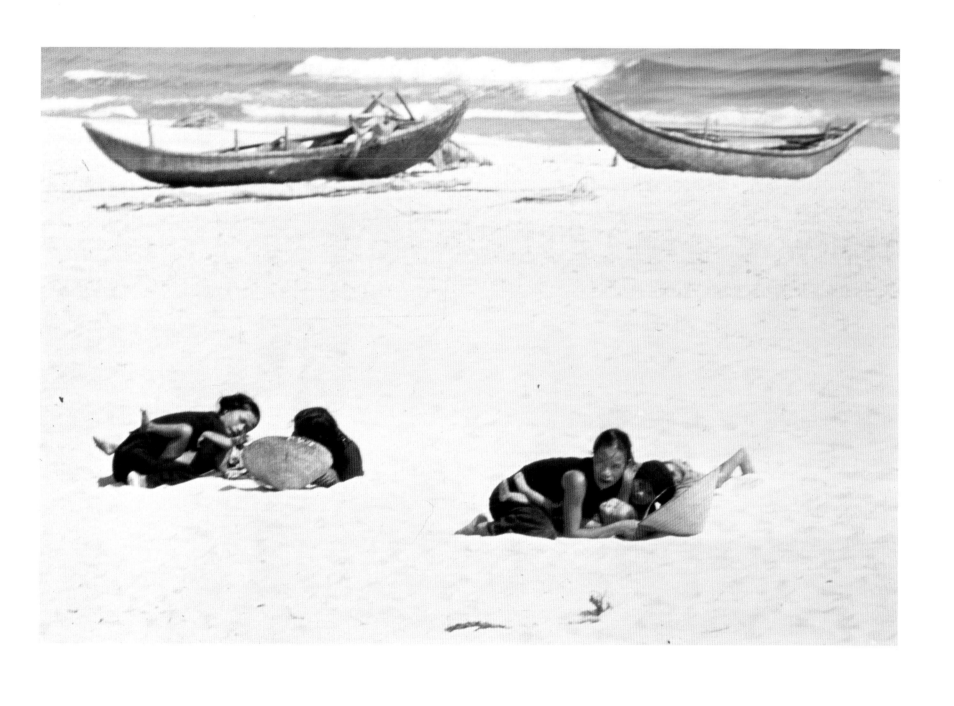

122.
STEPHEN SHAMES, American (born 1947)
IRA Gunman—Ireland, 1971
Chromogenic color print
[14 × 11 in.; 35.6 × 27.9 cm]
Courtesy Stephen Shames/Visions

IRA gunman displays armaments.

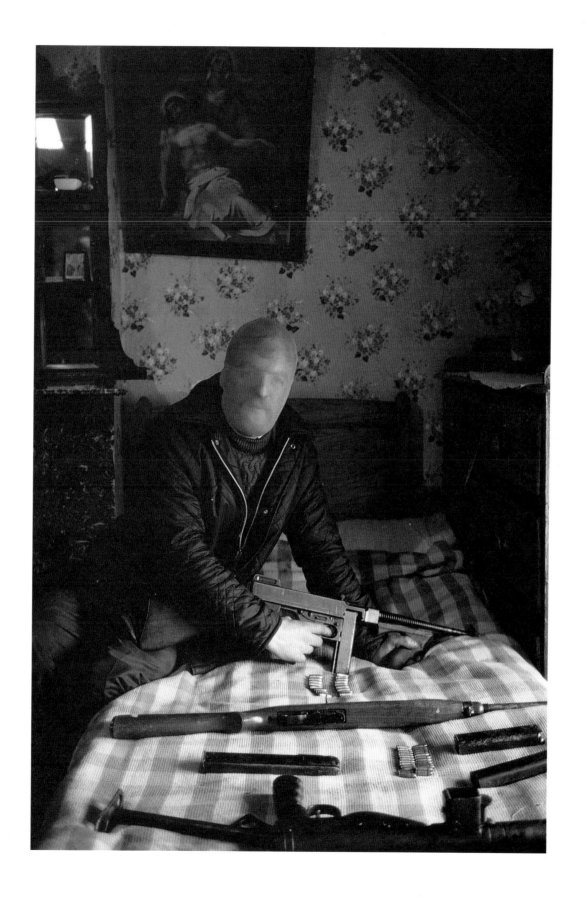

123.
ALAIN GUILLO, French (born Vietnam, 1943)
Grafitti—Afghanistan 1981
Chromogenic color print
[11 × 14 in.; 27.9 × 35.6 cm]
Black Star

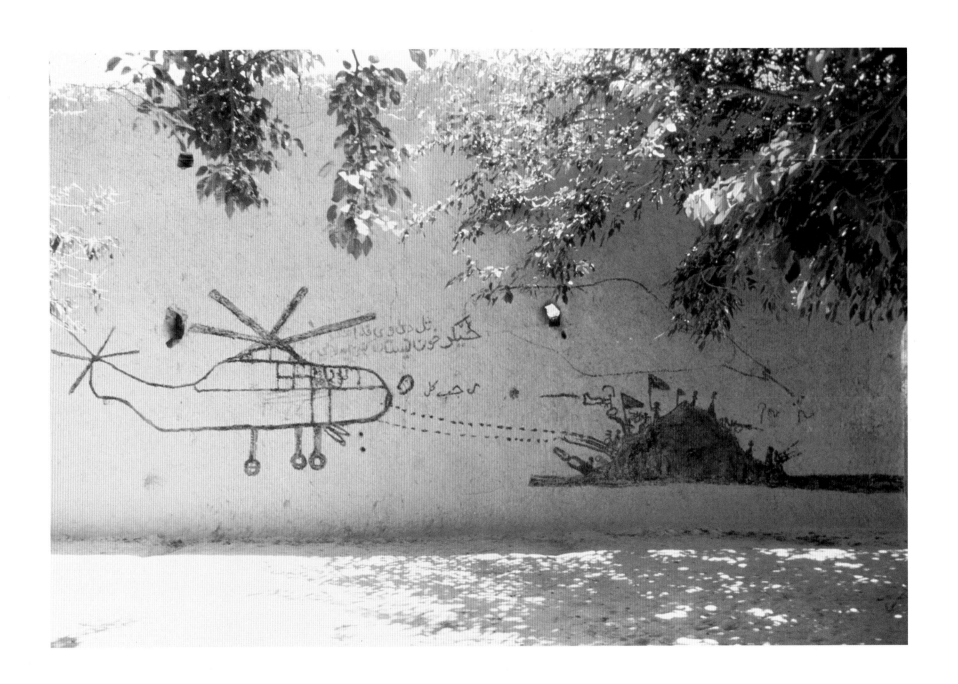

124.
Stephen R. Brown, American (born 1947)
PLO Soldier with Pistol and Artillery Shell. July 1982
Beirut, Lebanese War
Chromogenic color print
11 × 14 in.; 27.9 × 35.6 cm
Courtesy the Photographer

We were doing a 'rubble tour' near the front lines when this young man stepped out, pistol leveled at us, and asked what we were doing. When we explained, he took us on a tour of the camp which had been recently bombed, pointing out the various family houses which had been destroyed. We finally stopped at his house, and while he sat on the bed with a live artillery shell he told us he had bought the house recently because he intended to get married, but because of the siege, he had postponed his plans. The dust and rubble that surround him came from a hole made by an artillery shell in the roof. (Stephen Brown, pers. com. 1985)

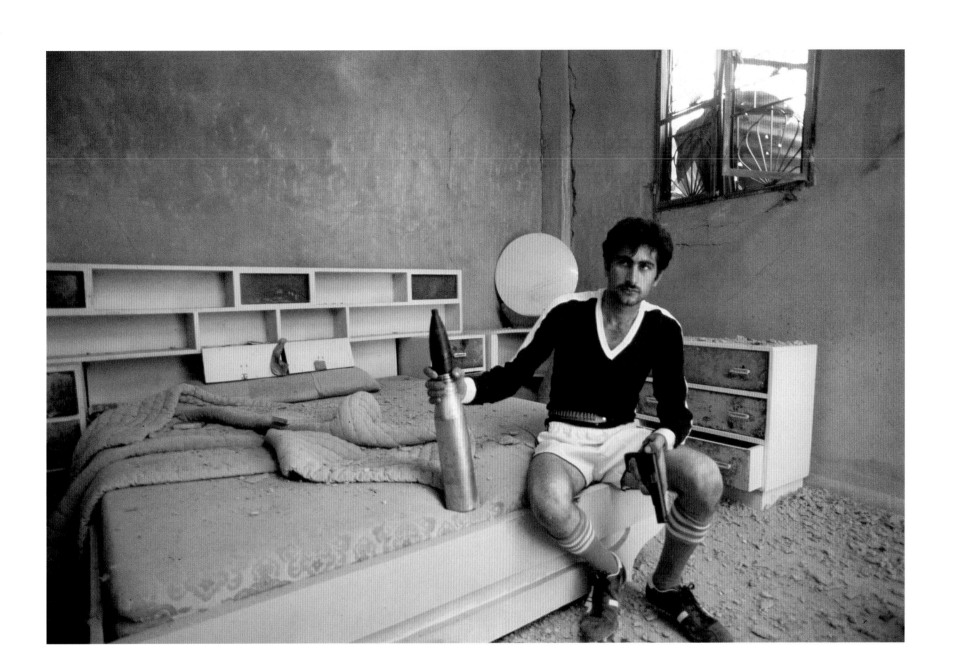

125.

HARRY MATTISON, American (born 1948)
Wounded soldier, Guazapa, 1982
El Salvador
Chromogenic color print
12¼ × 18 in.; 31.1 × 45.7 cm
Courtesy the Photographer

Combined government troops mounted a major offensive against rebel positions on the Guazapa volcano. The army suffered heavy losses, and wounded soldiers were stacked into the helicopters like cord wood to be evacuated to the capital. Many, like the officer in the photograph, died in transport. (Harry Mattison, pers. com. 1985)

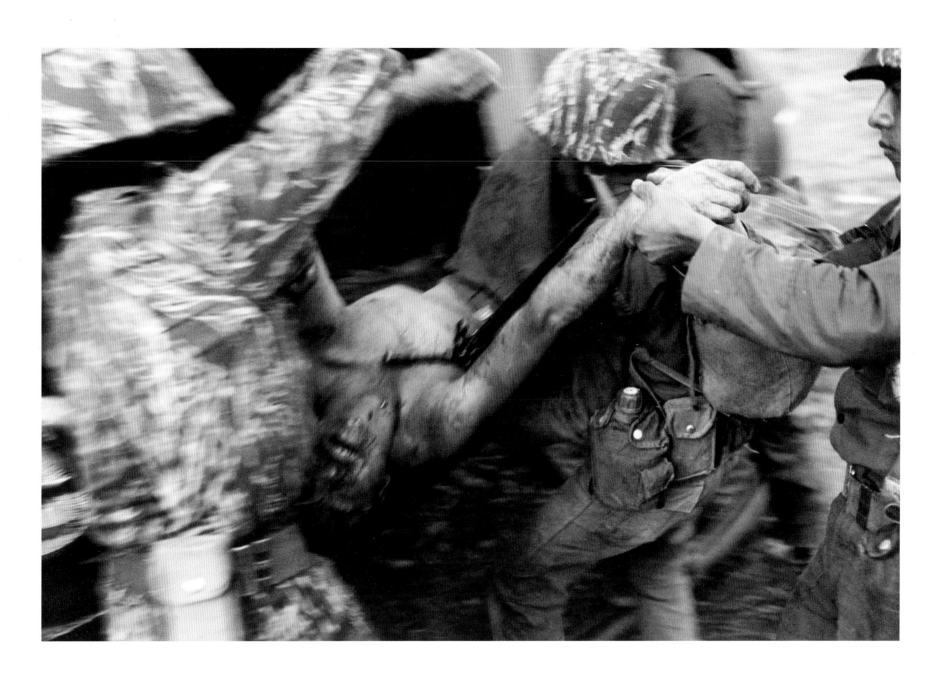

126.
Catherine Leroy, French (born 1944)
Beirut, August 8th, 1982. Israeli Shelling from the Air, the Ground, Sea . . .
Lebanese War
Chromogenic color print
[16 × 20 in.; 40.6 × 50.8 cm]
Courtesy the Photographer

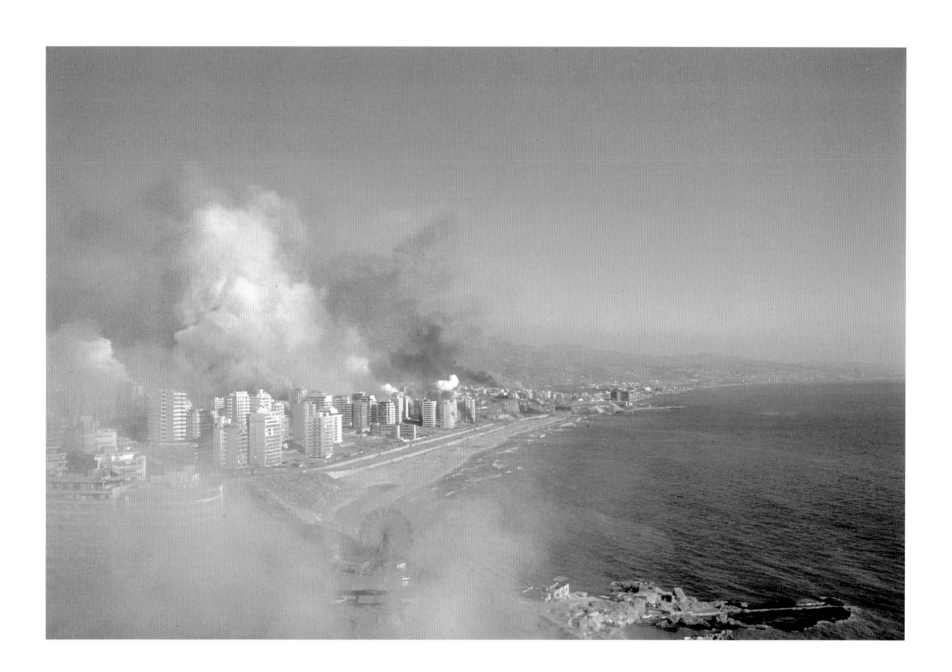

127.
JAMES NACHTWEY, American (born 1948)
Tripoli, Lebanon, December 1983
Lebanese War
Chromogenic color print
[16 × 20 in.; 40.6 × 50.8 cm]
Black Star

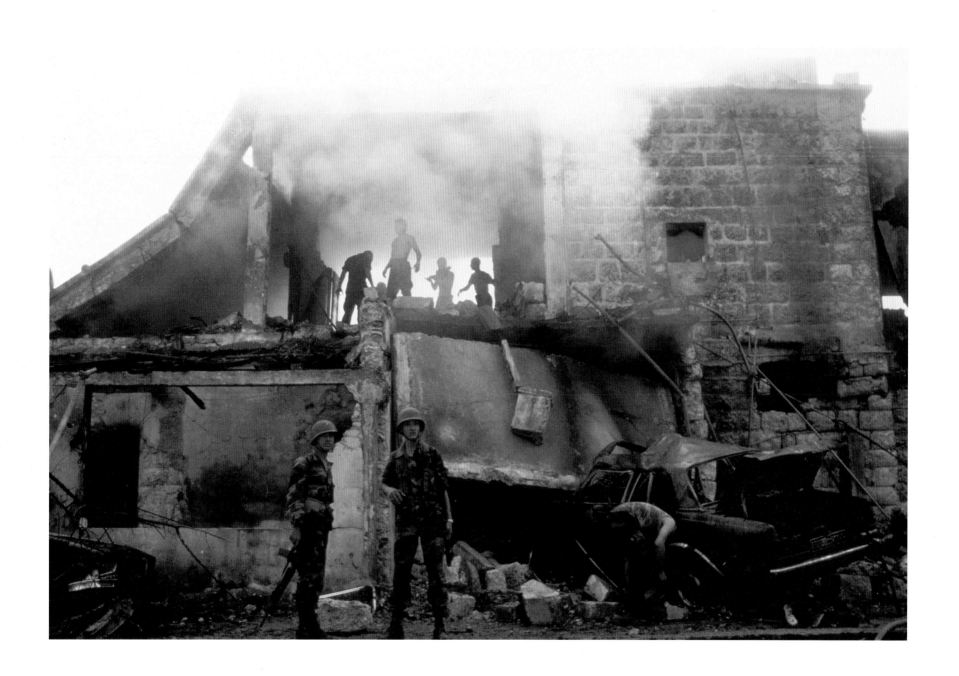